W9-BBB-879

R01016 56550

CHICAGO PUBLIC LIBRARY
UPTOWN BRANCH
929 W. BUENA AVE. 60613

T
500
.D9
M83
1993

Muccigrosso, Robert.

Celebrating the New
World.

$24.95

DATE			
SEP 1994			

CHICAGO PUBLIC LIBRARY
UPTOWN BRANCH
929 W. BUENA AVE. 60613

BAKER & TAYLOR

Celebrating the New World

CELEBRATING THE NEW WORLD

Chicago's Columbian Exposition of 1893

Robert Muccigrosso

The American Ways Series

IVAN R. DEE *Chicago*

CELEBRATING THE NEW WORLD. Copyright © 1993 by
Robert Muccigrosso. All rights reserved, including the right to
reproduce this book or portions thereof in any form. For
information, address: Ivan R. Dee, Inc., 1332 North Halsted Street,
Chicago 60622. Manufactured in the United States of America
and printed on acid-free paper.

Library of Congress Cataloging-in-Publication Data:
Muccigrosso, Robert.
 Celebrating the New World : Chicago's Columbian Exposition
of 1893 / Robert Muccigrosso.
 p. cm. — (The American ways series)
 Includes bibliographical references and index.
 ISBN 1-56663-013-4. — ISBN 1-56663-014-2 (paper)
 1. World's Columbian Exposition (1893 : Chicago, Ill.)
I. Title. II. Series.
T500.D9M83 1993
907'.4'77311—dc20 92-44963

R01016 56350

CHICAGO PUBLIC LIBRARY
UPTOWN BRANCH
929 W. BUENA AVE. 60613

To Maxine

Contents

Preface

IT SEEMS IRONIC that the city of Chicago decided not to celebrate in 1992 the five hundredth anniversary of the voyage of Christopher Columbus to the New World. A century earlier it had jousted fiercely with several other American cities for the privilege (and profit) of hosting the quadricentennial of that fabled event. After their victory, Chicago's civic, commercial, and artistic leaders joined the city's common citizens to pay handsome tribute to the Genoese seaman. Planners for this World's Columbian Exposition of 1893 (or Chicago World's Fair, as it was also known) proudly displayed reproductions of Columbus's three ocean-crossing ships as well as the building La Rabida, a gift from Pope Leo XIII which replicated the Franciscan monastery in which the mariner had dreamed of and planned for his venture. (La Rabida exhibited priceless books, letters, and assorted memorabilia.) An imposing statue of Columbus stood before the exposition's huge Administration Building; his last lineal descendant, the Duke of Veragua, came as a guest and remained until officials withdrew his stipend. Throughout its six months the exposition featured a host of Columbiana: artifacts, drama, poetry, music, and dance.

Other American cities joined in the celebration, though on a less spectacular scale. Columbus's voyage had first been formally commemorated in 1792, at a time when Americans, still reveling in the memory of their recent heroic struggle for independence, identified with Columbus and his exploits. In later years the anniversary fell into general neglect until its resurrection with the establishment of the Knights of

Columbus in 1882. This Catholic fraternal organization, which glowingly referred to the Italian admiral as "a prophet and a seer, an instrument of Divine Providence," began lobbying vigorously to transform October 12 into a national holiday. By 1892 Columbus was faring much better. New York, the nation's largest city, celebrated his feat for five days and built an impressive Columbus Circle dominated by a towering statue of its namesake at the entrance to the city's Central Park; Antonin Dvořák, the visiting Bohemian (Czech) composer, created his *From the New World* Symphony in honor of the occasion. Many Americans heartily agreed with an eminent speaker at dedication day of the Columbian Exposition who praised Columbus for having transported "Christ across the sea" for "the salvation of the world."

If Columbus enjoyed an increasingly glorified reputation by the early 1890s, the end of another century has witnessed a remarkable decline in approbation. No longer, for many, is he the intrepid hero. That Viking explorers antedated his perilous feat, as is now commonly recognized, does not account for this decline. (The Columbian Exposition itself featured a reproduction of a Viking ship.) Far more damaging for the man who brought "Christ across the sea" is the conclusion by detractors that Columbus was a rapacious, insensitive imperialist who brought death and destruction in his wake, permanently upsetting the human and ecological well-being of the New World. The National Council of the Churches of Christ in the United States in 1990 declared that "for the descendants of the survivors of the subsequent invasion, genocide, slavery, 'ecocide' and exploitation of the wealth of the land, a celebration is not an appropriate observation of this [five hundredth] anniversary." Rather, said the council, the occasion should be one of "repentance." Various Native American organizations declared 1992 "The

Year of the Indigenous People." One such group planned an hour of silence for the quincentenary, while a member of the American Indian Movement announced that "Columbus makes Hitler look like a juvenile delinquent." In 1992 the city of Berkeley, California, decided to change Columbus Day to Indigenous Peoples Day and to provide "an accurate history" of what transpired—"the conquest and destruction of ancient American civilizations." Even the executive director of the Christopher Columbus Quincentenary Jubilee Commission decided to describe the event in more neutral terms as a "commemoration" or "encounter" rather than a "celebration."

This denigration of Columbus and his feats has not gone unchallenged. Few may dispute the largely unintended consequences of his voyage, but many point to its positive achievements in the ledger of historical accountability. Notes the historian Stephan Thernstrom:

> The arrival of Christopher Columbus in the Western Hemisphere was a pivotal event in the making of the modern world. It did not usher in utopia, but neither did it destroy a paradise. The process it set in motion, for all of its ambiguities, was a step forward for mankind.

The changing stature of Columbus over the past relates to but also masks the larger question of how Americans see themselves—their past, their present, even their future; their attitudes toward science, technology, and the arts; the values and beliefs they live by; their conflicts and consensus regarding class, religion, race, ethnicity, and gender; their work ethic and amusements; their hopes and dread. Viewed from this perspective, the World's Columbian Exposition of 1893 paid tribute to the erstwhile discoverer of the New World, but Columbus himself was secondary to the exposition. For the United States in the 1890s, as it gazed Janus-faced,

forward and backward, was the principal subject of the exposition. It offered a mirror of American society to those who chose to see.

This book by no means aspires to be a full history of the Columbian Exposition. While it offers substantial details, it does not try to duplicate the more encyclopedic efforts of other works (cited in the Note on Sources at the end of this book). Instead I have attempted to describe and examine the exposition in a manner designed to help readers understand the American people at the turn of the nineteenth century.

Finally, some words of caution on my perspective. Several modern works that deal at great length with the Columbian Exposition have viewed that event in basically negative terms. The exposition, according to them, was largely an exercise in racism, class and gender domination, social control, and cultural retrogression. Although there is some substance to these allegations, I believe that most of them ring hollow. No scholar has cast the exposition as a morality play, but I am bothered by the tendency to offer rigid categorizations and to judge the exposition too harshly in light of today's ethics, values, and tastes. History, like quicksilver, has a certain sprawl that resists confinement; and though the historian Frederick Jackson Turner was undoubtedly correct in noting that "each age writes the history of the past anew with reference to the conditions uppermost in its own time," a greater willingness to give the past some benefit of the doubt seems to me in order. The Columbian Exposition, after all, was one of the nation's most celebrated and memorable events.

Acknowledgments

I AM GRATEFUL to a number of people for their generous assistance. David R. Contosta carefully read the manuscript and offered helpful suggestions and emendations. Thanks are also due to John Braeman, my editor, and Ivan R. Dee, my publisher, for having done likewise. John Lukacs, Louis Filler, Mary-Jo Kline, Anne Broderick, and Noel Allum offered encouragement and useful suggestions. I also wish to acknowledge the assistance of the staffs of the Chicago Historical Society, the New York Public Library, and the Brooklyn College Library, and especially William Gargan. Special thanks are due to Cliff Bernstein for having dragged me out of my typewriter past and into the word-processor present. Without his patient help I most likely would have yielded to my deep-seated Luddite instincts. To my wife, Maxine Engel-Muccigrosso, I give my warmest thanks for her unfailing support and devotion, and for having patiently endured my periodic snits. Finally, I offer the customary but sincere disclaimer that any errors and weaknesses in the book are mine alone.

R.M.

October 1992
Floral Park, New York

Celebrating the New World

1

Setting for a Celebration

THE YEAR 1893 witnessed its share of memorable developments. France and Russia concluded an agreement that would help to pave the fatal road to World War I. That same year two of their most celebrated composers, Charles Gounod and Peter Ilyich Tchaikovsky, died. In Germany Karl Benz constructed an automobile; Lady Margaret Scott won the first golf championship ever held in Great Britain. Across the Atlantic Grover Cleveland was inaugurated President of the United States for a second time and promptly squelched plans to annex the newly proclaimed republic of Hawaii. The longest recorded boxing event—110 rounds—took place over a two-day period in New Orleans in April. Cole Porter, a future titan among composers of popular music, was born to no special fanfare. However important these events may have been or may have seemed, none captured the public imagination in 1893 like the Chicago World's Fair.

Since ancient times, people have gathered to display their wares, exhibit their latest achievements, exchange ideas and gossip, and, not least of all, enjoy themselves. Localized at first, the most ambitious of these gatherings by the nineteenth century had become "world's fairs." Although their scope had broadened and their visitors were more numerous,

they continued to resemble smaller fairs of the past in their
overall concern to merchandise goods, boast of the newest in
artifacts and knowledge, and provide entertainment. Like
past assemblages, they also served as looking glasses that
reflected and sometimes refracted the values and assump-
tions of time and place.

It seems appropriate that London should have hosted the
first of the nineteenth-century world's fairs. England had
averted, if narrowly, the revolutionary fires that had engulfed
the European continent in the half-century since 1789. But
as the home of that even more powerful upheaval, the
Industrial Revolution, it had experienced industrialism more
fully than any of its Continental neighbors. Its "dark Satanic
mills" had blighted natural beauty, disrupted social relations,
and created urban nightmares. According to future prime
minister Benjamin Disraeli, the pernicious effects of this
industrialism had divided the country into "two nations,"
the rich and poor. Despite its devastating consequences the
Industrial Revolution had also provided economic, political,
and social benefits, especially to a growing middle class. And
if the lower classes were not sharing in these benefits—as
assuredly they were not—their time would presumably come.
This prospect of increasing material prosperity and human
progress may have seemed chimerical to some, but others
remained convinced of its certainty. Rapid change could
produce more than deep-seated problems, they reasoned.
Through patience, goodwill, and, above all, knowledge,
humanity might harness the forces of nature through science
and technology for the benefit of all.

Thanks to its pioneering role in the Industrial Revolution,
England enjoyed by the 1840s a manufacturing and com-
mercial position that others could only envy and seek to
emulate. None approved of its stature more fervently than
Belgian-born Prince Albert, royal consort to Queen Victoria.

To stimulate British industrialism and trade, to flaunt the nation's achievements but also to learn from others by inviting them to display their goods, and to promote international peace and amity, Prince Albert and associates organized the Great London World's Fair, which opened May 1, 1851. It quickly became better known as the Crystal Palace Exhibition—a name bequeathed by the British magazine *Punch*—because of its novel main building erected of glass and steel. Towering more than 100 feet and spanning more than two dozen acres, it contained 3,000 columns and some 900,000 square feet of sheet glass. The London international gathering represented the initial modern world's fair and was destined to provide a model for future fairs. The building remained intact until destroyed by fire in 1936.

The judges for the Great London World's Fair had turned down well over two hundred architectural designs before accepting one tendered by a gardener named Joseph Paxton. Originally they had wanted a design rich in historical reference, but they failed to concur on a specific blueprint. Pressed for time, they at last selected Paxton's abstract though highly functional model. According to the Renaissance scholar O. B. Hardison, Jr., their choice created an "aesthetic shock wave." John Ruskin, the hugely influential Victorian critic of art and architecture, bitterly denounced the finished product as graceless, lacking in historical allusion, and altogether too utilitarian. The London *Times* claimed, however, that the building produced "an effect so grand and yet so natural, that it hardly seemed to be put together by design...." Prince Albert construed it more fancifully as a symbol of "that great end to which indeed all history points—the realization of the unity of mankind."

Long suspicious of their English cousins, Americans were not prepared to concede the unity of mankind, but they did participate in the great exhibition. Congress, clinging to the

hallowed Jeffersonian precept of limited government, refused
to vote funds for American exhibits or for appropriate
decorations. It did provide a transport ship, but then it
made no money available for unloading the goods once they
reached their destination. Only the private efforts of an
American banker living in London, who paid $15,000 on his
own, saved the situation. American exhibitors ultimately had
to rely on private funding and initiative. This contrasted
markedly to the active support of European governments for
their displays. It also set a precedent for future international
exhibits in which the federal government would continue to
leave a good deal of responsibility, financial and otherwise, to
the private sector and to state governments.

Lack of public support notwithstanding, American exhib-
its, which totaled roughly five hundred of the overall fifteen
thousand, proved more than moderately successful, winning
more prizes proportionally than exhibits from any other
nation except for Great Britain itself. The names of a few of
the prizewinning American inventors resonate nearly a cen-
tury and a half later: McCormick, Colt, Singer, Morse,
Borden, Goodyear. Beyond the obvious pleasure given the
winning exhibitors, the awards inflated the pride of their
countrymen, constantly taunted by Old World barbs of New
World inferiority. At the start of the exhibition, *Punch* had
observed in derision: "By packing up the American articles a
little closer, by displaying Colt's revolvers over the soap, and
piling up the Cincinnati pickles on top of the vinegar honey,
we shall concentrate all the treasures of American art and
manufacture into a very few square feet...." But by the
exhibit's end the British press was laudatory. Praised the
London *Times*: "Great Britain has received more useful
ideas, and more ingenious inventions, from the United
States, through the exhibition, than from all other sources."
According to the *Liverpool Times,* the United States was "no

longer to be ridiculed, much less despised." In an even higher tribute to American know-how, the British government soon dispatched a commission across the Atlantic to study the technology of interchangeable parts that Samuel Colt had displayed in his firearms at the Crystal Palace.

The Crystal Palace Exhibition proved so popular that world's fairs quickly became fixtures in the Western world—and beyond. By the 1920s more than a hundred such ventures had been staged. The United States participated regularly in major fairs held abroad, but that participation, noted the historian Merle Curti, was "timid and private," at least until the 1880s. After its impressive showing at the Crystal Palace the United States provided only fifty-four displays in space set apart for twelve hundred exhibits at the Universal Exposition in Paris four years later, though the Americans did take home some impressive awards. Its energies consumed by the Civil War, the nation showed a renewed interest in world's fairs only after the fratricidal struggle had been determined. During a congressional debate in 1866 concerning the 1867 Paris Exhibition, former Union general Nathaniel Banks pleaded that it was "a duty to other nations, as well as to ourselves, to show them what we are." Playing upon the theme of economic self-interest, he reasoned that foreign nations, once exposed to American goods, would import more of them. Others, less sure, argued that such nations would merely pilfer American technology. Congress finally appropriated somewhat more than $200,000 for support, but more than twenty years would pass before another Congress would approve as much funding for an overseas fair. Congress was so wary or uninterested that it agreed to fund participation in Spain's Columbian Historical Exhibition, held in Madrid in 1892–1893, only in order to convince the Spanish government to lift its embargo on American pork products. (Spain, in contrast, freely accepted

an invitation to the Chicago World's Fair, held in the international center for pork products.)

During the quarter-century that followed the Crystal Palace Exhibition, the United States hosted two world's fairs of its own—one a dismal failure, the other a success. Private organizers drew upon the British model for inspiration, and in the summer of 1853 a Crystal Palace opened in New York to some fanfare but little applause, despite the managerial efforts of the famed showman P. T. Barnum and the publicity generated by *New York Tribune* editor Horace Greeley. The latter's famous advice, "Go West, young man," clearly did not appeal to Europeans, few of whom bothered to attend or to send exhibits. Nor, for that matter, were Americans present in expected numbers, a disappointment partly attributable to the building's leaky roof. In all, only slightly more than a million people visited the fair, whose sponsors consequently lost several hundred thousand dollars.

These blighted hopes notwithstanding, the celebration of the nation's centennial a generation later offered a rationale for hosting what was to be the first significant American world's fair. Philadelphia, site for the official rupture between the thirteen colonies and Great Britain a century earlier, proved an apt choice. During its six months, from May 10 to November 10, 1876, the Philadelphia Centennial drew more than ten million visitors, more than eight million of whom paid admission. The admission price of fifty cents entitled one to take in exhibits from some fifty nations. Unlike the insolvent New York World's Fair of 1853, the Centennial grossed receipts of $4.5 million. A good deal of its costs were assumed by Congress and by participating state governments.

National pride provided the principal motif for the celebration. Southerners, so recently in rebellion, now joined former Northern foes in commemorating a common heri-

tage of independence and nation building. Symbolic of the hope of many that Reconstruction might soon end (but with blacks truly free) was the hearty reception the audience gave the former slave and renowned abolitionist Frederick Douglass, who sat on the dais during opening-day ceremonies. The appearance and attitude of Emperor Dom Pedro of Brazil further enhanced American self-approbation. Gracious and accessible, Dom Pedro seemed more the democrat than the monarch, thus putting at ease those who were against or ambivalent toward kings and who initially opposed inviting the Brazilian ruler. By most accounts Dom Pedro was the fair's most popular visitor—at least human visitor. A life-size, scantily clad wax figure of Cleopatra provided strong competition.

For all its emphasis on patriotism, the Centennial also stressed material and technological progress. Americans had long prided themselves on material accomplishments, with a premium on gadgetry. New technological marvels abounded at the fair, awing visitors and convincing some that the United States was equal if not superior to the nations of the Old World. Conspicuous among these marvels were George Westinghouse's air brake, George Pullman's Palace Car, and the Quadruplex Telegraph of young Thomas Alva Edison which permitted the simultaneous transmission of several messages. Scottish-born Alexander Graham Bell, a teacher of phonetics, exhibited his newly patented invention, the telephone. No curiosity, however, came close to rivaling the steam engine of George H. Corliss, a builder of power plants for textile manufacturing. Rising more than forty feet, the twin cylinders of the Corliss engine furnished all the power necessary to run the plentiful machinery that filled the main building of the Philadelphia Centennial. This mechanical behemoth personified the nation's transformation, as agriculture inexorably gave way to industry, the farm and village to

he traditional to the new. Steam power itself was
ut its growing capacities were. Corliss's handiwork
oth fear and fascination. Foreign visitors, mean-
while, were impressed with the advanced state of American
technology: its burgeoning chemical industry, its civil engi-
neering, its printing, its precision instruments. One Euro-
pean observer noted that the United States could now
basically exist without Europe, but not vice versa. Even
the Swiss appeared concerned that American-made watches
would prove successful competitors.

If Americans in 1876 could boast of their technological
ingenuity, they were less secure in matters of high cul-
ture. Exhibits of American painting and sculpture were
abundantly visible at the Centennial, as in fairs of the past
and those to come. Quantity was not in question, but of the
numerous American artists represented at the Centennial,
only a few are memorable: Winslow Homer, Albert Bier-
stadt, John La Farge, Louis Comfort Tiffany. In bypassing
the works of Thomas Eakins and Albert Pinkham Ryder,
the fair's arbiters of culture managed to omit two of the
nation's outstanding painters.

The omission may not have mattered to some who be-
lieved axiomatically that American works were generally
inferior to their European counterparts. The quest for cul-
tural independence had proceeded since the early years of
the Republic, but a sense of cultural inferiority continued to
linger. Some had searched for a distinctive national culture;
others, viewing the search as quixotic, clung tenaciously to
what the Old World offered. Professor Charles Eliot Norton
of Harvard, New England Brahmin and leading spokesman
for high culture during the later nineteenth century, carried
the invidious comparison to new heights when he an-
nounced that even natural beauty in the United States was
inferior to that in Europe.

Presumably most people enjoyed their visit to the Centennial, which sought to instruct as well as to entertain. Some found cause for complaint. Workers with six-day weeks, who would have liked to attend the fair, protested the decision of officials to close on Sundays in observance of the Sabbath. Nor did the decision to ban the sale of hard liquor and to permit only weak lager beer meet with unanimous applause.

The Sunday closings and the lack of alcoholic beverages, annoyances to some, paled in comparison with larger developments outside the fair. Since 1873 the nation had been suffering from a panic (the term used for "depression" until the advent of the Great Depression of the 1930s). Rampant speculation in railroad construction, coupled with both industrial and agricultural overexpansion, shook the economy, bringing lower national income and severe unemployment. The panic did not end until 1878, a year after convulsive railroad strikes destroyed widespread property and brought fears of anarchy. Various state governments called out their militias, and President Rutherford B. Hayes ultimately sent federal troops to sustain hard-pressed militiamen.

Fear of a different sort gripped visitors to the Centennial and briefly muted their enjoyment. In early summer word filtered eastward of an appalling massacre of American troops near the Little Bighorn River in Montana. There General George Armstrong Custer, with 264 of his men, had been slain by Sioux Indians whom they had been pursuing. To Easterners the Indian wars of the West may have seemed far away, but news of this stunning defeat brought the fighting closer to home, as the nation mourned its dead soldiers and the handsome cavalry general who had led them. A century later Americans would look with less favor on Custer's military blunders and personal shortcomings, and with more sympathy for the frightful plight of Native Americans. But in 1876 there was little sympathy or sensitiv-

ity for the Sioux and other tribes who had been systematically driven from their lands by the ceaseless western drive of white settlers. The disaster at the Little Bighorn only served to confirm Americans' belief that the only good Indian was a dead one.

Women did not suffer the indignities of Native Americans, but they had made only grudging progress toward full civil, political, and social rights. In 1848 advocates of women's rights—some men, but predominantly women—had gathered at Seneca Falls, New York, to protest their condition. Their Declaration of Sentiments and Resolutions, modeled after the Declaration of Independence, included serious grievances: the legal inability of a married woman to control her financial resources combined with an inability to enter professions, to address a mixed assemblage, to enjoy a single standard of morality, and, most controversial of all, to vote. Two years later the concerned *New York Herald* referred in hysterical tones (supposedly the sort used only by the female gender) to the first Woman's Rights Convention meeting in Worcester, Massachusetts, as "that motley mingling of abolitionists, socialists, and infidels...this hybrid, mongrel, piebald, crackbrained, pitiful, disgusting, and ridiculous assemblage...may God have mercy on their miserable souls." By the time of the Philadelphia Centennial, women had achieved little economic and social equality and had won the vote in but one state, Wyoming.

Undaunted, determined reformers pressed forward. Speaking in New York, Susan B. Anthony, who with Lucretia Mott had founded the National Woman's Suffrage Association, told suffragists that she would go to the Centennial on July 4 "not to rejoice but to declare our freedom" and to "demand justice for the women of this land." True to her vow, the uninvited Anthony read her Declaration of Independence for Women on Independence Day at the Women's

Pavilion in Philadelphia and distributed copies to an audience that expressed a variety of emotions. Most exhibits by women at the Centennial seemed limited to homemaking and arts and crafts that were labeled "woman's work." A separate woman's building—designed by a man—may have further galled feminists by symbolizing the extraordinary difficulty women had in pursuing professional careers.

The condition of women and Native Americans was not the only discordant note in the City of Brotherly Love that summer. While friendly crowds had hailed Frederick Douglass, and the Reconstruction amendments had granted millions of slaves freedom, citizenship, and, if they were males, the franchise, the futures of black Americans remained uncertain. Soon-to-be-elected President Hayes would remove the last of federal troops from former Confederate soil, Reconstruction would end, and a long, agonizing period would begin in which the rights and opportunities of black Americans fell into deep eclipse. The millions of workers thrown into unemployment by the Panic of 1873, along with their families, could scarcely be optimistic. Nor were the nation's farmers in good spirits, especially those in the Midwest who were angrily forming third parties, seeking legislation to curb the powers of the railroads and middlemen, and demanding inflated currency with which to pay off their debts.

But if some Americans saw the glass as less than half full, others were more hopeful. During its full century of independence the United States had made remarkable progress in a variety of ways, as the Centennial celebration vividly portrayed in exhibits and words. Granted this progress was uneven and in some cases difficult to detect, most visitors to Philadelphia applauded the world's fair. Some may have even looked forward to the next one.

* * *

 1885 a few people were entertaining ideas for a
Exposition, but it was only in 1889 that Senator
Cullom of Illinois introduced a bill that would
commit the United States government to support a major
celebration of the four-hundredth anniversary of the Old
World's encounter with the New World. The trouble was
that Cullom, deliberately or not, failed to specify Chicago as
the host city for the fifteenth world's fair of the nineteenth
century. As a result, a strongly contested rivalry for that
honor blossomed, principally among New York, Chicago, St.
Louis, and Washington, D.C. Hosting the projected fair
would mean a grand infusion of spending by millions of
visitors. But civic pride also remained a substantial factor as
the race narrowed to a field of two: New York and Chicago.

As the nation's most populous and richest city, and as
recent successor to Boston as the hub of American cultural
activity—though numerous Bostonians disputed the succes-
sion—New York fully expected to win congressional desig-
nation. Mayor Hugh Grant and his friends in Tammany
Hall worked zealously on behalf of their city, knowing full
well the opportunities for graft and corruption that would
come their way. As for Chicago, Gothamites agreed with
Charles A. Dana, editor of the *New York Sun,* who sneered
at "the nonsensical claims of that windy city." Georgia-born
Ward McAllister, the leading late-nineteenth-century arbiter
of social taste and the man who claimed that genuine
American society included only "the four hundred" who
could fit into Mrs. John Jacob Astor's New York ballroom,
snobbishly noted that "the contact of New York and Chicago
society cannot help but open the eyes of our Western natives
to our superiority...." (He did qualify this observation by
expressing a belief that there was no reason why Chicago
"should not eventually catch up.") Rudyard Kipling also
disparaged Chicago. Visiting the United States for the first

time in 1889, the young British writer, who stood on the threshold of international fame, disliked most places he toured, but none so intensely as Chicago. "Having seen it," he lashed out, "I urgently desire never to see it again. It is inhabited by savages."

Such harsh words by Dana, McAllister, Kipling, and a number of other critics notwithstanding, few could deny that Chicago had become a truly major city. Its trade was second only to that of New York; more ships entered its harbor than those of New York. Excelling in manufacturing, it produced plentiful iron and steel goods, railway cars, and processed meat as well as chemicals, textiles, beer, and other alcoholic beverages. Besides its extraordinary stockyards, at least two of its commercial concerns had attained world prominence: the McCormick Harvesting Machine Company and the Pullman Palace Car Company.

After seven indecisive ballots, the House of Representatives chose Chicago over New York on February 24, 1890. President Benjamin Harrison signed the bill creating the Columbian Exposition almost exactly two months later, April 25. In retrospect, the selection of Chicago seems entirely appropriate. The city may have been only the nation's second largest, but in important respects it represented the quintessential American city of its time. Some, including Chicagoans, deplored its rawness, its crudities, its lack of an older, established society; others translated these apparent defects into virtues and praised the city for its preoccupation with success, its dynamic vitality, its openness to change. One European visitor to American shores in 1890, Paul de Rousiers, grasped an insight that is as applicable today as it was then. Europeans, he noted, held the false notion that New York was America. A staunch admirer of Chicago, this visitor applauded "the marvelous energy of the Western settlers, their true sense of their dignity and inde-

pendence, and that superb self-confidence which makes them undertake such astonishing projects." Both admirers and critics grasped part of the truth, for Chicago was all of these things—and more. The whole exceeded the sum of its parts. Sometimes ridiculously brash, sometimes oddly short on self-confidence, it prepared for yet another "astonishing" project which would allow Americans at large to measure their ideals, values, and assumptions, their hopes and fears.

2

The City on the Prairie

MONTGOMERY SCHUYLER, the nation's foremost architectural critic of the late nineteenth century, noted that "in this country mere bigness counts for more than anywhere else, and in Chicago, the citadel of the superlative degree, it counts for more, perhaps, than it counts for elsewhere in this country.... One cannot escape hearing and seeing it there a dozen times a day, nor from noting the concomitant assumption that the biggest is the best."

But in the beginning there was only the fort. Situated along the western shores of Lake Michigan, Chicago derived its name from an Indian word meaning, according to various sources, either "strong," "wild onion," or "polecat." It had remained an untamed wilderness since it was first visited by the French explorers Joliet and Marquette in the later seventeenth century. There, in 1804, the United States government, in order to strengthen its position against both the British and their Indian allies in the northwest territory, established Fort Dearborn. Few could have foreseen that this military outpost, erected on swampland, would grow into a metropolis before the end of the century. Probably fewer held this vision after Indians razed the fort and massacred all but a handful of its inhabitants at the outbreak of the War of 1812.

Within a few years a new and regarrisoned Fort Dear-
born stood on the site of the old structure. Yet by roughly
1830 Chicago represented little more than a small enclave of
traders who exchanged goods with local Indians. An upris-
ing by Chief Black Hawk and his Sac and Fox followers con-
vinced Chicago's settlers and the United States government
that amity built on commerce had its limits. But both Chica-
goans and politicians in Washington were prepared to cut a
deal. In an agreement signed by more than seventy chiefs in
1833, the numerically superior Indian tribes, for a variety of
goods and some cash, agreed to move west of the Mississippi.

With the ebbing of the Indian menace, a new era opened
for Chicago. Blessed by geography, it served as a nexus for
trade and reaped the gains of commerce with the East, the
Midwest, and the South. By the time of the Civil War
Chicago had indeed become a city. From scarcely 100
inhabitants as a trading village in 1830, Chicago had grown
in population to nearly 30,000 by 1850, and in a remarkable
surge to 109,000 a decade later.

But what kind of city was Chicago? Not a very impressive
one, critics suggested. It was a city mired in commerce and
mud. So difficult was it to transverse streets in Chicago that,
one historian concluded, "the mud was probably the most
famous topic of conversation." Over the years buildings had
inched downward and sidewalks, where they existed, had
settled unevenly. A little ingenuity ultimately solved the
sticky problem. In 1857 George Morton Pullman, a trans-
planted cabinetmaker and contractor from New York who
later was to become celebrated for his Pullman Palace Cars
and model town, devised a clever solution that derived from
his earlier work on the Erie Canal. After placing some six
thousand jackscrews under all the buildings on Lake Street,
he ordered six hundred hired laborers to turn the screws
simultaneously. All the buildings were elevated four feet.

Pullman then had his workers shore up the buildings with timbers until new, even sidewalks could be laid. When it was found that the buildings had incurred no damage, other contractors were soon hired to raise other establishments above the muck and mire.

Having picked itself up by its bootstraps, Chicago began to gain increased self-respect. The fledgling Republican party staged its convention there in 1860, the first in a long procession of party conventions in Chicago for both Democrats and Republicans. The Civil War enhanced the importance of the city. Patriotic zeal induced many to enlist under the Union banner, though a number of Democrats remained either lukewarm or hostile toward Union efforts, especially after the emancipation of slaves. The city also provided a prisoner-of-war camp (Camp Douglas at Thirty-third Street and Cottage Grove Avenue) for captured Confederate troops. More important, it housed the great McCormick reaper works, which fashioned machines that made possible remarkable quantities of foodstuffs for hungry Union forces.

Chicago's fortunes began to soar, literally and figuratively, in the postwar years. If geography is destiny, Chicago was ideally situated in mid-America and destined to enjoy the fruits of commerce that traversed the continent. The railroad boom that had gripped the nation even before the Civil War made Chicago indispensable to the transcontinental trafficking of the iron horse. Chicagoans could smell success, and by 1890 thirty-two different railroads ran more than fifty separate lines to and from the city.

Success, unfortunately, was not all Chicagoans could smell. On Christmas Day 1865 the Union Stockyards opened. Although located outside the city's limits and some four miles from its commercial center, Packingtown, as the stockyards came to be known, became a nineteenth-century version of an environmental hazard. Erected on a square

mile of land that lay a full two feet below the water level, Packingtown regularly conveyed its odors as well as its meats northward to the city proper. It also passed along worse than odors, some whispered, but the whispers would not be confirmed until the publication in 1904 of *The Jungle* by the young muckraker Upton Sinclair. Even before Sinclair's exposé, a single trip to the stockyards convinced a visiting British aristocrat never again to eat sausage. Meanwhile Chicago was becoming the world's most famous hog butcher, utilizing all of that animal, as the adage went, except for the squeal. By the time of the Columbian Exposition some 25,000 workers would be seeing to it that hogs as well as cattle and sheep were giving up their flesh, bones, horns, tails, and bodily fluids to provide humans with meats and such sundry items as combs, buttons, glue, felt, and fertilizer.

In the years after the Civil War the Lords of Packingtown—Philip Armour, Gustavus Swift, Nelson Morris, John and Patrick Cudahy—parlayed modest business concerns into huge enterprises which first served a local market and then, with the invention of refrigerated freight cars, the insatiable appetites of Eastern carnivores. Some of these beef barons, despite their newly acquired fortunes, remained simple men at heart. For years Swift lived near the stockyards so that he could spend more hours overseeing his domain. Eventually he relocated to a somewhat fancier though not attractive yellow brick residence on South Ellis Avenue, but he persistently refused to allow his wife the extravagance of curtains until the woman threatened to leave him. Even then he adamantly refused to have curtains in their bedroom.

Philip Armour also retained a certain simplicity after his arrival in Chicago from his native upstate New York. For years he showed up at his business by 7 a.m. and occasionally as early as 4 a.m. But one must not confuse simplicity

with naiveté. As Union and Confederate guns blazed, Armour, as befitted a Quaker, forswore war for peace. But he was not above turning a profit of $2 million in pork futures during one three-month period. A quarter of a century later the hugely successful Armour & Company was slaughtering nearly 3 million cattle, hogs, and sheep yearly, employed 7,900 workers, and had annual sales of more than $65 million. *Baedeker's*, a celebrated guidebook for visitors to the United States at the time of the Columbian Exposition, noted that "the processes of killing the cattle and hogs are extremely ingenious and expeditious, and will interest those whose nerves are strong enough to contemplate with equanimity wholesale slaughter and oceans of blood." By the time of the exposition Philip Armour, with his fortune of almost $40 million, was the Croesus of Packingtown and one of Chicago's richest citizens. Few were surprised when he confessed to having no other interest in life than his business.

Mrs. Patrick O'Leary, who in 1871 was residing on De Koven Street in an unfashionable sector of the city, did not run with the Armours. Like many of her fellow Irish who comprised a large share of Chicago's 300,000 inhabitants (nearly half of whom were foreign-born), Mrs. O'Leary could barely make ends meet for herself, her family, or the few animals the family kept in a barn near their modest home. As legend would have it, on Sunday evening, October 8, 1871, one of the calves in the O'Leary barn stepped over the kerosene lamp and into history. Firemen, exhausted by their successful efforts earlier in the day to quell a serious fire a half-mile northward, tried to contain what now had become an even more serious blaze. Their efforts proved fruitless. A record drought had enveloped the city that summer, and by October Chicago's many wood-frame buildings offered dangerous tinder. The drought had also imperiled the city's water supply. Any real hope for saving the city

perished when the flames reached the North Side, where they continued to rage until late Monday evening. According to one distraught victim,

> As far as the fire reached the city is thronged with desperadoes who are plundering and trying to set new fires. The police are vigilant. Thousands of special police are on duty. Every block has its patrolmen and instructions are explicit to each officer to shoot any man who acts suspicious and will not answer when spoken to the second time. Several were shot and others hung to lamp posts last night under these instructions.... Schoolhouses and churches are used to house the destitute. Fifty carloads of cooked provisions are on the road from St. Louis and the same from Cincinnati.... The like of this sight since Sodom and Gomorrah has never met human vision.

The writer could have been speaking for almost any Chicagoan in concluding, "I don't know what I shall do." Like other tragedies, the Great Fire of 1871—"The Great Conflagration," as others called it—failed to respect rank or wealth. The rich suffered along with the poor, and when it was over the statistically minded announced the reckoning: 17,000 buildings and an estimated one-third of the city's total wealth destroyed; 300 persons killed; nearly 100,000 individuals, roughly one-third of the city's population, left homeless.

Tragic though it was, the Great Fire was in truth a mitigated disaster. Almost 90 percent of the city's manufacturing capacity miraculously survived intact, as did at least three-quarters of its livestock, lumber, and grain holdings. Almost as soon as the last flames died, promises of financial aid poured in. Charitable agencies, banks, and the federal government pledged support; insurance companies assured nervous policyholders that they would receive compensation. Viewed from another perspective, the fire provided the city with an opportunity to start anew. As Ross Miller has noted

in *American Apocalypse,* "...its blasted condition and its
relative freedom from traditions, except its own powerful
self-mythologized belief in itself, allowed the city to reima-
gine itself completely." Within a few years, like the legend-
ary phoenix, Chicago rearose and quite literally soared
skyward. Pessimists grossly underestimated the resiliency of
its citizens. The example of the Potter Palmers is illustrative.

Quaker-bred Potter Palmer left his boyhood home outside
Albany, New York, and in 1852 arrived in Chicago where he
spent the next fifteen years building a highly successful dry
goods firm. An innovator, he shocked competitors and
customers alike by extending credit and the right to return
merchandise. Some also scoffed at the bargain-basement
sales in the bowels of his emporium. Doubters notwithstand-
ing, Palmer became a millionaire—only to have badly com-
promised his health in the process. On the advice of his
physician he turned over the operation of his store to his
trusted partners, Marshall Field and Levi Leiter. By the
time of the Columbian Exposition the new firm, enjoying
even greater success, employed almost five thousand workers
in its new State Street headquarters designed by Henry
Hobson Richardson, the most celebrated architect of the
Gilded Age. Palmer, who was too young to enjoy the
dubious blessings of sedentary leisure, now turned to real
estate and in the process handsomely augmented his already
considerable fortune.

One of Chicago's most eligible bachelors, the forty-four-
year-old Palmer wed twenty-one-year-old Bertha Honoré—
"Cissie" to her family and friends—in the summer of 1870.
After a brief honeymoon in Europe the groom presented his
bride with her wedding gift: the Palmer House, which, once
completed, was to have 225 rooms, to stand eight stories tall,
and to serve as one of the city's grandest hotels. Weeks later
the wedding gift, along with much of the rest of Chicago,

was in ashes. Palmer, who had been in the East to attend the funeral of his sister, rushed home to find that his wife was safe but that he had lost almost all the thirty buildings he owned. He was financially ruined. Palmer considered quitting the ravaged city, but his wife displayed the same mettle and character that within a few years would lead many Chicagoans to genuflect before her as their first lady. Heartened by her resolve to rebuild their fortunes, Palmer elected to remain and to start anew. Like other Chicagoans, he was "reimagining" his life.

The Palmers succeeded. Grandly, almost incredibly. Potter Palmer, his reputation as an honest and masterful businessman having withstood the destructiveness of the Great Fire, received an unheard-of loan of $1.7 million from an Eastern insurance firm. The loan, obtained with only the collateral of his good name, probably represented the largest personal loan any American had ever obtained. With it Palmer invested in the rebuilding of Chicago, including a new Palmer House which opened in late 1873 at the corner of Monroe and State Streets in the heart of the business district.

The new Palmer House, which took up an entire city block, seemed to symbolize the determination of Chicago to announce to the world, as Mark Twain was to have said of himself, that reports of its demise had been greatly exaggerated. The hotel flaunted its grandeur and wealth. Its magnificent façade, designed in a French style, only hinted at the splendors within: an Egyptian parlor and chandeliers; Venetian mirrors; a main dining room patterned after the palace of the Hohenzollerns in Potsdam; staircases carved from the finest Carrara marble; frescoed ceilings with gold trimmings. Freshly cut flowers invariably adorned the dining room while immaculately clad waiters catered perfectly to the needs of clientele. Reading, writing, and smoking rooms, a bar, various restaurants, and a billiard room blended with

numerous parlors to provide guests, many of whom were businessmen or politicians, with an assortment of comforts and diversions. For the nabob who could not leave his business cares behind, a telegraphic ticker in the lobby of the hotel gave ready access to the nation's financial markets. Electric call bells spared guests the irritation of paging bellboys; extensive electric lighting gave off a clean glow that gaslights had never offered. Probably in muted tones the guests spoke of what many considered the most startling feature of all: flush toilets in every room.

To build the Palmer House had cost a great deal of money. Some said $3.5 million, of which 225 silver dollars lay embedded in the floor of its celebrated barbershop, the "Garden of Eden," named for its proprietor, W. S. Eden. "A gilded and mirrored rabbit warren" where people congregated to discuss money and to spit a good deal, was how Rudyard Kipling curtly dismissed the Palmer House. (He strongly disliked the food served there, too.) But what did he know, asked the defenders of Mr. Palmer's grand creation? After all, they concluded, Kipling had probably spent too much time among the heathen. The new Palmer House had its new rivals—the Tremont House, the Sherman House, the Grand Pacific—but there was only one Palmer House, and for only three to six dollars per day one might have the grandest accommodations in America.

There was also only one "Palmer Palace." Wealthy Chicagoans had resided on the South Side of their city in the years before the Great Fire; most rebuilt on or near their original sites. The Palmers lived in their new hotel after the fire but then decided on a separate residence. Potter Palmer had granted the city certain riparian rights along Lake Michigan that would allow Chicago to develop the lakefront area around Lincoln Park. In return he received sand that he could use in reclaiming undeveloped land facing the lake on

the North Side. Construction began there in 1882, at the corner of Lake Shore Drive and Banks Street, for the Palmer residence. The original estimate for the three-story mansion ran to ninety thousand dollars. By the time of its completion in 1885 the cost had increased more than tenfold. It was no simple mansion. It soon became known as the Palmer Palace.

Conceived by the Boston architect Henry Ives Cobb, the Palmer Palace was a farrago of design and decor. Built in a Gothic mode, the mansion featured minarets, turrets, balconies, and, above all, an eighty-foot tower that encased a spiral staircase. The striped effect of its granite and contrasting sandstone exterior displeased Bertha Palmer as gloomy. Inside, however, six liveried servants and lavish surroundings did their best to dispel any hint of dreariness. The huge octagonal greeting hall contained Gobelin tapestries, mosaic marble floors, a tiger-skin rug, and the Honoré family coat of arms. Eclectic to say the least, interior spaces included rooms styled in Greek and Japanese, a Moorish ballroom, a Flemish Renaissance library, a Spanish music room, an English dining room, and a French drawing room with gilded Florentine chests. Count Boni de Castellane, the French socialite who had married a daughter of the notorious Jay Gould, pronounced the drawing room "abominable." But then the count, who was in the process of squandering more than five million of his wife's fifteen million dollars, and who would end his days financially pressed in Buenos Aires, may have been simply exhibiting a European's condescension to the American nouveaux riches.

Visitors were more apt to dwell on the dining room. Ninety feet long, forty feet high, and hung with Tiffany chandeliers, the room doubled as a ballroom and finally as a picture gallery. For the fifty or so guests who could be seated, French chefs prepared gargantuan meals which typi-

cally included selections of stewed terrapin, filets of beef, paté de foie gras, truffled turkey, sweetbread patties, chicken, snipe, boned quail in jelly, and lobster salad. Sorbets cleansed palates between courses; champagnes, ports, and sherries helped the gourmands to digest. Trying to avoid acute indigestion, or dyspepsia as it was then known, diners usually contented themselves with light desserts: ices, fruits, cheeses, or perhaps a charlotte russe. Yet only an elixir could have protected the invidious from painful twinges when Mrs. Palmer chose to wear her jeweled collar composed of seven large diamonds and 2,268 pearls. Such discomfort may have been even more distressing when she wore her collar while receiving guests in the room set aside for her dazzling display of French impressionist art. (Mrs. Palmer was probably the first important collector of such paintings in the United States.) Once the dinner or soiree had ended and guests had departed, the hostess could take one of two elevators that led to her boudoir and perhaps bathe relaxingly in her swan-shaped sunken tub before retiring to her ten-foot-high Louis XVI bed.

Enormous wealth and conspicuous consumption were by no means limited to the Potter Palmers, who by the early 1890s were worth an estimated fifteen million dollars (a dollar then could buy what ten dollars might buy today). The rapid economic expansion of the post–Civil War era had sired, according to an often cited magazine article of 1892, roughly four thousand millionaires. Chicago alone could boast two hundred, or 5 percent, of these titans, a figure that takes on added meaning in light of the Great Fire. The late-nineteenth-century novelist Henry B. Fuller wryly observed of Chicago, "... It is the only great city in the world to which all its citizens have come for the one common, avowed object of making money... and there are very few of us who are not attending to that object very strictly."

The public-spirited, rags-to-riches dry goods magnate Marshall Field, when he was not quarreling with his wife who eventually left him and Chicago for Paris, found sufficient time and energy by the time of the Columbian Exposition to become the Windy City's richest man. His estimated personal worth of $200 million easily outdistanced the $40 million of his nearest competitor, Philip Armour. The various meat moguls counted themselves millionaires as did Cyrus Hall McCormick and his offspring. Levi Leiter, Field's partner and a speculator in real estate, remained enormously wealthy even after his son lost nearly $10 million in a harebrained scheme to corner the wheat market. Young Montgomery Ward, meanwhile, was accumulating his first million dollars in dry goods. Unlike Field and Armour, who had amassed fortunes by underselling competitors, George M. Pullman achieved his through a superior product in a highly specialized field. At the time of the Columbian Exposition the Pullman Palace Car Company owned and operated some 2,500 railroad cars and annually produced 200 Pullman cars, 500 regular passenger cars, and 10,000 freight cars, all of which were valued at more than $10 million. In the style of a benevolent despot, Pullman had erected a company town for his employees near his plant. With clean, well-maintained houses and grounds that served as residences for more than 10,000 during the world's fair, Pullman town, established in 1881, was in many respects a model development. But Pullman also itched to control the lives of his workers, imposing on them a myriad of restrictive regulations. Noted one critic: "The autocrat of all the Russians could not more absolutely disbelieve in government by the people, for the people, through the people...." Still, Pullman would remain a highly respected figure until the bitter strike of 1894 that now bears his name.

By 1894 another Chicago millionaire, Charles T. Yerkes,

had little respect to lose. A transplanted Easterner, like so many of his fellow Chicago plutocrats, Yerkes had served a year in a Philadelphia jail after chicanery in bonds during the Panic of 1873. Although he was pardoned, the experience seems to have alienated him from the middle-class ethos of the Gilded Age. Despite having a wife and six children, Yerkes, whom Theodore Dreiser would fictionalize as the protagonist in his Frank Cowperwood trilogy, was widely reputed to be a notorious womanizer. Candid in his likes and dislikes, he shocked some with his coarse insults. But neither his speech nor his sexual mores caused the greatest furor. By the time of the Chicago's World's Fair Yerkes had acquired a fortune through real estate and, more conspicuously, through the city's transportation system. By bribing aldermen and even a governor, Yerkes had gained control of two vital street railways and was prepared to charge all the traffic would bear. Yet it should also be noted that by the time he left Chicago for New York he had created "one of the best street railway systems in the world," a system that in 1893 was operating five hundred miles of track.

Yerkes displayed his wealth with a costly Gothic mansion located at the corner of Michigan Avenue ("Millionaires Row") and Thirty-second Street. A number of the rich, including Robert Todd Lincoln and Franklin MacVeagh, the grocery magnate, followed the Potter Palmers to Lake Shore Drive, while the "Chicago Trinity"—Field, Armour, and Pullman—reigned on Prairie Avenue. Henry Hobson Richardson designed Romanesque residences for several, including a particularly memorable one for John J. Glessner. Cyrus McCormick's forty-five-room mansion on Huron Street stood surrounded by the domiciles of other McCormicks. Constructed in the Second Empire style, the huge McCormick mansion contained, among other features, a two-hundred-seat private theater.

Expensive furniture regaled most palatial homes. Gilt-edged satin damask covered the walls, as did expensive paintings of various quality recently brought back from Europe. Costly lamps, rugs, statues, and bronzes filled the rooms. Whether decorated tastefully or not, these residences were almost invariably ostentatious, a sign, perhaps, that even the wealthiest of moguls was insecure in matters of aesthetics. One wonders whom Perry H. Smith, vice president of the Chicago North Western Railway, was trying to impress by having three faucets in the butler's pantry—for hot and cold water, and iced champagne. Like the Potter Palmers and others, the Smiths illustrated the restless, dynamic spirit of a city seeking recognition.

Chicago seemed to be seeking its place in the sun in an even more literal fashion. By early 1889 the *Chicago Tribune* was referring to recently constructed tall buildings as "skyscrapers." Major technological breakthroughs such as the invention of the elevator in mid-century by Elisha Graves Otis, indoor plumbing facilities, and a central heating system had made skyscrapers feasible. Steel-frame construction removed the final major obstacle. As long as builders had to rely on stone masonry or brick as their primary structural material, the necessary thickness of their walls had limited verticality. Iron had provided more flexibility, but it proved less trustworthy as a fireproofing substance. By the 1880s, however, the advent of both the open-hearth and Kelly-Bessemer methods had made steel plentiful and commercially affordable. Engineers were prompting architects to build with steel. So too were the accelerating costs of land. During the 1880s alone the cost of a quarter of an acre of land in the business district of Chicago skyrocketed from $130,000 to $900,000.

Much as they competed to host the Columbian Exposition,

As reigning queen of Chicago society, Bertha Honoré Palmer did not take lightly to being called the "innkeeper's wife" by the Duchess of Veragua. *(Chicago Historical Society)*

Carter H. Harrison, five-time mayor of Chicago and enthusiastic booster of the exposition, fell victim to an assassin only a few days before the fair closed. *(Chicago Historical Society)*

Horse-drawn trolleys carried stunned Chicagoans past the ruins of their city after the Great Fire of 1871. *(Chicago Historical Society)*

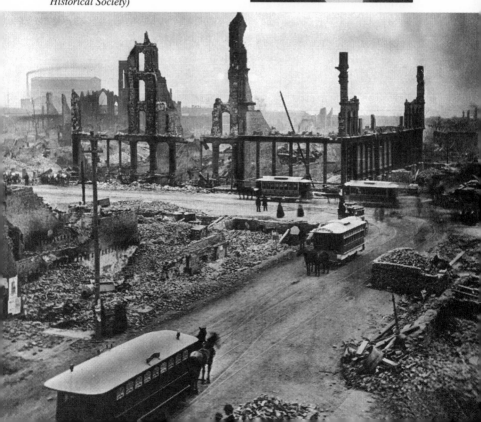

New York and Chicago vied for the honor of being home of
the skyscraper. Here too the nation's largest city came in
second. While New York actually had taller buildings, it was
Chicago that first embraced the concept and use of the
all-steel skeleton for construction, the hallmark of modern
architecture. The firms of William Le Baron Jenney and
Holabird & Roche pioneered in steel skeletons that sup-
ported the building's load. Jenney's Home Insurance Build-
ing (1884) was the first building in the United States to use
steel beams. But it was the Masonic Temple (1891), located at
Randolph and State Streets and designed by John Wellborn
Root, that soared twenty-three stories and for years remained
the tallest commercial building in the world. Small wonder
that a contemporary observer defined the skyscraper as "a
very tall building such as are now being built in Chicago."

Ironically, it was the Great Fire that enabled Chicago to
emerge as the leading center of modernism in architecture.
Immediately after the fire Chicagoans hurriedly rebuilt by
replication, or at least as nearly so as possible, their recently
razed homes and offices. But the economic panic that began
in 1873 and persisted until late in the decade slowed con-
struction appreciably and allowed architects and their clients
to reflect with greater measure on what they really wanted.
Drawn by the lure of reconceptualizing and rebuilding a
devastated city, young architects, their tastes still not fully
formed, came to Chicago where they were prepared to
experiment with new materials and design. By the end of
the panic they had availed themselves of the most advanced
technology: fireproofing innovations, stronger structural
foundations, electrical elevators and lighting, and an early
form of mechanical air conditioning. Having perceived that
the ornamentation on buildings had been the first thing to
burn during the October 1871 disaster, they were inclined to
reduce such embellishments which had figured prominently

in pre-fire design. Its continued use by Louis Sullivan and Frank Lloyd Wright notwithstanding, the diminution of ornamentation was to provide one of the most salient characteristics of architectural modernism, which found expression in a number of Chicago's commercial buildings of the 1880s and 1890s. As Ross Miller has noted in *American Apocalypse,* "Chicago became the testing ground for its own and imported ideas."

Despite their prodigious accomplishments in architecture, charges of cultural inferiority continued to nettle Chicagoans, who alternately bragged of or apologized for what they had to offer the nation. Sensitive to taunts, chiefly from Eastern and European visitors, that their city was merely a "Porkopolis" whose vision failed to extend beyond livestock, some vowed to achieve cultural parity, if not supremacy. At the time of the Columbian Exposition the city housed more than thirty theaters that at one time or another featured such prominent American actresses as Maude Adams and such celebrated international performers as the Italian Eleonora Duse and the British Henry Irving and Ellen Terry. Fabled international beauty Lillie Langtry also brightened the city with an appearance. The works of Clyde Fitch, now largely forgotten but then the nation's most highly regarded playwright, came to Chicago, as did William Gillette, whose portrayal of Arthur Conan Doyle's recently created fictional sleuth, Sherlock Holmes, riveted audiences. Oscar Wilde visited the city in 1883 during his much publicized lecture tour to the United States, and to the surprise of many and the disappointment of a few offered only minor criticisms and failed to ridicule.

Concert and lecture halls graced the city, as did an opera. Sited at Michigan Avenue and Congress Street, the Auditorium innovatively combined commercial offices, a hotel, and

a theater that seated 4,100. Designed by architects Dankmar
Adler and Louis Henri Sullivan, the Auditorium, built at a
cost of $3.5 million, was an immediate sensation. President
Benjamin Harrison attended its opening on December 9,
1889, and Adelina Patti, the reigning diva of opera, head-
lined the program and sang a medley of works that included
the sentimental favorite "Home, Sweet Home." By 1893
culture-conscious citizens could point to an Art Institute, a
Historical Society, and the Academy of Science Building
located in Lincoln Park. The Newberry Library, which
possessed quite possibly the best collection of books on music
in the United States, was completed that year, and the
cornerstone was laid for a new public library. John Crerar,
who died in 1890, meanwhile had left $2.25 million for
another major library on the city's South Side. Even more
impressive was the new university. It was the work of
Baptists who, concerned with the level of education of their
ministers, had prevailed upon John D. Rockefeller, their
richest congregant, for assistance. Then the wealthiest person
in the country, Rockefeller gave them $600,000 for a univer-
sity with the understanding that Baptist churches would
raise an additional $400,000. As it turned out, Rockefeller
donated even more generously, and at the time of the
exposition the university's endowment surpassed $7 million,
more than half of it contributed by the ruler of Standard
Oil. Marshall Field also provided largesse as he donated ten
acres of land on the lakefront, just north of what was to be
the site of the world's fair. Henry Ives Cobb, architect of the
Potter Palmer mansion, began designing the campus in the
collegiate Gothic style that institutions of higher learning
favored at the time in imitation of the older English univer-
sities. This "grey city" formally opened on October 1, 1892,
with six hundred students and an eminent faculty which
William Rainey Harper, the university's president and friend

of Rockefeller, had aggressively recruited. Under Harper and his successors the University of Chicago soon became far more than an institution known for training Baptist theologians.

Viewed from any one of several perspectives—physical size, population, cultural and educational aspirations, business fortunes, palatial residences, temples of commerce— Chicago was big. And as the home of packinghouses and refrigerated cars, Pullman Palace Cars and architectural innovations, this Midwestern metropolis also began to be called by some the "City of Big Ideas." But if Chicago was proud of its big ideas and accomplishments, it also had to contend with big problems.

Rebuilding after the Great Fire represented a breathtaking challenge, compounded many times over by an extraordinary growth in population. While it was true that Chicago in 1890 possessed the lowest density of habitation per square mile among the largest American cities—less than one-fifth the density of New York—the statistics were misleading. The upper and middle classes enjoyed space either in the northern and western sectors of the city or in the suburbs that were serviced by swift (for that time) commuter trains which legally could travel at twenty miles per hour. The working class and poor enjoyed no such luxury. Faced with a shortage of housing, the lower classes pressed together, frequently in squalid conditions that gave the city an estimated slum population of 160,000. That unenviable figure stood second to no American city except New York. Granted that the lower classes in Chicago (and elsewhere) were generally spared the vilest excesses that defaced and defamed New York, their slums and shanties bitterly reproached the new baronial mansions and skyscrapers.

Like New York and other principal urban centers, Chicago during the later nineteenth century counted an enormous number of foreign-born among its citizens. By 1890

more than 400,000 of them swelled the municipal popula-
tion. The 167,000 German-born were more than twice the
number of each of the two next largest ethnic groups, the
Scandinavians (73,000) and the Irish (70,000). Originally
settling on the North Side of the city, the Germans by the
mid-1880s were branching out to the west and southwest,
areas that were also becoming enclaves of newly arrived Jews
and Italians. Ethnic clashes erupted despite the tendency
toward group segregation, and all newcomers experienced
the sting of prejudice from the more intolerant among those
whose ancestors had reached American shores earlier. Gen-
erally none felt it more painfully or frequently than the city's
few hundred Asiatics who, with its 14,000 blacks (only slightly
more than 1 percent of the city's total population), represented
the most despised minorities. Chicago bowed to New York in
having the greatest numbers and percentage of foreign-born,
but by 1900 it would be the chief American residence for
transplanted Swedes, Norwegians, Poles, Bohemians, Dutch,
Lithuanians, Croatians, Slovakians, and Greeks.

The settlement house was not another of Chicago's "big
ideas," but Hull House, located on South Halsted Street in
the worst slum district on the city's West Side, was destined
to become the nation's most famous example of the type.
Established in early 1889 by Jane Addams and her longtime
friend Ellen Gates Starr, Hull House quickly demonstrated
how a concerned middle class could do something more than
wring its hands at the collective problems and prospects of
the lower classes. It also illustrated how dedicated women
could find both satisfying emotional outlets for their ener-
gies and widespread respect for their efforts.

Despite having been reared in a comfortable household
(her easygoing father had been a successful merchant in a
small Illinois town), Jane Addams early on experienced the
need to lead a useful life. She defied the norms of her day

and refused to settle for the duties of wife and mother. Instead she graduated from college—an unheard of feat for well over 95 percent of Americans—and traveled to Europe where she visited Toynbee Hall, a pioneering settlement house located in London's teeming East End. Realizing that by devoting herself to others she would likewise help herself, Jane Addams the reformer soon became "Saint Jane" to the thousands whose lives she and Hull House touched.

By 1893 an estimated two thousand visitors a week were braving the surrounding slums to visit Hull House in order to see for themselves the widely publicized workings of this social settlement. One of only half a dozen such establishments in the United States as the decade began, Hull House became the most renowned of more than a hundred such organizations by century's end, and of more than four hundred by 1910. During these years roughly 60 percent of the settlement workers at Hull House were women, of whom 90 percent, amazingly, had attended college. What visitors saw at Hull House was a multifaceted attack on the problems of poverty, deprivation, and ignorance, waged by Addams and her associates, some of whom, like Julia Lathrop, a pioneer in social welfare, became prominent national reformers. Fewer than twenty persons actually resided at Hull House at the time of the exposition, but its doors were open to all. Educational instruction there ranged from domestic and vocational training to college and university extension courses, and a great many social and cultural activities were offered. Twice yearly Hull House mounted art exhibits; weekly it provided free concerts. Various social and neighborhood clubs met on the premises, where there was a gym, coffee house, kitchen, dispensary, physician, nurse, swimming pool, and bathing facilities.

Hull House took a particular interest in the problems of labor. In general, industrial workers enjoyed more leisure

time and better wages to purchase goods at lower prices than had their counterparts before the Civil War. But the statistics had a negative side as well. Weekly hours in factories continued to average around sixty in 1890, despite the efforts of organized labor to secure the eight-hour day, and in some sectors of the economy the industrial workweek soared well beyond that figure. Not all workers earned decent wages. Chicago's most skilled artisans, such as masons, commanded a daily wage of $4; carpenters earned from $2.50 to $3. The semiskilled toiled for whatever pittance fell their way. Women and children were especially vulnerable. A woman laboring in a sweatshop might receive as little as twenty-five cents a day; children of the poor were forced to leave school at an early age and to work for scant wages in order to help their impoverished families survive. Thanks largely to the efforts of Jane Addams's associate Florence Kelley, the Illinois Legislature enacted a law in 1893 that prescribed a minimum age of fourteen for work, as well as a law that for the first time empowered the state to inspect factory conditions. Hull House itself established a labor bureau to help individuals to find employment. Anticipating the day-care centers that would become fixtures of the American scene a century later, it also allowed working mothers to leave their children at Hull House for only five cents a day.

In her concern for the foreign-born and for finding practical ways to acculturate them to American society, "Saint Jane" sometimes ran afoul of xenophobes who equated foreignness with radicalism. In 1901 vandals hurled stones through the windows of Hull House after Addams had successfully protested the arbitrary arrest of a Russian-born philosophical anarchist. Vivid memories remained of the Haymarket Riot of 1886, in which seven policemen were killed and nearly seventy people injured as a result of a bomb and an ensuing melee in which the police fired

indiscriminately. Eight anarchists, most of them foreign-born, were judged guilty, though conclusive proof was lacking. Four of them were executed, one committed suicide while in prison, and the remainder were serving life sentences until Illinois Governor John Peter Altgeld, in a highly controversial act, pardoned them during the course of the Columbian Exposition.

Jane Addams paid close attention to city politics—she had to. While not necessarily the worst-governed city in the nation, Chicago and its problems were all too typical of large American cities in the late nineteenth century. As Lord James Bryce, a distinguished, perceptive, and by no means unfriendly British visitor, noted in the 1880s: "There is no denying that the government of cities is the one conspicuous failure of the United States." He added, "The deficiencies of the National government tell but little for evil on the welfare of the people. The faults of the State governments are insignificant compared with the extravagance, corruption, and mismanagement which mark the administrations of most of the great cities."

Political machines dominated urban politics in Chicago and elsewhere. And if the Windy City did not have to contend with a machine as notorious as New York's Tammany Hall, it did not fare much better. The forty aldermen of Chicago were known locally as "the forty thieves." The low stipends given these legislators were partially to blame. Receiving only three dollars for each of their weekly meetings, many no doubt felt underpaid. At least one reformer suggested that they might as well receive ten thousand dollars annually since they made at least that much through bribes. Certainly John Powers, who served as the longtime alderman of the Nineteenth Ward in which Hull House was located, suffered no impoverishment. Known as the "Prince of Boodlers," Powers helped Charles T. Yerkes gain control

of municipal transportation franchises. He profited accordingly. For decades Jane Addams battled "Johnny de Pow" and bossism. She won occasional victories, but Powers kept winning reelection. With some truth, Powers, like machine politicians throughout the land, could point to the personal favors he did for his many underprivileged constituents, notably Irish and Italian immigrants or their descendants: jobs, charitable acts, legal assistance, the personal touch of knowing constituents and their families by name. In return, Powers and his counterparts in other cities asked only to be remembered at election time. Addams and other reformers objected that these favors corrupted the political system, demeaned the democratic process, and ultimately, by defrauding the city, stole from all citizens, rich and poor alike. But many grateful immigrants and working-class natives found the price levied by the machine an acceptable one. So did many of the city's business leaders and wealthy citizens, who averted their gaze from the shenanigans of their political representatives as long as the latter kept taxes and real estate assessments low.

John Powers may have been the "Prince of Boodlers," but it was two of his political enemies, "Bathhouse" John Coughlin and "Hinky Dink" Mike Kenna, who epitomized corruption in Chicago. Coughlin, the son of Irish immigrants who labored hard only to lose their prosperous business during the Great Fire, was an outsized figure, a garish dresser, a good family man and doting husband. Not known for his interest in intellectual matters, this popular figure looked back upon his family's misfortune as a blessing in disguise. "If not for that bonfire," he boasted, "I might have become a rich man's son and gone to Yale—and never amounted to nothing!" According to one observer, seeing Coughlin attired in his familiar outfit of crimson tie, lavender vest, fawn-colored trousers, and a Prince Albert coat

provided "probably the best free entertainment in the city." As a young man he had worked in a Turkish bath and then gone into business for himself. As a proprietor of public bathhouses, "The Bath," as he was commonly called, earned a good income. As a politician he earned more.

In contrast to "The Bath," with whom he had allied in the early 1890s, "Hinky Dink" Kenna was small in stature, subdued in personality, and highly intelligent. He also preferred to let his ally enjoy the limelight while he remained quietly in the background. Ostensibly he sold newspapers for a living. In fact, with Coughlin he ran the First Ward with a knowing touch for half a century. Encompassing the city's business district and most of its wealth, the First Ward played the decisive role in Chicago politics. "The men who controlled the First Ward," rightly perceived one politician, "controlled Chicago and the second richest municipal lootbag in the land."

What gave the First Ward its worst reputation was the Levee. Extending from Twelfth Street to Van Buren Street and from State Street to Pacific Avenue, this stretch of Coughlin and Kenna's fief offered unlimited gambling and prostitution and provided a mecca for all sorts of underworld figures: dips (pickpockets), boosters (shoplifters), ponces (pimps), yeggs (safecrackers), plug-uglies (rowdies), drug dealers, and murderers. In a city that counted seven thousand saloons at the time of the world's fair, the Levee contained more than its share, including the Lone Star Saloon and Palm Garden, whose owner, a certain Mickey Finn, gained an enduring distinction from the drinks he served. His "Mickey Finn Special" and "Mickey Finn Number Two" contained potent drugs as well as alcohol and were reported to have killed their unfortunate imbibers or rendered them unconscious for days. Once made insensate, the

victim was robbed, stripped of his clothing, and unceremoniously thrown into the street or a back alley.

The Levee also contained a few hundred brothels. Ranging from the fairly inexpensive House of All Nations to the posh Everleigh Club, presided over by the Kentucky-born sisters Ada and Minna Everleigh, they indulged a variety of tastes. Prices reputedly started at fifty dollars at the Everleigh Club.

What was true of the Levee was also true for much of the rest of Chicago. Far from hiding its vices, the city paraded them. An easily obtained directory listed vice districts with such suggestive names as "Black Hole," the "Bad Lands," "Dead Man's Alley," "Satan's Mile," "Little Cheyenne," and "Hell's Half Acre." So vicious was the last of these districts that police reportedly refused to enter it except in pairs. Chicago had become dangerous as well as vice-ridden. In the years between the Great Fire and the Columbian Exposition the murder rate more than quadrupled. Eight times as many homicides occurred in Chicago as in Paris, and one of every eleven Chicagoans could expect to be arrested each year. Weapons went unregistered, and poor street lighting made evening outings hazardous. Famed American humorist George Ade recalled how he carefully walked in the middle of the street at night in order to avoid would-be robbers. And that was no joke.

In Chicago as in other late-nineteenth-century American cities, ethnic and racial groups left a strong mark on criminal activities. Houses of prostitution and gambling halls seem to have fallen largely to the Irish, Jews, and blacks, while Italians preyed on their own. By the end of the century an estimated seventy to eighty gangs of Italian criminals belonged to the Black Hand, which derived from the Mafia and Camorra, the secret societies that thrived in Sicily and Naples respectively. For those who disliked these groups—and there were many—crime was a product of

degenerate blood or character. Others argued that poverty and cultural alienation were the critical factors in fostering criminals. Either way, statistics and perception reinforced such stereotypes.

Law-abiding citizens questioned why Chicago's police force, more than a thousand and still growing, had failed to curb crime. Some knew that the police themselves were a large part of the problem. First, it should be noted, police in Chicago and elsewhere felt overwhelmed by the surge in criminal activity. In the fifteen years between 1878 and 1893, arrests for assault in Chicago had increased thirtyfold. Police in Chicago, as elsewhere, were underpaid and overworked. In 1892 patrolmen received yearly salaries that ranged between $720 and $1,000. This was not exceptionally low pay for the time, but the maximum salary had not increased in twenty years. A patrolman was also expected to contribute 1 percent of his wages to a pension relief fund and 2 percent to a benevolent association which provided financial help in times of illness. No sick leave was available, nor was there an official police surgeon to attend the wounded. Patrolmen had to buy their own uniforms. Long hours brought further grumbling. Day patrolmen worked twelve hours; evening shift duty lasted nine hours. In either case, the men worked six days a week. Politics could bring further demoralization, depending on party affiliation. Police Superintendent Joseph Kipley began demoting or firing Republican policemen in favor of Democrats in 1885, much to the chagrin of both Republicans and civil service proponents. By this time Chicago was a strongly Democratic city, and until 1895, when it adopted civil service reform, the police department retailed political plums.

Police brutality posed another urban problem. Even children, it was reported, were arrested and beaten on the merest suspicion. In part this brutality stemmed from the

nature of police work itself: repeatedly witnessing violence may engender violence or dull one's sensitivity toward it. But whatever the cause, neither police brutality nor police politics could compare with what the public deemed the chief problem of the Chicago police force: corruption.

Earning limited wages and in a position to obtain extralegal money, many policemen simply could not resist temptation. Madams, pimps and their prostitutes, gamblers and saloons, peddlers, opium dens and poolrooms frequently had to pay protection money to law-enforcement officials in order to stay in business. The more vice-ridden the patrolman's beat, the greater the opportunity for graft. Corruption was also rampant at the higher echelons of the force. Given their greater opportunities for illegal payments, captains sometimes had to pay for their positions. So corruption-riddled had the Chicago police force become by the 1890s that the Pinkertons, a private security organization famed for its investigative activities and infamous for its strike-breaking, offered to serve as the city's police force at two-thirds the cost then needed to maintain the established department. The Pinkertons promised that "the citizens would actually be protected."

Vice could not have thrived without the support of the police, who, in turn, could not have prospered without the connivance, tacit or explicit, of corrupt aldermen like Bathhouse John, Hinky Dink Kenna, Johnny de Pow, and their fellow "grey wolves," as citizens disdainfully called them. Many reformers during these years hoped they could correct the problem by electing a sympathetic mayor. Instead they got Carter Henry Harrison—five times.

Like Bertha Honoré Palmer and the Everleigh sisters, Carter Harrison came to Chicago from Kentucky, where he grew up on a plantation during the antebellum years. A collateral descendant of a signer of the Declaration of

Independence and a relative of Presidents William Henry Harrison and Benjamin Harrison, the future mayor of Chicago graduated from Yale in 1845, spent two years in Europe, and at length received a degree in law in 1855. Shortly thereafter he married, sold or manumitted all his slaves, and moved to Chicago before the Civil War erupted. In the years before the Great Fire he amassed a small fortune in real estate; in the years immediately following he entered politics, serving first as a county commissioner and then for two terms as a Democratic representative to Congress. Turning again to local politics, he successfully ran for mayor of Chicago in 1879, 1881, 1883, 1885, and 1893.

As mayor, Harrison proved virtually impervious to calls for reform. He did order prostitutes to relocate from fashionable State Street, but he also owned a brothel as well as a saloon. (No teetotaler, Harrison ordered two hundred barrels of whiskey for official entertaining during the Columbian Exposition.) He made no attempt to curtail gambling; in return, gamblers contributed handsomely to his mayoralty campaigns.

The election of 1893 was typical. Two years earlier Harrison, who had retired from politics in 1887, traveled extensively, and written two books, had almost won a fifth term in office running as an independent. Now, on April 4 in the year of the exposition, he returned to the Democratic fold, received strong party support, and trounced his Republican opponent Samuel Allerton, a millionaire businessman who had founded the Union Stockyards. In Jane Addams's ward, the nineteenth, Harrison won by a three-to-one margin. On hearing that "Our Carter" was elected and inaugurated just a few weeks before the exposition was to open, one prospective visitor from Indiana purportedly exclaimed, "I'm a goin' to Chicago to the fair, but I'm goin' to wear nothin' but tights and carry a knife between my teeth and a pistol in each hand." To the surprise of many, Harrison did order

raids on gambling haunts, only to discover that countless visitors to the exposition seemed as intent on visiting the Levee as the fair. Chicago seemed to be striving hard to win a reputation, according to one alarmed critic, as "the wicked-est wide-open town in the nation," although for the well-being of visitors *The Sporting House and Club Directory* listed the safer of the city's nearly one thousand houses of ill repute.

Despite—perhaps because of—his ready acceptance of vice and corruption, the witty Harrison was an extremely popular figure, winning reelections more through this popu-larity than because of chicanery at the polls. A wealthy man, he was also, many thought, a man of the people. Grey-bearded and dark-eyed, he was a distinguished, recognizable presence riding astride his white mare. Workers greatly respected him, and with reason. After a strike and violence at the McCormick reaper works on May 1, 1886, during which Pinkertons killed six strikers, Harrison refused to order the police to break up the Haymarket protest that took place a few days later. Equally important, he paid frequent Sunday visits to the foreign-born sections of the city and spent considerable time speaking with children there. Con-vinced of this legendary politician's generous nature, few interpreted these visits as mere politicking.

Who, then, was the real Carter Harrison? The popular mayor who led an impeccably correct private life, who refused to side with organized capital against labor, and who showed genuine concern for immigrants; or the amoral city leader who winked at vice and corruption and made un-seemly arrangements with the likes of Coughlin, Kenna, and Powers? Or was he, as future Columbian Exposition entre-preneur and Congressman Sol Bloom perceived, simply a charming and educated man who viewed compromise as the *sine qua non* of the political process? And what of Chicago? Was it a city of thriving businesses, palatial estates, modern

architecture, and a burgeoning cultural life, or was it a city sharply divided along lines of class, ethnicity, and race? Was it the "black city," as some called it—a metropolis discolored by rampant corruption, reeking of the slaughterhouse, badly deficient in such needed amenities as clean water and paved sidewalks? Indeed, environmental problems were besetting the city. The Chicago River, one person claimed, contained "grease so thick on its surface it seemed a liquid rainbow," and some days it seemed to compete with the stockyards in its foul smell. So polluted was the city's atmosphere that Giuseppe Giacosa, playwright and librettist for Giacomo Puccini, claimed that one morning as he was standing atop a railroad viaduct the "city seemed to smolder, a vast unyielding conflagration." Yet while he "would not want to live there for anything in the world," the Italian visitor insisted that "whoever ignores it is not entirely acquainted with our century, and of what it is the ultimate expression." Which, then, was the real Chicago?

Chicago, in fact, like its five-term mayor, was all the above, an embodiment of seeming contradictions. In several respects the most dynamic major American city of the late nineteenth century, it was the City of Big Problems as well as Big Ideas. Thanks to Congress and President Harrison, it was also to be the home of the Big Opportunity. How it responded to the challenge of hosting the World's Fair of 1893 would say much for Chicago. The city itself, predicted a reporter for *Harper's Weekly,* would serve as the "main exhibit" of the fair.

3

A Gathering of Architects

CHICAGOANS HAD ANTICIPATED their good fortune. As early as August 1889, before Congress had decided on the city as the site of the exposition, a civic group of more than 250 persons incorporated as the "World's Exposition of 1892" (eventually giving way to the "Chicago Exposition Company") and sent delegates to attend, and presumably to learn from, the Universal Exposition in Paris. The corporation also optimistically issued bonds valued at five million dollars, expecting that Chicago would host the forthcoming celebration. By the time Congress and President Harrison made the choice official, the bond issue had been fully subscribed. More difficult hurdles remained before the exposition could be transformed from dream to reality. By 1890 it had become necessary to float an additional five-million-dollar bond offering. State legislators tendered diverse advice, and Congress authorized a national commission of twenty to work with—some critics said against—the local Chicago Company. Despite occasional bureaucratic difficulties, the local organization along with the chief of construction and general artistic director made most of the important decisions about the fair. Composed primarily of business leaders, the company's board of directors was a mixed lot that included the much respected Harlow N. Higinbotham,

an officer of the Marshall Field department store; banker Lyman Gage; and the vilified traction magnate Charles T. Yerkes. As political leader of the city, Carter Harrison also served on the board of directors for the "World's Columbian Exposition," as the fair had come to be officially designated.

Selecting the actual site for the fair posed an initial problem. Civic leaders pushed for a central location adjacent to the business district and along the shores of Lake Michigan. This would have necessitated a landfill to provide sufficient acreage for the fair, and the War Department, which had jurisdiction over this riparian land, refused its permission. Fortunately for fair officials, they turned for counsel to Frederick Law Olmsted and his youthful partner Henry Codman.

Born in Hartford, Connecticut, in 1822, Olmsted as a youth groped unsteadily in his choice of a career, trying his hand at occupations as diverse as farming and sailing while enjoying the good fortune of having a well-to-do family that indulged his experiments and missteps. With a flair for observing and writing, Olmsted three times toured the South during the 1850s and wrote a compelling series of articles on slavery and antebellum conditions that was collected as *The Cotton Kingdom* (1861), a work that continues to be useful today. But it was as a landscape designer and urban planner that Olmsted left his mark. During the second half of the nineteenth century he became, and remained, peerless in his field.

Like many thoughtful Americans of his time, Olmsted was alarmed by the rapid growth of cities and the concurrent loss of values and psychological comforts associated with the countryside. Yet he was too astute and realistic a critic to believe that the tide could be reversed. Instead, as a thoughtful conservative he hoped to deflect the powerful forces of change into safer channels. People, he knew, moved to cities for positive reasons—economic, social, cultural—or

they were simply born there. In either instance, Olmsted hoped to ameliorate some of the worst characteristics of urban life—boring work routines, overcrowding, noise, and class antagonisms—by naturalizing the urban scene, building city parks and thereby permitting city dwellers to profit from the positive, soothing forces of nature. Olmsted wrote:

> ... We want a ground to which people may easily go after their day's work is done, and where they may stroll for an hour, seeing, hearing, and feeling nothing of the bustle and jar of the streets, where they shall, in effect, find the city put far away from them. We want the greatest possible contrast with the restraining and confining conditions of the town which will be consistent with convenience and preservation of good order and neatness.

Achieving fame first as codesigner, along with Calvert Vaux, of New York City's Central Park, he envisioned a harmonious, largely noncompetitive society created through a whole series of urban parks and suburbs. In the years after creating Central Park, which he thought would bring together the disparate social classes and allow for peaceful musings and strollings, he worked restlessly to achieve this vision. As the urban historian Thomas Bender has noted, Olmsted "tried to civilize American urban life by using landscape and cityscape as counterpoises."

Chicagoans had special reason to trust and admire Olmsted. During the 1860s he had surveyed a number of the city's parks and designed the popular suburb of Riverside. Now, in the summer of 1890, fair officials paid Olmsted and Codman one thousand dollars to investigate possible sites for the Columbian celebration. The architects narrowed their choices to two. Reluctantly they discarded a possible site on the city's northern lakefront because no one would guarantee the construction of adequate public transportation to

convey visitors there. Then, in February 1891, they settled on Jackson Park. Located further south along the lakefront, between Fifty-sixth and Sixty-seventh streets, the undeveloped park lay like a sad wasteland of sand, sparse vegetation, and marshes. Olmsted conceded that it featured "the least parklife growth within miles of the city." Nonetheless, he and his twenty-three-year-old associate were convinced they could utilize both the land and its water to construct fairgrounds, lagoons, and canals that would prove aesthetically pleasing and practical. So, apparently, did real estate speculators. Land in the Jackson Park area appreciated as much as 1,000 percent in the year following the announcement of the fair's site. Some of the land that lay partially submerged under water, and was previously valued at six hundred dollars an acre, now fetched fifteen thousand dollars.

Shortly after selecting Olmsted and Codman as landscape architects for the Columbian Exposition, fair officials, who were legally responsible for constructing, paying for, and operating the exposition's buildings and grounds, came to a second far-reaching decision. They chose Daniel Hudson Burnham as chief of construction and his partner John Wellborn Root as consulting architect. This decision not only affected the ultimate design of the fair but led to a controversy over that design that persists to this day.

Daniel Burnham (1846–1912) moved with his family to Chicago in 1855 from Henderson, New York, a small upstate town. His father became a successful businessman, but success seemed to elude young Burnham, who failed the entrance requirements to Harvard and then failed at various commercial enterprises, including an attempt to reap a bonanza in Nevada silver mines. Somewhere during these years he acquired an interest in architecture and undertook an apprenticeship with the Chicago-based builder William Le Baron Jenney. Burnham vowed to his mother in 1868

that he would "become the greatest architect in the city or country," judging that only "a determined and persistent effort" would be necessary. The words have the ring more of bravado than conviction, but in 1872 he reached a crossroads in his career when he began working for Peter B. Wright, another young Chicago architect. As Thomas S. Hines, Burnham's most recent biographer, has pointed out, Wright's scholarly abilities had a forceful impact on this novice, who was sorely aware of his own educational limitations. Working for Wright allowed Burnham to develop self-confidence and to meet his future partner.

The background of John Wellborn Root (1850–1891) differed notably from Burnham's. Born into a prosperous Georgia family, Root passed the Civil War years in England where he studied the organ. He intended to enter Oxford but instead returned to the United States after hostilities ended and settled with his family, which had by this time relocated to New York. Upon graduation from New York University in 1869, where he had studied engineering, Root became an apprentice architect and in 1872, aware of the opportunities created by the devastating fire of the previous year, he moved to Chicago.

A firm friendship between the two young architects quickly developed. Their personalities proved complementary. Burnham, once hesitant, had become more assertive and outgoing. Root, in contrast, was more shy in public, though at ease in the company of friends. A similar complementary quality characterized their talents. Burnham had a genius for organization and the tenacity to carry through large-scale projects. Such projects, in fact, fascinated him, and he frequently advised: "Make no little plans; they have no magic to stir men's blood." He took his own advice on a grand scale for the Columbian Exposition. The younger Root, less the practical organizer and more the solitary artist, was content to

create on the drawing board while his partner cajoled and convinced clients. Whatever the exact nature of their chemistry, the two men, conjoined by mutually sympathetic and reciprocal ways, established a partnership in early 1873. Their timing was inauspicious: shortly after they opened their office the panic of 1873 struck. Nervous clients begged off commitments; the post-fire building boom that had reinvigorated the city receded. During these early trying times the partners persevered. Burnham, concluded the poet Harriet Monroe, sister-in-law to Root and friend to his partner, sustained the younger man's confidence in the same way he would preserve him from "dilettantism" and channel his sometimes unrealistic plans "to a definite purpose." After a few minor undertakings the partners achieved a breakthrough in 1874 when John B. Sherman, a wealthy stockyards entrepreneur, commissioned them to build a house on Prairie Avenue, the newest quarter for the rich. Pleased with the results, Sherman helped the firm obtain other commissions from famous and prosperous individuals, including Civil War general Philip Sheridan, dry goods millionaire Joseph Sears, and journalist-reformer Henry Demarest Lloyd, whose later and controversial *Wealth Against Commonwealth* (1894) denounced the Standard Oil monopoly in particular and wealth and greed in general (though Lloyd's father-in-law owned a fourth of the *Chicago Tribune*). Sherman also made it possible for Burnham to enjoy success of a different sort. In early 1876 the architect, who had been known as a frolicking bachelor, married Sherman's only daughter, Margaret.

The Sherman commission heralded financial and artistic achievement for Burnham and Root. In almost twenty years together the partners constructed public and private buildings valued at more than forty million dollars. Essentially they catered to the tastes of the rich and the middle class, which in the Chicago of the 1870s and 1880s meant design-

ing in a variety of late Victorian modes: Gothic, Renaissance, and the Romanesque style made popular by Henry Hobson Richardson. But Burnham and Root were no mere imitators, content to enrich themselves while ruffling no aesthetic feathers. As Thomas Hines has shown, the two, while never breaking with past styles in their design of residences, signified "both the end of an older order and ... a transition to the revolutionary work of [Frank Lloyd] Wright and his contemporaries." It was in their design of large-scale buildings, however, that they achieved their greatest fame. Along with a handful of like-minded Chicago architects, they sensed that the skyscraper was no fad. With their Montauk Building (1882), Rookery (1888), and especially the Monadnock Building, a fifteen-story office building constructed of massive masonry and completed in 1892, the partners established themselves as one of Chicago's premier architectural firms.

Considering their prestige, the selection of Burnham and Root to direct construction of the Chicago World's Fair of 1893 raised few eyebrows, though a few of the city's leading architects, notably William Le Baron Jenney and Dankmar Adler, the partner of Louis H. Sullivan, would have preferred New York–based Richard Morris Hunt.

Burnham and Root, in conjunction with Olmsted and Codman, drew up preliminary plans for the fair in early September 1890. They reached no agreement on questions of style at that time, but Root did speak of a fair that would feature a variety of designs and colors. Before they could make a firm commitment to style, however, the planners had to decide who would design the buildings. On December 9 Burnham informed the committee on grounds and buildings of three options: (1) a single architect might undertake all the work; (2) a group of architects might work as a team, their selection being the result of open or closed competition; or (3) the planners might invite the participation of other

architects. Root, Olmsted, and Codman all concurred with Burnham who, mindful of the scheduled opening of the exposition in October 1892 (the date would later be delayed), encouraged the committee to accept the last option. It did, and Burnham then made the decision official.

By the 1890s, critics then and now have agreed, Chicago architects marched in the vanguard of American building design, their progressive work increasingly noted by other pioneering architects both at home and abroad. Why, then, did not Burnham and his partner restrict their selection to gifted locals—Adler and Sullivan, Holabird and Roche, Jenney? If time was short, it made sense to choose Chicago firms that could direct the work with swift, on-site inspections. But it was no lack of respect for local artists that induced Burnham and Root to look beyond the host city.

For Burnham, the Columbian Exposition signified a national event, one that should draw upon a variety of architectural talents. Root agreed with his partner; so did Olmsted and Abram Gottlieb, the original consulting engineer for the fair. Consequently Burnham looked eastward for established, nationally recognized architects and invited the participation of three New York firms—Richard Morris Hunt, George B. Post, and McKim, Mead and White—as well as the Boston firm of Peabody and Stearns. The fifth and final invitation went to Van Brunt & Howe, who were located in Kansas City but who had originally practiced for a number of years in the East.

After studying at the prestigious École des Beaux-Arts in Paris, Hunt designed a number of prominent public buildings in New York that included the Metropolitan Museum of Art. He also created palatial residences, most notably "Biltmore" for George W. Vanderbilt in Asheville, North Carolina, and resorts in fashionable Newport, Rhode Island. Post had worked in Hunt's office before opening his own

practice in 1860. Like his mentor, he built costly residences for various Vanderbilts, but also such Gotham offices as the Equitable, *New York Times,* and Pulitzer buildings. Charles F. McKim and Stanford White had met while both were apprentices to Boston-based Henry H. Richardson. With William Mead, who cared for business and day-to-day matters, they formed a partnership in the late 1870s which by century's end was generally considered the premier architectural firm in the nation. Robert S. Peabody and George G. Stearns established their Boston office in 1870 and for the next forty-five years designed public and private buildings throughout New England. With Frank M. Howe, who had been his apprentice before becoming his partner, Henry Van Brunt, another prominent Boston-based architect, relocated to Kansas City in the 1880s to design railroad stations in the West.

Burnham noted, "My plan was to bring together the men of the greatest experience." Only Van Brunt and Howe initially accepted, but Burnham persisted. A few days before Christmas in 1890 he met with the reluctant Easterners who were dubious that the exposition would be worth their while. But "Uncle Dan was an impresario," as Frank Lloyd Wright later explained, and his personal enthusiasm and conviction proved irresistible. Over dinner he apparently persuaded the architects, delivering a rhapsodic speech that hailed the Columbian Exposition as the third greatest event, following the Revolution and the Civil War, in the nation's history.

Having won over the Easterners, Burnham faced a rebellion on the home front, where his selection of non-Chicagoans piqued local pride and pocketbooks. Burnham's critics howled that Chicago, after all, was taking the financial risks of underwriting the fair. Bowing to pressure, Burnham invited five local firms to participate: Adler and Sullivan, William Le Baron Jenney, Henry Ives Cobb, S. S. Beman,

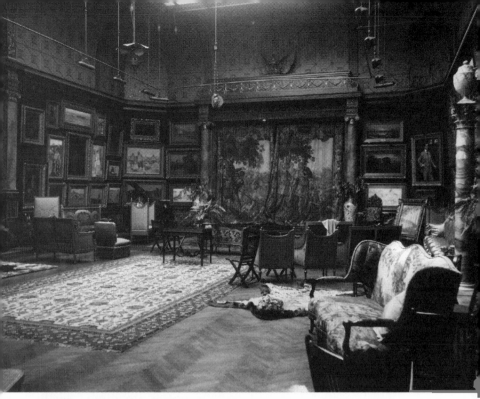

The palatial gallery of the Potter Palmer residence on Lake Shore Drive. *(Chicago Historical Society)*

The most prominent individuals in this photograph of the directors of the exposition are Daniel H. Burnham (extreme left), George B. Post (second from left), Richard Van Brunt (fourth from left), Francis D. Millet (fifth from left), Augustus Saint-Gaudens (eighth from left), Henry S. Codman (ninth from left), and Charles F. McKim (third from right). *(Chicago Historical Society)*

and Burling and Whitehouse. On January 5, 1891, the committee on grounds and buildings approved all of Burnham's choices.

By the following week all the participants had gathered in Chicago. Anxious to view the exposition site firsthand, the non-Chicago architects were dismayed upon reaching Jackson Park. This normally dreary, undeveloped plot of more than five hundred acres must have seemed even more desolate in the bleakness of a Chicago winter. Apparently a welcoming dinner that evening put the anxious travelers in a more positive frame of mind, for when they met formally with the local architects for the first time two days later, on January 12 in the offices of Burnham and Root, they seemed both prepared and eager for their ambitious undertaking. The group elected as their chairman Richard Morris Hunt, whose reputation for civic and private building dwarfed that of the others. As Henry Van Brunt was to say after Hunt's death in 1895, "The natural dominance of the master again asserted itself without pretension and we once more became his willing and happy pupils." Even before the fair opened, Van Brunt thought of the Court of Honor, the fair's central complex of buildings, as a continuum built by a family.

Hunt served as the paterfamilias, with Post and Van Brunt as his children, in a professional sense, since they had apprenticed themselves to him. These two, in turn, had trained Howe, Peabody, and Stearns. McKim was a kind of admiring younger cousin who had fallen under the same architectural influences as Hunt. Van Brunt's warm, almost fawning accolade for his former teacher failed to stir Louis H. Sullivan, who was elected secretary for the group and who years later vigorously denounced both Hunt's influence and Burnham's acceptance of it. At this important meeting, however, Sullivan said nothing to oppose Hunt. Burnham, who stood somewhat in awe of the gruff Hunt, might have

felt crestfallen when the latter interrupted the Chicagoan's welcoming speech by snorting, "Hell, we haven't come out here on a missionary expedition. Let's get down to work." As Sullivan later interpreted the scene, Burnham had been groveling before the Eastern architects and confessing to the cultural inadequacies of the West when Hunt cut him short. Sullivan may have exaggerated Burnham's defensiveness, but Burnham did have enormous respect for the work of the Eastern architects and may have stood ready to defer to their judgments, backed as they were by the force of their practical successes and personal éclat.

The most controversial judgment of the wise men from the East involved the choice of style. Even before reaching Chicago they had agreed among themselves that the major buildings of the exposition should be neoclassical in design. Once in Chicago they apparently encountered little difficulty in convincing the others, though no Chicago architect had ever employed the style in fashioning a local building. Explained Henry Van Brunt, apropos the edifices that comprised the Court of Honor: "It seemed at least safer to proceed according to established formulas...." Still, the choice of style, reached by consensus and seemingly noncontroversial at the time, has managed to inflame opinions ever since.

Despite later dissenting voices, the meeting of January 12 augured well for the immediate future of the fair. Having concurred in the overall design for the centerpiece of the exposition, the Court of Honor, the planners could proceed to complete work in time for the scheduled formal opening on May 1, 1893. But three days later the group and the architectural profession at large were stunned when forty-one-year-old John Wellborn Root succumbed to pneumonia, a difficult disease to treat in an age before antibiotics. Root's last words to his grieving partner were, "You won't leave me again, will you?"

With Root's death Burnham had lost a close friend and valued associate, one who, according to the architectural historian Carl Condit, might have ranked below only Richardson, Sullivan, and Wright as the greatest American architect. What loss had the Columbian Exposition sustained? A tremendous one, according to Harriet Monroe. Had her brother-in-law lived, she lamented, "there would have been another battle of Chicago against the East, new methods against old, our own beauty against the past." Root, it is true, had spoken of a fair designed in various styles and colors that reflected the ideas of the individual architects. The Philadelphia Centennial had offered a precedent for eclecticism by featuring buildings of such diverse styles as Moorish, Gothic, and Renaissance. But it is also true that Root recorded no opposition to the decision to adopt a neoclassical style. Whatever his feelings, Root, had he lived, might have contributed to the totality of the fair. As it was, some give him credit for conceiving the highly successful plan for a water basin surrounded by the main buildings.

Critics of Burnham and the Easterners have listened less to poet Harriet Monroe and decidedly more to Louis Henri Sullivan. Born in Boston in 1856, Sullivan briefly studied architecture at the Massachusetts Institute of Technology, home of the first school of architecture in the United States, before transplanting himself to Chicago as a teenager in 1873. There he apprenticed under William Le Baron Jenney (as had Burnham), studied for a year in Paris, returned to Chicago in 1879, and joined Dankmar Adler's firm. Two years later Adler made his young associate a full partner. In the ensuing decade Sullivan established his reputation through several important commissions, notably the Chicago Auditorium and the Wainwright Building in Saint Louis, the memorable skyscraper that, like the Auditorium, still stands. Sullivan enjoyed continued success for more than a

decade after the exposition, but after the death of Adler in 1900 commissions arrived more slowly and his talents seemed, at least to some, less extraordinary. By the time of his own death in 1924 he had become impoverished, irascible, and generally forgotten, his work championed by a few disciples like Frank Lloyd Wright, his reputation awaiting resurrection by future generations.

Sullivan's *The Autobiography of an Idea,* which appeared the year he died, is a strange work that blends poetic vision, acute insights, prophetic warnings, and bombastic rhetoric. Like *The Education of Henry Adams,* it is written in the third rather than the first person. Sullivan concludes this intriguing and abrasive work with a discussion of the Columbian Exposition and a stinging denunciation of its architecture. From his vantage point on the cutting edge of modern architecture, Sullivan interpreted the neoclassical design of the Court of Honor buildings as a travesty, a betrayal of progressive principles to the dead hand of the academic past, a selling short of democratic America to the tyranny of the ancient world and feudal Europe. In overwrought prose he characterized the individual buildings and ensemble to the fair's architecture as "an appalling calamity"; "a lewd exhibitionism of charlatanry"; "incredible vulgarity"; "a lewd exhibit of drooling imbecility." "Thus," he wailed, "architecture died in the land of the free and the home of the brave,—in a land declaring its fervid democracy, its inventiveness, its resourcefulness, its unique daring, enterprise, and progress. Thus did the virus of a culture, snobbish and alien to the land, perform its work of disintegration." Sounding like a prophet of the apocalypse, Sullivan concluded that "the damage wrought by the World's Fair will last for half a century from its date, if not longer. It has penetrated deep into the constitution of the American mind, effecting there lesions significant of dementia."

Beneath the overblown language lay a degree of truth. The progressive architecture of the Chicago School took its place in the forefront of modernism when that movement was challenging the status quo. Academic architecture, while it was upheld by critics and many practicing professionals, did represent obeisance to the past, even though the more creative of those inspired by the past—Henry Hobson Richardson, for example—tried to infuse life into one or more historical traditions by adapting its features to contemporary materials, technology, and local traditions. Some seriously questioned the relevance of banks shaped like classical temples, or private residences designed in the manner of French châteaux in a nation that prided itself as a "new" world. Complained the twentieth-century critic Fiske Kimball: "The issue, whether function should determine form from within or whether an ideal form might be imposed from without, had been decided for a generation by a sweeping victory for the formal ideal." Sigfried Giedion, an even more influential architectural critic of this century, went further, excoriating the design of the Court of Honor as "mercantile classicism" which betrayed a "national inferiority complex." Politically independent for more than a century, the United States, in the eyes of Sullivan and others, still seemed in thrall to foreign tastes. An industrial giant, its culture had yet to come of age.

Lost in the fury of arguments for and against the neoclassicism of the Court of Honor is the prominence of colonial revival architecture elsewhere at the exposition. The United States Government Building, with its domed rotunda, followed the lines of this variant expression of neoclassicism, as did the popular reproduction of George Washington's Mount Vernon home. The Standard Oil Company, symbol of the rapid industrialization and modernization of late-nineteenth-century America, built a pavilion in S. S. Beman's

Mines and Mining Building that hid its modern wares behind a colonial façade. The state buildings especially highlighted the revival. Either through direct imitation of past edifices or through the employment of apt themes and ornamentation, no fewer than twenty-one of the fair's thirty-nine state buildings chose a form of the colonial. Most of those states, in keeping with their historical development, decided on a colonial that was Southern, New England, or English in derivation. Four states (Florida, Texas, California, and Colorado) stressed the Hispanic influence while two (Louisiana and Arkansas) looked to their French inheritance.

One could argue that the colonial revival, although it too was neoclassical, had deep roots in the nation's past. Like the neoclassicism of the Court of Honor, however, it too was an academic, fundamentally antimodernist style which looked backward at a time when much of the United States was hurtling forward. It was also reactionary and reflected the "old family" roots of the white Anglo-Saxon Protestant upper class that favored it. In any event, it was the neoclassicism of the Court of Honor buildings, not the colonial revivalism of others, that visitors best remembered. As Sinclair Lewis, the incisive chronicler of fictive American middle-class tastes, noted of his protagonist in *Babbitt* (1922), "Fifty times he opened the book of photographs of the Chicago World's Fair of 1893, fifty times he looked at the picture of the Court of Honor."

These criticisms notwithstanding, much was said in defense of Burnham, the Eastern architects, and their choice of the neoclassical. Both historical precedent and practical considerations for the decision abounded. Classicism was the accepted style for denoting grandeur. Moreover, most of the principal architects had received formal training in classicism either at the École des Beaux-Arts or through persons or American institutes influenced by the École. Given the

pressure of time, the desirability of a single style became apparent. The Parisian school, as the historian William H. Wilson has correctly noted, "advocated no particular style, but its emphasis on logic, vigor, and the fine arts favored the classic." The fact that the non-Chicago architects had to transmit their instructions from afar instead of on site reinforced the need for simplicity and readily understood directives, a need that a single, historically familiar style could fulfill. At the meeting during which the convened architects chose the neoclassical design, no one put forth an alternative style—not even Louis Sullivan.

Neoclassical buildings were already a substantial component of the nation's architectural heritage. Thomas Jefferson had chosen such buildings for Washington, D.C., the Virginia state capitol, and the University of Virginia; the Boston Public Library, brilliantly conceived by McKim, Mead and White, provided a magnificent adornment to Copley Square. Neoclassical, the style of numerous statehouses, also had been selected for the new Library of Congress. Still, the most immediate inspiration for choosing this style for the Columbian Exposition may have been no one American building or series of buildings but rather the Paris Universal Exposition of 1889, which integrated neoclassical buildings with the kinds of formal and informal landscaping being planned by Olmsted.

The larger question, that of cultural dependence or independence, was more complex and perplexing. Since achieving nationhood Americans had suffered from a sort of schizophrenia, first demanding the creation of a proud, distinctly indigenous art, then looking eastward to Europe for its tastes and artifacts. "The Old World was both an inspiration and lure to Americans," the historian Cushing Strout has noted, "even while it remained in political terms the incarnation of the enemy.... Only a society that had

defined itself as a fresh start in history could have produced such nostalgic hungers for a Europe made enchanted by the traces of an ancient past." Ralph Waldo Emerson, in "The American Scholar" address given at Harvard in 1837, sounded a call for national cultural emancipation; so did others who preceded and followed Emerson. But few heeded the call, and while many boasted loudly of American superiority, they remained sorely sensitive to reproofs from Europeans and, for that matter, from European-oriented Easterners.

Much of the criticism aimed at the Columbian Exposition came from visiting French architects who disdained what they considered its lack of imagination. Their critique was ironic: American architects had directly or indirectly absorbed their preference for neoclassicism from the Parisian École des Beaux-Arts. Progressive Gallic builders proudly pointed to their own astonishing iron and steel tower designed by Alexandre Gustave Eiffel for the Paris Universal Exposition of 1889. Soaring to 984 feet, the Eiffel Tower, which commemorated the centennial of the French Revolution, achieved a *succès d'estime* as it fused advanced engineering with imaginative design. It was to remain the tallest edifice in the world until the erection of New York's Empire State Building forty years later. Some French architects may have been enamored of modernism, but a number of their compatriots—artists, intellectuals, and average persons—vigorously dissented. Fumed Guy de Maupassant, the Eiffel Tower was "useless and monstrous." He asked, "Will the city of Paris continue to listen to the baroque, mercantile fancies of a builder of machines, and irreparably lose its honor and beauty? For the Eiffel Tower, which even the commercial Americans would reject, means, without any doubt, a Paris dishonored." The French, it seems, could be no less traditional in their tastes than Americans. As the late French critic Roland Barthes has pointed out, Maupassant fre-

quently lunched in the restaurant inside the Eiffel Tower not because of its cuisine but "because it was the only place in Paris where you don't have to see the Tower itself."

Architects and critics from the American East could seem as unappreciative of their Western counterparts as the visiting Frenchmen. In 1891, for example, the Eastern-based, professionally prominent *American Architect and Building News* published its list of 129 noteworthy American buildings: ten could be found in Chicago; fourteen lay further west; almost all the others stood east of the Mississippi. Small wonder that Daniel Burnham seemingly deferred to architects from the East. But it is also important to note a certain contradictory voice among those who have followed Louis Sullivan and others in their rejection of European and Eastern elitism. In their rush to embrace modernism and to condemn classicism as a dead branch on the tree of culture, they willfully disregarded the plain fact that most visitors to the fair were wildly enthusiastic about the architecture. The tastes of the many—democratic tastes, that is—seem to have counted for little with them. Democracy, it would appear, can be a highly selective commodity for a cultural elite. A further irony is that most of the twentieth-century architectural historians who have vehemently attacked the neoclassicism of the Columbian Exposition have been ardent defenders of twentieth-century architectural modernism, the International style. Today as much opprobrium seems to surround this later style as it did the earlier classicism of the World's Fair.

Whatever the merits or demerits of their decision to build the Court of Honor in a uniform style (but with individual designs), the various architects of the fair dispersed and then reassembled in Chicago late the following month. With them they brought initial sketches for their respective buildings: Administration Building (Hunt); Agricultural Build-

ing (McKim, Mead and White); Manufactures and Liberal Arts Building (Post); Machinery Building (Peabody and Stearns); Electricity Building (Van Brunt and Howe); Transportation Building (Adler and Sullivan); Fisheries Building (Cobb); Horticulture Building (Jenney and Mundie); Mines and Mining Building (Beman); Venetian Village (Burling and Whitehouse).* At the same time they were able to study the preliminary landscape designs of Olmsted and Codman. The next day an excited grounds and buildings committee reviewed all plans. By the end of the day the sculptor Augustus Saint-Gaudens, who had come from New York as an unofficial adviser but who would soon accept an official position, exuberantly exclaimed to Burnham that this had been "the greatest meeting of artists since the fifteenth century." Having exchanged mutual congratulations on the excellence of their plans, the group now turned to the task of building the fair—and quickly.

The Columbian Exposition, like any grand enterprise, resulted from the contributions of many: architects and engineers, painters and sculptors, skilled and unskilled workers, promoters and investors. Above all, it took the executive talents of one man, Daniel Burnham, to coordinate their efforts, adjudicate disputes, reject or hold fast to plans, offer compromises, understand finances, react to unforeseen occurrences, kindle enthusiasm among both those involved in the project and the outside public, and manage his own moods—in short, to play the role of a man for all seasons, or in this instance, one prolonged season. In his capacity as majordomo, Daniel Burnham, who spent most of his days and nights in a shanty on the fairgrounds, with a telephone connecting his office there with his office downtown, succeeded admirably.

*The Venetian Village was never constructed, though the fair prominently displayed Venetian motifs, notably lagoons and canals.

One of Burnham's chief duties was to maintain the flow of work. This was usually difficult. None of the physical work for the fair began before the spring of 1891, and time-consuming problems were constantly at hand. Burnham regularly sent letters of complaint to dilatory architects, particularly Peabody and Stearns, whose Machinery Building, second in size only to Post's Manufactures and Liberal Arts Building, was the last major structure to be completed—and proved too small to house all the displays.

More frequently, Burnham had to intervene in questions concerning the designs themselves. Richard Morris Hunt's Administration Building, for example, with its massive dome, central location, and proposed uses, occupied a pivotal position in the overall layout of the fair and created genuine difficulties. Despite his regard for Hunt, Burnham on several occasions persuaded him to alter his designs. (So much for Louis Sullivan's complaint that Burnham was hopelessly enslaved to the wishes of Eastern contributors!) Burnham, as chief of construction, also had to ratify designs for all state buildings. He was vexed when Montana proposed that its structure assume the shape of a mountain. "An exceedingly ugly thing," he thought. South Dakota also peeved him by proposing a pavilion in the form of a Sioux tepee. Clearly, not all the states worshiped neoclassicism.

Of course, neoclassicism was never intended to be the sole style of the exposition. Among its more than two hundred buildings, French Gothic and Richardsonian Romanesque proved quite popular for state exhibits while the pavilions from abroad reflected their local cultures. (Burnham had no control over foreign exhibits in any case.) As the focus of the exposition, however, the five buildings that comprised the Court of Honor—the Administration Building, Manufactures and Liberal Arts Building, Machinery Hall, Electricity Building, and Agricultural Building—adopted a mandated

neoclassical style and common cornice height. Other major buildings were rendered in this style: Charles Atwood's Fine Arts Building, William Le Baron Jenney's Horticultural Building, James Windrim's United States Building, and Sophia Hayden's Woman's Building. Several state exhibits incorporated neoclassical forms inside their buildings, sometimes with quaint results. Illinois displayed a mosaic composed of grains of different hues; Ohio presented its homegrown cereal products within a miniaturized version of the Parthenon. Boldest of all, California erected a large Roman-style column comprised of oranges and topped by an eagle. Doubtless exhibitors did their best to coordinate the past with the present.

Two of the official architects for the fair, Cobb and Sullivan, shunned a neoclassical style. Cobb, designer of the Potter Palmer mansion, turned to the Romanesque for his Fisheries Building. Innovative in some respects, his building still appeared mainly derivative. Louis Sullivan's Transportation Building attracted greater attention, especially its "Golden Door," a series of five receding arches colored red, orange, and yellow which produced striking visual effects. Its lavishly ornate design—a Sullivan trademark—strikingly contrasted to the relative simplicity of the remainder of the building. For all its beauty it posed certain problems. Sullivan has long been famous for his insistence that there be a close relationship between the appearance and purpose of a building: "form follows function," as the shorthand would have it. Most of Sullivan's structures followed his strictures, but the Transportation Building decidedly did not. With angels adorning the arcade, with Islamic and Byzantine motifs, with an interior too small to contain all the intended exhibits, it suffered from technical defects and artistic contradictions. As the architectural critics John Burchard and Albert Bush-Brown have noted, it made "no statement about

n ... no important prediction for future railroad
ier. ..." Had this building served as a precedent,
d, American architecture would have been no
than with neoclassicism. French critics applauded
for the Transportation Building, but it was for his
luxuriant ornamentation redolent of Art Nouveau design,
not for the building as such. Burnham, the recipient of much
of Sullivan's ridicule, augmented the building's positive fea-
tures by persuading its creator to simplify his work and to have
a single entrance rather than the traditional two entrances.

Burnham also had to deal with the thwarted intentions of
Frederick Law Olmsted. Early in their planning Burnham
and Root and Olmsted and Codman had agreed to leave a
small island in one of the lagoons free from pavilions.
Olmsted envisioned it as a place of refuge from its sur-
roundings. Serving "as a foil to the artificial grandeur and
sumptuousness of the other parts of the scenery," its foliage
was to counterbalance the "great towering masses of white,
glistening in the clear, hot Summer sunlight of Chicago."
Visitors to the fair, Olmsted reasoned, would welcome "a
place of relief from all the splendor and glory and noise and
human multitudinous [sic] of the great surrounding Babylon."

But Olmsted's concern for jangled nerves carried less
weight than did commercial demands to utilize all existing
space, particularly space that was fetching such a steep price.
Burnham at one point contemplated a music hall on the
island but eventually backed the proposal of the exuberant
outdoorsman Theodore Roosevelt, then a United States civil
service commissioner, to establish a model hunter's camp.
Olmsted, who had dedicated so much of his life to preserv-
ing landscapes, adamantly opposed the plan. Finally Burn-
ham managed to persuade the landscape artist to accept a
Japanese exhibit in the form of a garden and temple (later
donated to the city of Chicago). Assuming that the nature of

The Manufactures and Liberal Arts Building under construction in March 1892. *(Chicago Historical Society)*

This aerial view from the dome of the United States Building captures a variety of the sights and enjoyments the exposition offered. Prominent are the wooded island, the Woman's Building, and the Ferris Wheel. *(Columbian Gallery)*

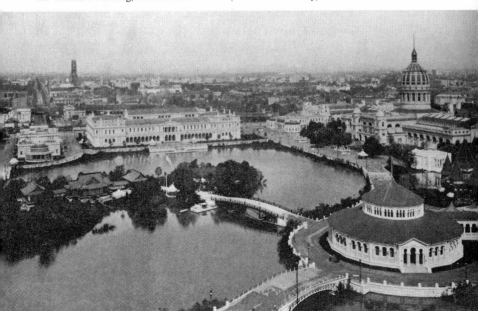

this exhibit would engender tranquility in visitors and that any other kind of exhibit was less likely to do so, Olmsted was reasonably mollified.

The overall cooperation of Burnham and Olmsted made possible an impressive, imaginative spectacle which conjoined the classical with the romantic. Observed Montgomery Schuyler: "In no point was the skill of Mr. Olmsted and his associate more conspicuous than in the transition from the symmetrical and stately treatment of the basin to the irregular winding of the lagoon. As the basin indicated a bordering of formal and symmetrical architecture [the Court of Honor buildings] so the lagoon indicated and invited a picturesque and irregular architecture." The Columbian Exposition represented the first attempt since Pierre L'Enfant's much earlier plan for the nation's capital to integrate architecture and landscape planning on a grand scale.

Burnham the impresario also needed all his managerial talents to contend with the problems of labor and construction that attended the building of the fair. He employed a work force of thousands of men of disparate backgrounds and dispositions. Not unsympathetic to labor, Burnham had to make a series of difficult decisions. First, he and the fair's directors refused the demands of organized labor for a closed shop: union workers were to be hired, but only on an individual basis, and a company union was to be formed. A number of workers were recently arrived immigrants, but Burnham insisted that the security forces, insofar as possible, be recruited from the ranks of the native-born—and only those native-born with acceptable work references. His memories of the Haymarket Riot still fresh, and fearing that a good deal of labor violence stemmed from the agitation of the foreign-born, Burnham wished to take no chances. Throughout the construction he was concerned about violence and strikes, both from outside agitators and from those

who had managed to obtain employment within. Relatively little violence occurred, but disruptive strikes threatened the already tight timetable. Less than a month before the scheduled opening, some workers affiliated with the carpenters' union struck. They returned to their jobs only after directors agreed not to discriminate against them as union members and to pay them the minimum wage originally demanded by the carpenters' union. At times Burnham could show marked consideration for his men, intervening to prevent discrimination against individuals, to see that they received adequate food and water, and to make sure that if injured, they or their families received compensation. The last item proved a major concern. Eighteen workers died and more than seven hundred were injured in 1891.

While Burnham was seeing to the various problems posed by laborers and participating architects, he was also actively publicizing the fair. During the course of construction numerous visitors—as many as five thousand at a time—came to observe the work. They wandered about, hoping to satisfy their curiosity but in the process unavoidably impeding workers. Raising the fee for visitors from twenty-five to fifty cents failed to diminish either their numbers or their ubiquitousness. Burnham did order certain visitors off the premises if he sensed they were disruptive. Dignitaries were another matter. Public officials, private personages, and journalists from throughout the country and abroad were eager for a peek at the exposition. Burnham, in his capacity as chief of construction and general artistic director, felt it incumbent to guide such individuals or groups personally and on occasions to arrange for entertainment while they stayed in Chicago. The fair, after all, represented a very serious business proposition, and Burnham fully understood the importance of advance publicity, both formal and informal.

So did other Chicagoans, who were determined to make

the fair a success. New hotels were erected and existing buildings refurbished; transportation was expanded and facilitated; the inevitable committees were formed. Ingeniously, General Nelson A. Miles organized a bicycle race to New York as an advertisement for the upcoming celebration. Politicians also did their part: aldermen defeated a proposal to restrict the number of saloons in residential areas. Visitors need not fear they would have to go dry.

As the immensity of the undertaking became apparent, the planners hit upon a scheme that would expedite construction and inadvertently give the exposition its most memorable feature and later nickname. According to Burnham, a group of architects were viewing S. S. Beman's nearly completed Mines and Mining Building when one of them suggested painting the structure white. There had been no dictum concerning colors, but now the time-saving suggestion took hold, and the planners ordered that all the buildings around the Court of Honor receive a coat of "staff," a mixture of plaster, cement, and fiber that had its origin in France a generation earlier. This durable, cheap, and easily produced white admixture became the coating for the fair's framed structures of iron and wood and for its statuary as well. Of all major buildings, only Sullivan's Transportation Building offered polychromy. Applying a single color to buildings obviously saved time, and so did an innovative means of application: a powered paint sprayer. What emerged from a measure of convenience was nothing less than an aesthetically startling "White City," whose glistening surfaces intensified the aura of ancient Greece and Rome evoked by its neoclassical architecture and whose luster enthralled millions of visitors.

Columbus may have encountered the New World on October 12, 1492, as people then generally agreed, but Burnham and his associates pushed back the fair's dedica-

tion day to Friday, October 21, 1892. Purists stressed that the later date represented the actual day of discovery according to the revised calendar that had been accepted during the intervening centuries. It seems just as likely that it was New York's five-day celebration of the event, and the need for time for those in New York to reach Chicago, that occasioned the delay. Whatever the reason, the delay helped the exposition's planners: the buildings stood half finished, the grounds likewise.

Fair officials had provided lunch for 70,000 anticipated attendees, but an estimated 100,000 to 150,000 persons thronged to dedication day ceremonies. New York architect George B. Post's massive Manufactures and Liberal Arts Building, then the largest building in the world, provided the focal point. Some seven million feet of lumber were required for the flooring of this gargantuan structure, which also demanded five carloads of nails, eleven acres of skylights, and more than three dozen carloads of glass for its roof. Its frames consumed more than twice the amount of iron and steel used to construct the Brooklyn Bridge a decade earlier. Measured from ground to apex, it rose the equivalent of nineteen stories.

Massiveness in other ways proved the order of the day, underscoring Burnham's observation that little plans could never capture the imagination. Military marching groups and carriages of official guests paraded from downtown Chicago to the exposition, as large, noisy crowds lined the way or followed the procession to the fairgrounds. To initiate ceremonies, Theodore Thomas, who had organized the Chicago Orchestra only a year before, conducted an ensemble of 500 musicians and 5,500 singers in a performance of the "Columbia March," a work specially composed for the occasion by the then well-known but now largely forgotten John K. Paine. Somewhat later Thomas led the orchestra

and chorus in Handel's "Hallelujah Chorus" and in Harriet Monroe's "Columbian Ode," which George W. Chadwick, another forgotten composer, had set to music.* Francis J. Bellamy, an editor of *Youth's Companion,* earlier that year had written the *Pledge of Allegiance to the United States Flag,* which the Bureau of Education then proceeded to distribute to schools throughout the nation and which President Harrison heartily endorsed. Now, at dedication day, which Bellamy wanted declared a national holiday, the audience, among whom were schoolgirls patriotically attired in red, white, and blue, was encouraged to recite the *Pledge.*

Ritualized speechmaking abounded. Burnham, various fair officials, and Chicago's mayor, Hempstead Washburn, who was soon to turn over his office to Carter Harrison, extended greetings; Harlow N. Higinbotham, president of the fair's board of directors, awarded medals to participating architects and artists. Henry Watterson, nationally prominent editor of the *Louisville Courier-Journal,* presented a dedicatory oration, as did the future senator from New York and current head of the New York Central and Hudson River Railroad, Chauncey Depew. Vice President Levi Morton, substituting for President Harrison, whose wife was dying, then dedicated the fair to "humanity" and "to the world's progress in arts, in science, in agriculture, and in manufacture." A more pointed speech came from Chicago's foremost lady. Speaking for the board of lady managers, Bertha Honoré Palmer took advantage of the infrequent opportunity for a woman to address a mixed assemblage of sexes on a formal occasion. Acknowledging the role that

*Charles T. Yerkes, who had served on the exposition's committee on ceremonies, had been largely responsible for the commission awarded to Monroe. A pioneering figure in the literary Chicago Renaissance, Root's sister-in-law enjoyed little success with her "Ode," copies of which she claimed to have used "all that winter ... for fuel in the little stove which heated my bedroom study...." A souvenir edition that went on sale at the exposition after opening day sold no better.

Queen Isabella had played in the historic voyage of Columbus, she assured her listeners that "even more important than the discovery of Columbus, which we are gathered to celebrate, is the fact that the General Government has just discovered woman."

Dedication day offered entertainment along with the speeches. The Marine Corps band and a Mexican band played popular music; members of the nation's military and diplomatic corps were present in resplendent uniforms. By the time festivities concluded in late afternoon, dedication day counted itself a success. The crowds seemed delighted. So was Daniel Burnham, but he knew that much work remained before "the greatest ceremonial of all time" could officially open the following spring.

During the six months between dedication day and the opening of the fair, planners experienced serious doubts whether they could finish all the work. Numerous buildings awaited completion, as did the projected canals, lagoon island, and basin which the Court of Honor would envelop. Almost two years to the day after the death of John Root, Henry Codman died unexpectedly following an appendectomy, leaving Olmsted dispirited and without an able assistant, and casting a pall over activities. Accidents, assorted labor difficulties, and problems with individual buildings proliferated, and to make matters worse the city experienced a grim winter, even by Chicago standards. Snowdrifts piled up and caved in several roofs. Horses trudged painfully through the snow, as did workers; all had to contend with the mud of the spring thaw. Neither all the buildings nor the grounds and walks could be completed on schedule despite the painful physical toil and painstaking artistic planning. Nonetheless, after more than two years and $19 million expended on preparation ($16 million for construction), the World's Columbian Exposition of 1893 officially opened.

4

"You Must See This Fair"

AN EARLY MORNING rainstorm on Monday, May 1, 1893, failed to dampen Chicago's enthusiasm for the opening of the Columbian Exposition. Twenty-three carriages conveyed dignitaries from the downtown area to Jackson Park. President Grover Cleveland, recently inaugurated for a second, though nonconsecutive, term in office, led the entourage, which included most cabinet members. German-born, liberal-minded Illinois Governor John Peter Altgeld drew loud cheers but not as loud as those reserved for newly elected Mayor Carter Harrison. General Nelson A Miles, the conqueror of Geronimo, the Nez Percé, and at length the Sioux at Wounded Knee, also received sustained huzzahs for his role in the pacification of Native Americans. Daniel Burnham of course rode in the procession, as did Bertha Palmer, her role among the female notables challenged only by the presence of the Duchess of Veragua, wife to the sole living descendant of Columbus, and the Infanta Eulalia.* The caravan entered the exposition from the west, passing

*The imperious Infanta would soon earn the wrath of Mrs. Palmer, whom she disparaged as the "innkeeper's wife," and the dismay of genteel Chicagoans, whom she shocked by publicly smoking cigarettes. Not one to suffer insults, the "innkeeper's wife" would retaliate by referring to her affronter as "this bibulous representative of a degenerative monarchy."

through the crowded Midway Plaisance to the rhythm of beating tom-toms and the roars of four trained lions. Finally it reached Hunt's towering Administration Building, whose dome exceeded the nation's capitol in height. The luminaries descended from their vehicles and joined others on a dais constructed to seat three thousand.

After the requisite introductory prayer, poem, music, and welcoming speech, a portly man arose, the nation's fifty-six-year-old chief executive. He and his wife were expecting a child, the first born of any president and first lady occupying the White House. But President Cleveland's buoyancy was tempered by unsettling economic news. The nation's gold reserves had dwindled alarmingly in April, falling below the $100 million level considered necessary for maintaining the gold standard. In the same month more than two dozen banks had failed. Since the beginning of the year business bankruptcies, including that of the important Philadelphia & Reading Railroad, had been increasing, and the stock market had become skittish. The president could not have known that within days the nation would plunge into an economic panic, the most severe to that time. Nor could he have foreseen that within these same few days he would feel a growth on the roof of his mouth. Physicians would diagnose the growth as malignant, requiring surgery and the painful implantation of a prosthetic jaw made of vulcanized rubber.

For the moment the president's duty seemed clear. He spoke briefly, linking the country's technological achievements with its democratic values and expressing the hope that other nations would achieve similar success. Then, shortly before noon, he switched on an electric key. Immediately the flags of the United States and Castile, along with the ancient banner of Ferdinand and Isabella, ran up different masts, while flags of other nations simultaneously un-

furled. Water began to gush from the exposition's many
fountains; the shroud fell from the *Republic,* the huge statue
that dominated one end of the basin; guns from warships on
Lake Michigan boomed their salute. The World's Colum-
bian Exposition had officially opened.

A gigantic crowd—paid attendance alone was 128,965—
thronged the fairgrounds on this opening day. The price of
admission was fifty cents for adults and twenty-five cents for
children. Although fairly steep for that period, it was a price
that probably few begrudged. One elderly man informed his
wife that it was worth spending all his burial money to
attend the exposition. Many must have shared the excitement
of the young writer Hamlin Garland. After taking in the
spectacle, Garland implored his parents, who were living on
a farm in South Dakota, to "sell the cook stove if necessary
and come. You must see this fair." Garland's parents did
come. Over the next several months so did millions more.
Final attendance figures exceeded 27 million, more than
three times that of the Philadelphia Centennial nearly a
generation before.

Chicago had hurriedly prepared accommodations for the
expected visitors. New apartment buildings and hotels went
up to complement existing dwellings for out-of-towners.
Established hotels charged from three to six dollars a day for
a single room, while room and board could be had in
virtually any section of the city for between five and fifteen
dollars per week. Additional accommodations were provided
for workers who built the exposition but who were not
native Chicagoans.

What must have impressed visitors once they arrived at
the fair was its sheer size. First were the crowds. No
previous event in the nation's history had drawn together so
many people, in so small an area, over so short a period.
Looking back a century later, one can begin to appreciate

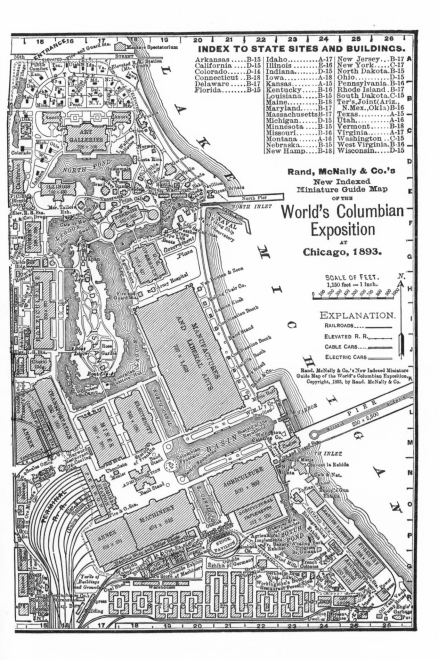

INDEX TO STATE SITES AND BUILDINGS.

ArkansasB-15	Idaho.........A-17	New Jersey...B-17
California ...D-15	IllinoisE-16	New York.....C-17
Colorado.....D-14	Indiana.......D-15	North Dakota.B-15
Connecticut .B-18	Iowa..........A-18	Ohio..........D-15
DelawareB-17	Kansas........A-15	Pennsylvania.B-16
Florida.......B-15	Kentucky.....B-16	Rhode Island .B-17
	Louisiana....B-15	South Dakota.C-15
	Maine.........B-18	Ter's,Joint(Ariz.,
	Maryland....B-17	N.Mex.,Okla)B-16
	Massachusetts B-17	Texas.........A-15
	Michigan.....D-15	Utah..........A-16
	Minnesota....B-15	Vermont......B-18
	Missouri......B-16	Virginia......A-17
	MontanaA-16	Washington ..C-15
	Nebraska....B-15	West Virginia.B-16
	New Hamp....B-18	Wisconsin....D-15

Rand, McNally & Co.'s
New Indexed
Miniature Guide Map
OF THE

World's Columbian Exposition

AT

Chicago, 1893.

SCALE OF FEET.
1,150 feet = 1 inch.

EXPLANATION.

RAILROADS....
ELEVATED R. R.
CABLE CARS....
ELECTRIC CARS

Rand, McNally & Co.'s New Indexed Miniature
Guide Map of the World's Columbian Exposition.
Copyright, 1893, by Rand, McNally & Co.

how *crowded* the exposition must have seemed to those who attended, considering that the nation's population, according to the Census of 1890, registered just under 63 million, less than one-fourth as large as today's. Taking into account foreign visitors as well as repeaters, it still seems likely that a great many Americans followed Hamlin Garland's advice to his parents.

The size of the crowds varied enormously. Opening day attracted an abnormally large crowd. Chicago Day, October 9, the twenty-second anniversary of the Great Fire, drew an even greater throng as schools and workplaces closed in honor of the most famous event in the city's history. Overall attendance was disappointing at first, but special "days" and the attractions of the Midway Plaisance drove up daily average figures to roughly 150,000 during the final two months of September and October. Sunday attendance was lower. Congress, bowing to pressure from Sabbatarians, wanted the fair closed on Sundays, but the fair's directors, bowing to Mammon, kept it open. This brought a court case to decide the matter of Sunday openings. When it became evident that the working class was spending less on the Sabbath than had been projected, the fair's directors, "thoroughly tired of the agitation," acceded to congressional and Sabbatarian wishes and closed the grounds on Sunday. The Philadelphia Centennial had adhered to such a policy. That the Columbian Exposition tried to remain open indicates some loosening of formal religious customs and a growing secularism as the century waned, a condition underscored by the vigorous, sometimes shrill counterattacks of Sabbatarians during these years.

For some, the crowds themselves likely contributed to the fair's attraction. Many Americans had traveled little, and their life experience had remained provincial. The Philadelphia Centennial, for all its magnetic force, attracted visitors

largely from the eastern seaboard. The Columbian Exposition, in contrast, drew more visitors from throughout the country as well as from Europe. Chicago enjoyed a central location and was the acknowledged hub of the nation's new system of railroads. Not all roads led to Chicago, but many of them did. And the price of travel, while not easily affordable for those with limited incomes, was manageable for many. A traveler from New York could journey second-class by rail for seventeen dollars; from the other end of the continent one could make the trek to Chicago for forty-five dollars. Cheaper round-trip fares were available from both coasts. Having reached the Windy City, visitors found a well-developed system of railroads, trolleys, horsecars, cable cars, and boats to transport them to their destination. The Illinois Central Railroad, having enlarged its station at Van Buren Street and having added 41 locomotives and 300 coaches to its fleet, alone brought 541,312 passengers to the fair on Chicago Day. Transportation to and from the fairgrounds was relatively inexpensive. The various tramways—cable, electric, and horsecars—charged only five cents per ride, and cabs, more leisurely and comfortable, carried one or two passengers for seventy-five cents per hour. Steamers that plied the waters of Lake Michigan and disembarked passengers at Jackson Park, along with the Illinois Central, also offered reasonable rates.

Some· visitors complained of the lack of transportation facilities within the fairgrounds. These may have been inadequate, but they were certainly diverse. For twenty cents a visitor could traverse the grounds on an elevated railroad powered by a pioneering electrified third rail. It allowed the visitor to get off at any one of several stops along the way. Abutting the lake, and with lagoons carved to Olmsted's specifications, the fair also provided assorted and reasonably priced water transportation: electric- and steam-powered

launches and, more quaintly, gondolas constructed and manned by native Italians. For the handicapped, the elderly, the fatigued, or the just plain lazy, the fair rented out rolling chairs, a novelty derived from the Paris Universal Exposition. These were not inexpensive: 40 cents an hour; $6 per day with a guide; $3.50 per day without a guide.*

For all their attraction, the crowds also had a disquieting side. Throughout the course of the fair people sometimes fainted or became ill from the pressing swarms of humanity or from the blistering heat of a Chicago summer. (Some may have recalled and feared a recurrence of the city's almost incredible heat wave of July 1890 when fifty persons died from sunstroke in one day alone.) Of greater concern to fair officials was crowd control. The exposition attracted countless numbers of thieves and con men to a city already replete with them. On opening day one enterprising thief snatched Jane Addams's purse. Purse stealing and pickpocketing proved a continuous problem, though they did not embarrass officials as much as the spectacular theft of a riding whip set with two diamonds, on loan from King Leopold of Belgium. All this took place despite the presence of the Columbian Guard, the private security force hired to maintain law and order. Clad in bluish grey uniforms and yellow-lined capes, these 1,750 guardians formed a highly visible presence to discourage criminals and the disruptions of anarchists. A pervasive if unstated fear was that a mass of normally well-behaved people might unexpectedly transform itself

*The guides were mostly college students working for the summer, and since many were majoring in religion the rolling chairs acquired the name "gospel chariots." One of the guides was Lee De Forest, who was studying physics at Yale under Josiah Willard Gibbs and who would later become a major figure in wireless telegraphy and, according to some, the "father of radio broadcasting." Whenever possible, the technology-oriented De Forest wheeled his clients into Machinery Hall.

into an irrational, frenzied mob. As a further precaution against crime and chaos, officials brought in 250 plainclothes European and American detectives.

The fears of exposition officials and their security forces mirrored those entertained by society at large. The unsettling forces of industrialization, urbanization, and immigration were leading many, in the historian Robert H. Wiebe's phrase, on a "search for order." Perplexed by the confusions inherent in the vast economic and social transformations that were taking place in America, they sought to overcome the destructive forces of rapid change with stability through professionalization, efficiency, rationalization, and harmony. At its most extreme this search for order concerned itself with violence—the violence of capital-labor conflicts and urban crime and disorder. Much of this violence was potential, but a good deal was also real. Reacting to explosive events such as the Haymarket Riot or the Homestead Strike of 1892, some educated and responsible citizens warned of an American version of the French Revolution or the Paris Commune. The fears seem vastly exaggerated—but only in historical hindsight. For a generation who lived through these events there could be no guarantee that unrest and confusion might not degenerate into revolution and anarchy. The hundreds of armories built in the United States between 1880 and 1910, and their blatant military iconography, point to this concern for class warfare. It was not accidental that most of these structures looked like castles, intended to protect the defenders of civilization from the onslaughts of barbarians.

Some historians have viewed the Columbian Exposition as part of this larger attempt to impose order on the masses. Alan Trachtenberg, for one, has interpreted the exposition as an effort to achieve unity at the expense of diversity by linking the forces of business and government with high

culture. Certainly key individuals associated with the celebration, such as Burnham and Olmsted, were genuinely concerned with disorder, urban and otherwise, as a growing national tendency. Nor were they alone in their concern. In veiled relief, various visitors to the fair commented favorably on the behavior of the crowds. According to the Reverend William Rainsford, an Episcopal clergyman from New York, "order reigned everywhere." There was, he noted, "no boisterousness, no unseemly merriment. It seemed as though the beauty of the place brought gentleness, happiness, and self-respect to its visitors." Another observer commented in even more laudatory terms, "Courtiers in...Versailles or Fontainebleau could not have been more deferential and observant of the decorum of the place and occasion than those obscure and anonymous myriads of laborers....In the presence of the ignorance, vice, poverty, misery, and folly of modern society... pessimism seems the only creed; but doubt is banished here." The pleasant surprise shown by these visitors underscores the seriousness of their concern over the violence that numerous Americans were experiencing.

Yet one may overemphasize connections between the Columbian Exposition and the late-nineteenth-century search for order. Frederick Law Olmsted, who had been confronting and battling the problem of urban disorder for forty years, was convinced that the crowds at the exposition were, in fact, *too* well behaved. Noting how dignified they appeared—and photographs of visitors to the fair bear this out—the venerable creator of magnificent parks complained that the exposition lacked "incidents of vital human gaiety." He suggested strolling singers and banjo players, musicians performing from boats on the lagoons, and lemonade vendors to bring touches of lightheartedness, ease, and informality. In fact the exposition was much more than a question of order versus disorder, formality versus informality, sobri-

ety versus exuberance. For some it was principally a finan-
cial investment, filled with the lure of profit and the risk of
loss. (The Chicago Company and its investors netted an
estimated $1.4 million after defraying total costs of roughly
$67 million. The city itself gained an appreciable if indeter-
minate amount as a result of the tourist trade.) The issue of
civic pride also loomed large. Virtually undisputed as the
nation's preeminent city west of the Hudson, Chicago wanted
others to see and appreciate it. What better way than to host
a world's fair? Chicagoans were also Americans, and their
civic pride swelled into national pride at the prospect of
displaying their progress to foreign and out-of-town visitors.

The technology exhibits alone seemed well worth the
price of admission. Among the international displays, Ger-
many's 130-ton cannon, the largest in the world and manu-
factured by Krupp, particularly caught the attention of
visitors. Standing before this awesome weapon of destruc-
tion, few could have surmised that in twenty-one years it
would be a part of World War I. (Archduke Franz Ferdi-
nand, soon to be heir to the throne of Austria-Hungary and
the man whose assassination in Sarajevo was to trigger the
conflict, was among the many foreign visitors to the fair.)
But Americans could also marvel at their own scientific and
technological achievements. The Philadelphia Centennial
had featured Alexander Graham Bell's newly invented tele-
phone. In 1876 only 3,000 phones had existed. By 1900 the
industry, while still in its infancy, would provide 200,000
such devices. At the Columbian Exposition visitors wit-
nessed American Bell Telephone negotiate the first long-
distance call from the Midwest to the Atlantic seaboard, in
this instance New York. Exposition visitors could also view
the latest in office equipment, including adding machines,
cash registers, and an even more revolutionary device, the
typewriter. George Pullman displayed his giant locomotives

for the occasion, while Charles Yerkes provided a huge (for its time) telescope which he later donated to the observatory that bears his name at the University of Chicago. The most recent sewing machines, which were to transform the garment industry, were also on hand. On a more colossal scale, visitors to Peabody and Stearns's Machinery Hall could see the two powerful steam engines that maintained a supply of water for the exposition by pumping twelve million gallons daily. Larger than the Corliss steam engine that had mesmerized visitors to Philadelphia in 1876, these behemoths attracted less attention than the dynamos, the newly invented electric generators that they powered.

Nothing, in fact, captivated fair visitors more than electricity. In addition to his advanced version of the phonograph, Thomas Alva Edison, the nation's most prolific and respected inventor, exhibited yet another product of his genius, the kinetoscope. This invention, the forerunner of the motion picture, allowed a single viewer to watch film as it passed through a peephole. Edison had shown his first film, a twenty-second depiction of three men working and drinking beer, on May 9 to the Brooklyn Institute of Arts and Sciences. For the fair he provided lengthier and more diverse entertainment via a fifty-foot strip of film that passed through a magnifying glass, powered by an electric motor and battery. The film captured a variety of circus animals, the popular dancer Carmencita, and the boxer James J. Corbett, who was soon to win the world's heavyweight championship (September 7) by knocking out John L. Sullivan in a twenty-one-round bout in New Orleans. The kinetoscope also featured renowned strong man Eugene Sandow, a highly popular attraction on the Midway during the fair. While bearing a platform and three horses on his chest, Sandow expanded his forty-seven-inch torso to sixty-one inches. Remarkably, Edison showed serious interest in

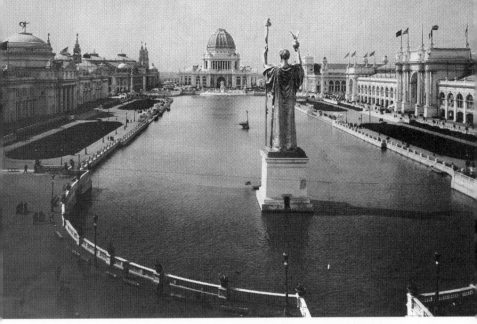

Neoclassical in style, the buildings that comprised the Court of Honor provided the focal point for the exposition. *(Chicago Historical Society)*

The Electricity Building exhibited the startling advances made since the days of Benjamin Franklin. *(Columbian Gallery)*

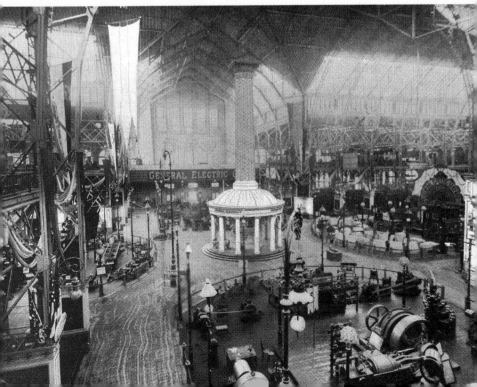

the kinetoscope only after two British visitors to the fair began to manufacture their own version. Besides exhibiting his kinetoscope and updated phonograph, the "Wizard of Menlo Park" also installed an electric railroad that ran for one-third of a mile within the fairgrounds. The train, which could carry twenty passengers at a time, transported more than 26,000 riders during the course of the exposition.

Edison was not the sole virtuoso of electricity to appear in Chicago that summer. Nikola Tesla, a Croatian who was born in what became Yugoslavia, demonstrated his "high-tension" currents there. Tesla, who was to patent numerous inventions, understood, as Edison did not, the importance of alternating current. The father of fluorescent and wireless lamps, Tesla reshaped the world of electricity in the twentieth century.

The fairgrounds were lighted with the help of British-born Samuel Insull. After serving as Edison's adviser, he had become president of Chicago Edison in 1892 with the help of a $250,000 loan from Marshall Field. The following year his company and its chief rival, Commonwealth Electric, pooled their resources to bring electricity to the grounds, waterways, and fountains of the Columbian Exposition. Impressive by day, the White City became ever more dazzling by night, the stark whiteness of its Court of Honor buildings illuminated by the most powerful display of electricity yet devised. (Childe Hassam, the Boston-trained American impressionist painter who had studied in Paris, captured this striking spectacle in a series of memorable works.) Insull would go on to merge the two Chicago utility companies as Commonwealth Edison in 1907. He lived long enough to see his empire fall into ruin during the Great Depression as a result of financial malfeasance, but no one denied him credit for the magical display he helped to create in 1893. Indoors, the Electricity Building itself, designed by

Van Brunt and Howe, turned out to be one of the most popular enticements at the fair. Filled with a great many electrical devices, it was designed to educate the public as well as to promote sales. Of particular interest to householders was an all-electric kitchen. Unfortunately the kitchen became readily available only in the 1920s.

The Edison Tower of Light became the focus of attention in the Electricity Building. Almost eight stories high and thirty feet in diameter, it contained thousands of lights that could be manipulated to provide a variety of colors and designs, thanks to the ingenuity of Edison's General Electric Company. But it was the Westinghouse Company, a rival organization and one which utilized alternating rather than direct current, that underbid General Electric to become the chief supplier of electricity for the rest of the fairgrounds.

Few understood the precise nature of this new, cataclysmic force of energy. Henry Adams, accomplished historian and scion of presidents, professed his ignorance:

> One lingered long among the dynamos.... Men of science could never understand the ignorance and naiveté of the historian, who, when he came suddenly on a new power, asked naturally what it was; did it pull or did it push? Did it flow or vibrate? Was it a wire or a mathematical line? And a score of such questions to which he expected answers and was astonished to get none.

"Education ran riot at Chicago," Adams added, "at least for retarded minds which had never faced in concrete form so many matters of which they were ignorant." Adams exaggerated his own ignorance but not that of less erudite and curious onlookers who were satisfied to see but not necessarily to understand.

Whatever their level of scientific comprehension and sophistication, visitors to the Columbian Exposition could

scarcely fail to be impressed with the possibilities of harnessing electrical energy. The three-ton General Electric searchlight that illuminated and scanned the fairgrounds by night aptly symbolized the search for power and knowledge that drove American science and technology at the end of the nineteenth century. That search embraced pure as well as applied science. The government was establishing more bureaus to explore the assorted avenues of science, and in 1893 appeared the *Physical Review* and the *Astrophysical Journal*, the nation's first specialized journals of science. That same year Columbia University awarded its first advanced degree in physics to Robert A. Millikan, who was to earn international recognition in the next century. At the same time Americans were beginning to achieve new scientific respect abroad. A colleague of Thomas Edison noted that theoretical physicists, especially those in Europe, tended to denigrate the work of the practical-minded Edison, but at the closing banquet of the exposition Germany's Hermann Helmholtz, hailed as one of the world's foremost physicists, made it a point to greet Edison. Later that evening other physicists who had been cool toward Edison repeatedly called upon him to speak.

Americans had already accepted Edison's inventive genius. One of the young engineers at the Edison Illuminating Company in Detroit stood in particular awe of him. Later this engineer was to become a friend of Edison and, in the opinion of some, a genius of rival proportion. But by that time Henry Ford was the world's most famous manufacturer of automobiles. Ford attended the Columbian Exposition but did not meet his hero. He was already interested in building an automobile but probably was unaware of the advances made by European pioneers such as the Germans Daimler and Benz. But Ford did know of the Duryea brothers, Frank and Charles, from Chicopee, Massachusetts.

Bicycle designers like Orville and Wilbur Wright, the Duryeas successfully built and then publicly demonstrated a gasoline-driven automobile in nearby Springfield, Massachusetts, on September 20, 1893. (The Wright brothers attended the exposition, noted that they enjoyed the bicycle exhibits, but failed to mention the aeronautical conference held at the fair!) Ford completed his first successful gasoline engine the day before Christmas, but it was not until two and a half years later that he gave his automobile a test run.

Electrical machinery and gadgetry represented only a fraction of all exhibits at the World's Fair. For perplexed visitors, one guidebook cited the names, location, and relative interest of more than five thousand displays. Thirty-six nations, forty-six states and territories of the United States, and miscellaneous private organizations swamped the exposition with displays intended to demonstrate their achievements in industry, agriculture, and the arts. Most of the exhibits were of a serious nature and were designed to educate, uplift, provide enjoyment, and stimulate commerce. On display were everything from furniture to dyes, from carpet sweepers to fire alarms, from plumbing fixtures to prize livestock. As Thomas J. Schlereth has pointed out in *Victorian America*, the Manufactures and Liberal Arts Building housed the world's largest department store, whose wares "provided a cornucopia of material culture that not only catered to middle-class taste but helped to form that taste." Some exhibits, intentionally or not, appeared odd if not downright bizarre: a Venus de Milo sculpted in chocolate; a map of the United States made of pickles; a knight on horseback crafted of prunes, compliments of California. Other exhibits were intended to satisfy the senses or impart a respect for history: fifty thousand roses blooming on the island in the lagoon; the largest canary diamond in the

United States; the original contract made between Queen Isabella and Columbus for the voyage in search of the Indies.

Yet machinery and technology did represent the largest displays at the exposition, aptly so. This was the "age of energy" for the United States, an age increasingly symbolized by electricity and the dynamo, an age when raw power and bigness were reshaping the contours of national life and thought into new, hardly recognizable patterns.

Although less prominent, cultural concerns formed an essential part of the exposition for both its creators and its beholders. An unofficial motto for the fair perhaps said it best: "Make Culture Hum!"

"Culture" is an uncertain, problematic term. The contemporary anthropologist, whose domain can seem all inclusive, generally employs the term in its broadest meaning, that is, as the sum total of ways of living for a given social group. Certainly the Columbian Exposition, with its rich array of representations from Western and non-Western peoples, displayed much of this kind of culture. But the culture most in evidence at the Columbian commemoration was of a different sort. There culture meant "high culture," which was synonymous with the most refined and developed arts and music. Today most people recognize the distinction between highbrow and lowbrow culture. That distinction was considerably less clear for Americans during the late nineteenth century, but the lines were firming. The "high" culture of the Court of Honor stood in marked contrast to the "low," or at least middlebrow, culture that characterized the Midway. These different locales may have sharpened the distinction, but it would be wrong to be rigid about it. The "high" culture of the Court of Honor did, after all, contain certain elements—the subject matter of Edison's kinetoscope, for example—that spoke to "low" or "popular" culture. And the

Midway initially attempted to provide education as well as entertainment.

A synonym for the high culture of the late nineteenth century is the term "genteel tradition." Spanish-born George Santayana, who studied at Harvard and taught philosophy there, coined the phrase in an address given in the summer of 1911 at the University of California at Berkeley. Its title—"The Genteel Tradition in America"—misinforms. More than an arraignment of American philosophy, the essay, according to one interpreter, damns the entire "dominant intellectual tradition in America and its effect on artistic and speculative enterprises." Santayana's striking assessment of American high culture for the preceding century seems worth quoting at some length:

> ...One-half of the American mind, that not occupied intensely in practical affairs...has floated gently in the backwater, while, alongside, in invention and industry and social organization the other half of the mind was leaping down a sort of Niagara Rapids. This division may be found symbolized in American architecture: a neat reproduction of the colonial mansion...stands beside the sky-scraper. The American Will inhabits the sky-scraper; The American Intellect inhabits the colonial mansion. The one is the sphere of the American man; the other, at least predominantly, of the American woman. The one is all aggressive enterprise; the other is all genteel tradition.

Also striking is the pervasiveness of this tradition. Noting how it "dominated high culture from 1865 to 1915 and...infiltrated the culture of the middle class," the historian Howard Mumford Jones wrote:

> During this half-century the genteel tradition was our cultural norm; that is, it was a central principle for aesthetic values, philosophy, upper-class religion, and high-

er education, which influenced secondary education im-
portantly in these decades. The genteel tradition was also
consonant with a renewed admiration for important as-
pects of European culture, particularly British literature,
"classical" music, and the approved great masters of
sculpture, painting, and architecture. The decorative arts
were also involved. Its idealism was at once moral,
aesthetic, and philosophical....

Stated somewhat differently, believers in the genteel tradi-
tion tended to equate high culture with the well-being of
society itself. They took very seriously the pronouncement of
Matthew Arnold that culture—"the knowledge of the best
that has been thought and said in the world"—could lead to
"sweetness and light" and preclude anarchy, or at least an
inferior civilization. Culture for most of the adherents to the
genteel tradition was not art-for-art's-sake, an aesthetic
experience to be savored in and for itself. It had a utilitarian
value as well, one that would uplift and civilize. This
viewpoint formed an integral part of both the idealism and
imperialism of the late nineteenth and early twentieth centu-
ries. Few seriously argued that the masses in the West
suffered from the same cultural deprivations as the masses
elsewhere. Yet according to *Outlook*, a respected turn-of-the-
century journal, the United States stood "in danger of
exalting the average man, and rejoicing in...mediocrity."

To equate high culture with the good society is to present
a less than foolproof argument, as there is no way to
confirm it. Advocates of high culture differ as to its precise
components; others reject the premises of the argument
entirely. For some, high culture should be the special pre-
serve of the elite, that "saving remnant" that can appreciate
"sweetness and light." Others, more democratic, believe that
high culture can inspire everyone. Both groups were present
and active at the World's Columbian Exposition.

The genteel tradition itself formed part of a larger cultural movement often referred to since 1880 as the American Renaissance. For roughly fifty years, from the end of Reconstruction to the Great Depression, this perspective grew from a renewed European appreciation for the Renaissance, particularly the Italian Renaissance of the fifteenth and sixteenth centuries, which in turn had drawn its primary inspiration form the classical world of Greece and Rome. Works such as Walter Pater's *Studies in the History of the Renaissance* (1873), John Addington Symond's *The Renaissance in Italy* (1877), and Jacob Burckhardt's *The Civilization of the Renaissance in Italy* (translated from the original German into English in 1878) fueled this revival, as did increased study and training abroad by Americans interested in the fine arts.

But the American Renaissance, at least in theory, represented more than mere dependence on the historical past and transatlantic tastes. Those who played an active role in the movement or at least sympathized with its meaning and achievements were cultural conservatives. They believed that to be self-reliant one must first internalize the authority of tradition. For them a defense of the past was a virtue, not a vice, and at the same time a ballast for the present and a bridge into the future. "The artistic community," noted one critic, "announced that America was the unique synthesis. It proclaimed that a new society based on science, industry, commerce, rational order, democracy, and the great energy of the people had been forged and was the legitimate heir to the concept of the Renaissance." Francis J. Bellamy, author of the *Pledge of Allegiance*, very likely would have applauded this patriotic vision, as did the mayor of Philadelphia who in 1893 initiated the observance of Flag Day. The American Renaissance was enthusiastically nationalistic, using "symbols and images of past civilizations... to create a magnifi-

cent American pageant." Arches, domes, and columns were among the Greek and Roman achievements that the Renaissance had transmitted, but in the hands of late-nineteenth- and early-twentieth-century American artists they became the cultural emblems of a modern republic with imperial trappings. Nowhere during the 1890s was this more in evidence than at the Columbian Exposition and, more precisely, in its Court of Honor.

Situated toward the southern end of the fairgrounds and just off Lake Michigan, their exteriors of white, their cornices of even height, the vertical divisions of their walls arranged proportionally, the buildings that made up the Court of Honor projected a harmony and grandeur that evoked the best efforts of the classical world. Like those efforts, they conjured up images of order and balance that rested on the assurances of power. Two monumental statues positioned within the basin itself intensified the classical frame of reference. At the eastern end of the basin, facing west, with the Agricultural Building to its right, stood the imposing statue of the *Republic* designed by Daniel Chester French. French's works already included *The Minute-Man* at Concord, Massachusetts, and would later include the seated Lincoln of the Lincoln Memorial in the nation's capital. Sixty-five feet in height, the female figure that personified the republic towered over the Court of Honor. Draped in a toga, laurel wreath about her head, a spear in one hand and an eagle atop a globe in the other, the statue conveyed virtues prized by the ancient Greeks and Romans: repose suffused with latent power. Further augmenting this classical motif was the monumental Peristyle, or colonnade, that stood behind French's statue and enclosed the eastern end of the basin. Designed by Charles Atwood, it rose more than 150 feet and extended more than 800 feet. Its Corinthian columns, representing the American states, opened onto the

lake. The Peristyle, with promenades and pavilions, also featured a Quadriga, an arch atop which rode a figure of Columbus in a Roman chariot pulled by four horses and led by two young women.

Facing the *Republic* at the opposite end of the basin, into which flowed both a north and south canal, was the Columbian Fountain, the work of Frederick William MacMonnies, whose Soldiers and Sailors Memorial Arch in Manhattan, and statue of Nathan Hale in Brooklyn, had already earned widespread praise for this young protégé of Augustus Saint-Gaudens. The Columbian Fountain, cast as a ship on which rode allegorical figures of Fame and Time, with a female Columbia at its top and with four female rowers, represented progress through a dignified and controlled classicism.

The idea for the Columbian Fountain originated with Saint-Gaudens, a major planner for the exposition. Born in Dublin in 1848 to an Irish mother and a French father, he immigrated to the United States as a child, recrossed the Atlantic to study sculpture at the École des Beaux-Arts, and then resettled in New York. A close friend and frequent collaborator of the architect Stanford White, the red-haired Saint-Gaudens had earned a reputation as the premier sculptor of the American Renaissance with such famed and geographically disparate works as *Lincoln* (Chicago); *The Puritan* (Springfield, Massachusetts); the *Shaw Memorial* (Boston); *Admiral Farragut* (New York); and the *Adams Memorial* (Washington, D.C.), which he designed for Henry Adams's wife, who had committed suicide.

Burnham wanted the celebrated artist to design all the sculpture for the World's Fair, but eventually Saint-Gaudens was responsible only for the Columbus that stood before the Administration Building. Even that statue, according to his son, was both modeled and executed by a pupil (Mary

Lawrence), with the master's advice. Saint-Gaudens did serve Burnham as general adviser on sculpture, and in this capacity he recommended the Peristyle as well as French's *Republic*. At first he wanted to design the Columbian Fountain and suggested that MacMonnies assist him. But MacMonnies preferred to work alone, and Saint-Gaudens consented. Once completed, the Columbian Fountain, which became popularly known as the MacMonnies Fountain, seemed too stilted and contrived for some, but not for Saint-Gaudens. He effusively praised the work as "the most beautiful conception of a fountain of modern times west of the Caspian mountains."

Hundreds of pieces of sculpture filled the buildings and grounds of the exposition. Foreign artists contributed, but it was chiefly American sculptors, working under the watchful eyes of Saint-Gaudens, who provided most of them. Besides French and MacMonnies, other prominent artists like Lorado Taft and Karl Bitter participated, as did the young female sculptors Janet Scudder and Bessie Potter Vonnoh, who exhibited their initial work at the exposition. Looking back on this artwork a century later, one is struck by the formality, even stolidity, of the pieces, as well as by their frequently flamboyant, almost rococo details. With few exceptions these works do not speak to the modern temper, conditioned as it has been by nonrepresentational abstractionism. Yet for the generation of the Chicago World's Fair this was high culture, and for us to condemn it summarily would be as gratuitous as it is ahistorical.

Some works seemed to surpass the genre of "occasion art" and to hold an allure that, if not timeless, transcends the years of the American Renaissance. One such work was Saint-Gaudens's celebrated statue of Diana, goddess of the moon and hunt and protectress of women. Formed from beaten copper and standing eighteen feet high, *Diana* first

stood atop the tower of Stanford White's Madison Square Garden in New York. It weighed nearly a ton and looked out of proportion on the tower, so it was taken down and later replaced by a smaller, more visually proportional replica. Meanwhile its creator decided to transport the original to the Columbian Exposition. Mrs. Potter Palmer very much wanted this enormous nude for the Woman's Building, but the structure lacked an appropriate pinnacle. Many Chicagoans, including those who belonged to the Women's Temperance Union, were outraged by *Diana*. Much to the consternation of White they denounced the statue's nudity and suggested drapery. Commenting on the prudery of the American public, the young American painter Kenyon Cox lamented, "It is just such a feeling that makes great art almost hopeless in this country." A furious Stanford White, refusing to heed the pleas for modesty, positioned the naked goddess atop his firm's Agricultural Building, squarely in the midst of the White City.

The brouhaha over *Diana* raised a more subtle point beyond the more explicit battle between those who preferred their goddess clad and those who did not. Aesthetically speaking, the "golden girl," as *Diana* was called, was a tour de force, one of Saint-Gaudens's most successful undertakings. But were the crowds at the exposition more appreciative—and appreciative they were—of art or more titillated by the sight of a lithesome nude conceived and displayed in an age that strongly emphasized female modesty? In New York multitudes had gathered to enjoy the "naughtiness" of Saint-Gaudens's goddess, and probably the same was true for Chicago. There is nothing exceptional in crowds that are more interested in the shocking and exciting than in the reposeful and meditative. But they do call into question the degree to which art can provide cultural uplift and enjoyment at the same time. And so it would seem that *Diana*,

her bow pulled taut, aptly if unwittingly caught the tension that existed between high and popular culture.

The exposition lavished somewhat less attention on paintings than it did on sculpture and architecture, but that attention was still considerable. The Palace of Fine Arts provided memorable quarters for most of these works. Drawing upon the classicism of ancient Greece, but with a large cast of the Roman emperor Augustus in front, the palace was the handiwork of the talented Charles B. Atwood, the New York architect who became the exposition's designer-in-chief and the mainstay in Burnham's office after the death of John Wellborn Root. Atwood designed some sixty buildings for the fair, and some regarded his Palace of the Fine Arts as the finest structure in the exposition. As one who did not qualify his compliments, Saint-Gaudens gushed to Burnham that it was "the best thing done since the Parthenon." Burnham went further, calling it "the most beautiful building I have ever seen."

The Palace of Fine Arts exhibited no fewer than nine thousand works, most of them by Europeans from a dozen separate nations, and many by Americans, but also some that flowed from the brushes of Canadian, Mexican, and Japanese artists. Quantity was not tantamount to quality. According to twentieth-century American art historian Oliver W. Larkin, these paintings "... with a few distinguished exceptions, constituted a display of empty dexterity which knew no national boundaries. They hung three and four deep with no other principle of arrangement than a farmer uses to build walls with stones of different sizes." Larkin's assessment may seem unduly harsh, but a good deal of chaff, both of the European and American variety, could be found among the wheat.

No one seriously doubted the intentions of the fair's planners to bring what they deemed the best of culture to

visitors, most of whom had never seen nor ever again would see so many original works of art. Many of the painters whose work was displayed today merit no more than a footnote in the history of art, but they did enjoy distinction and even fame in their own time. Empowered to select canvases, the fair commissioners sought the "best" of European art. To a pronounced degree this meant exhibiting works of the French art establishment, that is, the French Academy. If the works of these academic painters—William-Adolphe Bougereau, Jean-Léon Gérôme, Jean Louis Ernest Meissonier—are largely in disfavor today, the Academy favored paintings that "polite" society found acceptable, much in the manner that the École des Beaux-Arts shaped but also bowed to pubic taste. Before consigning these favored works of yesteryear to the dustbin of cultural history, one would do well to keep in mind the fluctuating reputations of such twentieth-century phenomena as Abstract Expressionism, Pop Art, and Op-Art in painting, as well as the International style in architecture. Altogether more than six hundred French paintings went on view at the exposition, more than double the number of any other contributing nation and a tribute to the power of the French over Western artistic tastes at the close of the century.

The arbiters of high culture at the World's Fair chose foreign works conservatively, though not entirely so. They did accept the works of some virtually unknown artists of the day, and in some instances they selected wisely. But by and large they turned their collective backs on what the French Academy had spurned. They failed to select, for example, works by any of the particular *bêtes noires* of the Academy, the Impressionists, who a century later represent possibly the single most popular school of painting in the Western world.

American art collecting was enjoying its golden age in the

late nineteenth century. The establishment of great American fortunes, coupled with the decline of wealth among the European nobility, opened a spectacular transatlantic trade that exchanged European art treasures for American dollars. Many of the nouveau riche businessmen on the western shores of the Atlantic had little interest in and less knowledge of art. Still, to use Thorstein Veblen's timeless words, the "leisure class" needed to indulge in "conspicuous consumption." Unfamiliarity with the world of art was no insurmountable obstacle to those tycoons who relied on and paid for the advice of experts. Some of these moguls, through their own travels or those of their agents, regularly crisscrossed Europe to amass collections that continue to astound. J. P. Morgan and Henry Clay Frick readily come to mind. Others, like Commodore Vanderbilt's son William, less wisely poured sizable amounts of their fortunes into works of the French Academics. As fine-art collectors, residents of replicated French châteaux and Georgian Revival mansions, and members of private clubs fashioned along neoclassical lines, these bankers and industrialists formed integral parts of the American Renaissance. Powerful chieftains of economic and poltical affairs who gathered loyal armies of paid retainers to do their bidding, they were reminiscent of the fierce *condottieri* of the Italian Renaissance. One look at the famous scowl and red bulbous nose of J. P. Morgan, as well as at his imperious, commanding career, testifies to the resemblance.

Such men dominated the world of art collecting. But there were others. In Boston Isabella Stewart Gardner— "Mrs. Jack," as she became known—turned her compliant husband's wealth to good aesthetic use. Far from being one of the city's proper, sedate matrons—she startled visitors to the Boston Zoo by walking a lion and, it was widely rumored, may have posed nude for her famous artist friend John

Singer Sargent—she apparently had little if any intention of
cultivating polite society in the usual manner. Instead she
assembled a collection of Byzantine, Gothic, Baroque, and,
most notably, Renaissance art, the latter with the invaluable
assistance of her young, Harvard-educated protégé, Bernard
Berenson.

As a collector and connoisseur of art, Isabella Stewart
Gardner had only one female rival, but a most formidable
one: Bertha Honoré Palmer. Proud of her diamond-studded
collar, Bertha Palmer also prided herself on the works of art
she had purchased with her husband's blessings. While Mrs.
Jack concentrated on works from earlier centuries, Mrs.
Palmer, guided by her friend, the expatriate artist Mary
Cassatt, looked more to the present. Although she was born
in Pittsburgh and spent some early years in Philadelphia
where she studied at the Academy of Fine Arts, Mary
Cassatt settled in Paris in the 1870s. As an admirer and then
a close friend of Degas, she joined the Impressionist school
and soon won acclaim from her French associates. Despite
her fame, a local Philadelphia newspaper insisted on identi-
fying her as the sister of Alexander J. Cassatt, president of
the Pennsylvania Railroad. Whatever doubts she may have
inspired in Philadelphians, she fared much better with
Bertha Palmer, who avidly began collecting the works of
Impressionists on Cassatt's advice. Rather few Americans
had been exposed to, or had allowed themselves to appreci-
ate, Impressionist art in the years before the Columbian
Exposition. Thanks to the efforts of Bertha Palmer, who lent
her collection to the exposition, this began to change. With-
out traveling abroad Americans could now experience first-
hand the talents of Degas, Monet, Renoir, Manet, and
Pissarro along with that of earlier French Barbizon painters
such as Corot, whose works also formed part of Palmer's

collection. (Visitors to the fair seem to have preferred the Barbizon painters to the Impressionists.)

As hosts to a world's fair, Americans were intent on displaying their cultural tastes and achievements. Francis (Frank) D. Millet, who taught at the Art Institute of Chicago and who would later go down with the *Titanic* in 1912, was director of decoration for the exposition. In this capacity he was responsible for adorning its seemingly endless expanses of walls, ceilings, domes, and vaults. Murals particularly demanded his attention. Mural painting had been increasingly in vogue since the late 1870s when John La Farge completed his murals for Boston's Trinity Church and William Morris Hunt, brother to the architect Richard, finished his for the New York state capitol in Albany. (One of Hunt's two panels, "The Barque of the Discoverer," depicted four female allegorical figures pointing Columbus to the New World.) As the American Renaissance flowered, the appeal of this genre increased. McKim, Mead and White's recently completed neoclassical Boston Public Library commissioned murals in the early 1890s from several prominent artists, including Mrs. Jack's friend, John Singer Sargent. The United States government a few years later appropriated funds for murals (and sculptures) to grace the Library of Congress. Some American artists, like La Farge and Sargent, were consummate muralists; others, like Millet and Kenyon Cox, the son of an Ohio governor and grandson of abolitionist Charles Grandison Finney, were also accomplished.

In keeping with the tastes of the American Renaissance, murals and paintings that portrayed classical themes and allegories, told straightforward narratives, or gushed sentiment proliferated at the exposition. Like most of the statuary, these works presented traditional themes or techniques while avoiding innovation. Most of the famous American

artists of the day were represented. In addition to those by the expatriates Cassatt, Sargent, and James McNeil Whistler, among the approximately one thousand works of American artists that the exposition chose to mount were entries by Thomas Eakins, Winslow Homer, George Inness, William Merritt Chase, Abbott Thayer, Elihu Vedder, Childe Hassam, Alden Weir, John Twachtman, and Edwin Blanshfield. Prominent American illustrators also fared well, as Millet and his colleagues included works by such artists as Charles Dana Gibson, Frederic Remington, Howard Pyle, and Charles Pennell. Despite the predominance of American Renaissance tastes, the selections manifested diversity, genuine talent, and a desire to inculcate high culture. To what extent visitors to the fair appreciated this "high culture" is debatable. At least one art historian has claimed that the single most popular painting at the fair was the mawkish *Breaking Home Ties* by the little-known Thomas Hovenden, a gifted teacher who taught, among others, Robert Henri. According to another source, the most popular work was a fifteenth-century Spanish rendering of flagellants, whose "appeal no doubt involved titillation as much as spiritual aspiration."

The tension between high and popular culture that characterized the visual arts of the Columbian Exposition also stamped its music. Once again the serious competed with the light to define, distinguish, and dictate cultural tastes.

No one better personified or shaped the contours of serious music in the United States during the last half of the nineteenth century than did Theodore Thomas (1835–1905). Born in Germany, the son of an obscure musician, he immigrated with his large and penniless family to the United States as a child. When family fortunes failed to improve, young Thomas took to the streets with his violin

and occasionally played for social events. While still in his teens he toured the South and offered solo performances. His financial lot improved soon afterward. He became a member of the New York Philharmonic in 1854, and eight years later he organized his own orchestra. Around this time, claims music historian John Tasker Howard, Thomas arrived at some fundamental conclusions which gave new dimensions to symphony orchestras: (1) Conductors must assume firm authority over orchestra members. (2) In order to maintain standards, members must dedicate themselves to the orchestra and refrain from what we today would call "moonlighting." (3) To make this financially feasible—orchestras typically functioned on a part-time basis—tours would be necessary. Over the next three decades or so, as conductor of the New York Philharmonic (a position he accepted in 1877), organizer of the music at the Philadelphia Centennial, guest conductor, and frequent adviser to others in the music world, Thomas worked unstintingly to elevate standards for musicians and the tastes of the concertgoing public. Judiciously mixing light with serious compositions, he made audiences more respectful of serious music—although, as Howard notes, the philistines still complained that they preferred *Yankee Doodle* to the complex, attention-demanding works of the controversial Richard Wagner.*

In 1891 Chicago made Thomas an offer that he chose not to refuse. The city's business leaders wanted a first-rate symphony orchestra and promised to make up any deficits that such an organization might incur. Thomas had earlier

*Somewhat earlier Swedish singer Jenny Lind and Norwegian violinist Ole Bull, celebrated visiting artists, had to entertain their American audiences with versions of *Yankee Doodle*. And at the gala opening of the Chicago Auditorium in 1891 Adelina Patti, hailed by some as "queen of the opera," temporarily forswore bel canto arias for *Home Sweet Home*. Thomas, incidentally, informed Patti during a rehearsal, "Here *I* am prima donna."

risked his own resources on music projects and had nearly gone bankrupt as a result. He was also annoyed by the wrangling between his New York Philharmonic and the New York Symphony Society, conducted by his bitter, also German-born rival, Leopold Damrosch; as a consequence he turned down a similar financial offer from New Yorkers. Engaged to lead the Chicago Orchestra, a position he would enjoy until shortly before his death, Thomas noted gleefully, "I would go to hell if they would give me a permanent orchestra." He also agreed to become director of music for the Columbian Exposition. As with all his musical ventures, Thomas took his engagement with the exposition quite seriously. During the fair he provided music for the enjoyment of both visitors and workers; for the dedication and opening days he assembled, rehearsed, and conducted enormous orchestras which at times performed with even larger choruses.

Harriet Monroe reminisced that "... music was to have a grand summer under Theodore Thomas...." In addition to the local orchestras and choral groups that performed on dedication and opening days, the German-born conductor and musical educator issued invitations to other American and European orchestras and choral ensembles, as well as to individual soloists. Among those that accepted were the Boston Symphony Orchestra, which had seventy musicians under contract by 1890, and the New York Symphony Orchestra, under conductor Walter Damrosch, who had succeeded to that position upon the death of his father in 1855. Antonin Dvořák, then sojourning in the United States, was also on hand.

Despite his predilection for European, especially German, composers, Thomas persistently encouraged American composers and agreed to perform their works if he found them acceptable. In addition to John K. Paine's *Columbia March*,

Thomas conducted Harriet Monroe's *Columbian Ode*, which had been set to music by Paine's fellow New Englander George W. Chadwick, and the *Festival Jubilate* by Mrs. H. H. A. Beach, another New Englander and America's most respected female composer of the nineteenth century. These recognized composers of the past are virtually unknown today. Other notable American composers of classical music during the nineteenth century—Louis Moreau Gottschalk, Edward MacDowell, Charles Tomlinson Griffes—have only barely survived the rigorous test of time, although ambitious musicologists periodically seek to resurrect their lost reputations. That such a fate has befallen these composers can hardly be attributed to any lack of effort on the part of Theodore Thomas.

Years earlier Thomas had learned the wisdom of interspersing serious with lighter musical compositions. Given the unavoidable heterogeneity of the crowds that would be attending the exposition, he again planned to offer them both, but with a modification whose importance would transcend the occasion: they would be separated more distinctly.

The exposition allotted five principal buildings for music in addition to various makeshift structures. These were Charles Atwood's Music Hall for symphony concerts led by Thomas, a Festival Hall for choral works, and three bandstands for daily concerts of more popular fare. The division of labor may have reflected more than expediency or whim. According to the historian Lawrence W. Levine, it represented a growing determination to establish a cultural hierarchy. In his provocative book *Highbrow/Lowbrow: The Emergence of Cultural Hierarchy in America*, Levine argues that music, with other art forms, was undergoing a dramatic transformation at the close of the century. For various reasons, including a repugnance for unruly crowd behavior,

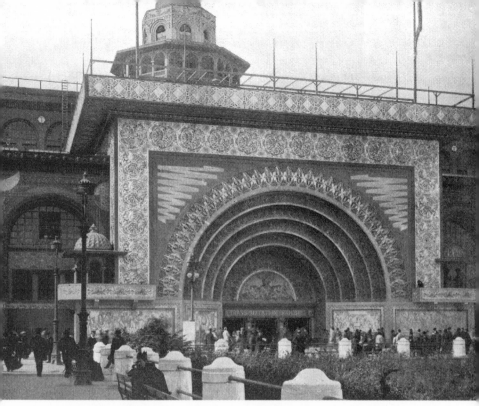

The Transportation Building of Louis H. Sullivan contrasted sharply to the buildings of the Court of Honor. *(Columbian Gallery)*

Most visitors likely reached the exposition via one of the several trains that carried them to the Terminal Station in the background. Note how well dressed the crowd is. *(Columbian Gallery)*

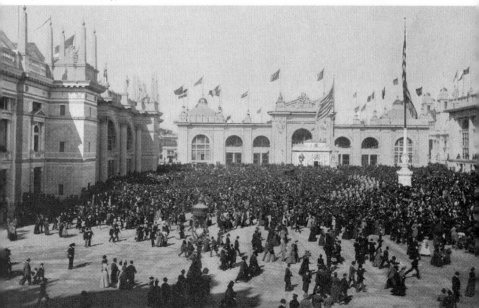

custodians of culture, as well as upper- and middle-class audiences, sought to insulate themselves from the masses. One obvious way to do so was through the pocketbook. Charging high, or at least higher, prices for "serious" performances and admissions to museums would discourage the masses from attending and, as some of them had been prone to do, from talking loudly or harassing performers. In more subtle and complex ways, according to Levine, the arts themselves were becoming more and more the preserve of the "expert," whether performer or critic.

It is worth noting that admission to symphonic concerts in the exposition's Music Hall cost a dollar, a dear price for the working class; admission to performances of more popular music at other sites on the fairgrounds, in contrast, was free. This arrangement no doubt suggests that the upper and middle classes were already more associated with serious music than the lower classes. But it also may reflect the wish to separate the classes and to contain the possibility of rowdy behavior. Thomas, for one, did not suffer an unruly audience lightly. He once requested a noisy New York audience to quit the premises. He also grew intolerant of nonserious music. He noted in *A Musical Autobiography*: "Light music, 'popular' so called...has more or less devil in it."

Whether or not its musical director would have lost his patience with popular music by exposition's end remains speculative, for on August 12 Thomas acceded to the demand of the fair's national commission for his resignation. Two developments touched off this bombshell. The first involved the famous Polish virtuoso pianist and future prime minister of his country, Ignace Jan Paderewski. Intensely romantic in appearance and musical tastes, much like his countryman Frederic Chopin whose music he worshiped, Paderewski was scheduled to perform at the fair on May 2 and May 3. This long-haired matinee idol on both sides of

the Atlantic insisted that he would play only on a Steinway. The exhibitors of musical instruments at the fair protested, insisting that only instruments provided by companies that displayed at the fair should be used—and Steinway & Sons had refused to exhibit their world-famous pianos. (At least one source claims that Steinway so acted because it believed the selection of awards had been rigged.) The national commission agreed with Steinway's rivals; Theodore Thomas, supported by the fair's local commission and Daniel Burnham, sided with Paderewski. "Paddy" performed on a Steinway surreptitiously brought into the concert hall at night, but Thomas paid a dear price for having defended what he deemed artistic integrity. Steinway's rivals, greatly abetted by various newspapers, savagely questioned the conductor's honesty, and the national commission called for the musical director to relinquish his post. Backed by local officials and others, Thomas, who had not committed an illegal or even unethical act, refused to step down.

But the Panic of 1893 did Thomas in. Worried by its impact on attendance and by a possible financial debacle for the fair, local officials cut back on scheduled performances of "serious" music, where attendance was undeniably flagging. Harlow N. Higinbotham, president of the Chicago Company (the local commission of the Columbian Exposition), acknowledged in his official report to the board of directors that these "serious" concerts—unlike the "light" ones, which were free—"were criticized as of a character too severely classical to suit the holiday surroundings and the tastes of people exhausted from sightseeing." Embittered by the verbal abuse he had received and by the cutbacks in his ambitious series of programs, Thomas quit, claiming that his presentation of serious music had been a failure and that the remaining performances at the fair should be for "amusement" only.

On one level, the Paderewski contretemps seems a product of strained egos and misunderstandings. But critics have argued that the affair also underscores the omnipotence of money over art: the Steinway competitors remained indifferent to Paderewski's artistic needs; the exposition's board of directors, so it was rumored, were relieved to be able to cancel the remaining money-losing concerts dedicated to serious music. Whether this is all or partially true, it is impossible to overlook the real achievements of Theodore Thomas, who during somewhat more than three months oversaw the presentation of more than a hundred performances of well-conceived, quality programs by the special symphonic orchestra he had organized. In music no less than in the visual arts, visitors to the exposition were offered more than an idle smattering of serious culture. "Make Culture Hum!" may have sounded more than a bit silly, but it was no empty motto. Neither was another motto, "Not Matter, But Mind," for the World's Columbian Exposition teemed with congresses of individuals determined to reform society, if not the world.

5

A Community of Ideas

> "The time has come," the Walrus said,
> "To talk of many things:
> Of shoes—and ships—and sealing wax—
> Of cabbages and kings—
> And why the sea is boiling hot—
> And whether pigs have wings."

So SAID THE Walrus to the Carpenter in Lewis Carroll's *Through the Looking-Glass*. In all likelihood a number of those who participated in the World's Congress Auxiliary at the Columbian Exposition had read these lines, published some twenty years earlier, and, like the Walrus, they were prepared "to talk of many things." But where Carroll's work had been one of fantasy and satire, that of the World's Congress was in deadly earnest. And while Carroll hoped chiefly to interest and amuse, the Congress sought to edify and instruct.

The prime mover for these gatherings was an idealistic Chicago jurist, Charles Carroll Bonney, whose proposals received a favorable response from the United States Congress and various officials of the exposition. As president of the World's Congress Auxiliary, officially established in 1890, Bonney, along with associates who included the ubiquitous Bertha Honoré Palmer, drew up a statement of intentions

and guidelines for the forthcoming assemblies. Convinced that the exposition needed something beyond the "material triumphs, industrial achievements, and mechanical victories of man," they called for "representatives of all interests, classes, and peoples" to come together in a so-called World's Congress to discuss advances within their fields as well as remaining problems and possible solutions. "Not Matter, But Mind" became the official motto of the leaders of the World's Congress Auxiliary, with the furtherance of peace and prosperity a stated objective. In an effort to insure harmony, they organized the various programs around the formal presentation of papers but ruled out subsequent comments, controversy among speakers, and motions from participants or from the audience.

Fittingly for an undertaking that placed ideals above materialism, the World's Congress convened in the massive Art Institute of Chicago, which contained nearly three dozen halls. (John Wellborn Root had been selected to design the Art Institute; after his death the commission went to the Boston firm of Shipley, Rutan, and Coolidge.) Despite assurances to the contrary, the Art Institute, which was located near the exposition, had not been completed by the time festivities began, nor would it be finished until early July. This delay did not destroy Bonney's plans. The World's Congress convened in the uncompleted building in mid-May and remained there until October 28. During this time nearly four thousand speakers from every American state and almost a hundred foreign nations and their possessions offered more than six thousand presentations. In all there were more than two hundred subdivisions of the Congress's principal concerns, which as spelled out by Bonney included: "Woman's Progress, The Public Press, Medicine and Surgery, Temperance, Moral and Social Reform, Commerce and Finance, Music, Literature, Education, Engineering, Art, Government, Sci-

ence and Philosophy, Social and Economic Science, Labor, Religion, Sunday Rest, Public Health, and Agriculture."

The records of the various congresses are, regrettably, incomplete. Not all the gatherings left behind accounts of their proceedings, and of those that did, some are more complete than others. Nonetheless, it seems fair to infer that these conclaves were successful events attended by some 700,000 spectators, a number of whom judged them the highpoint of the entire World's Fair. The attendance figures suggest the popularity of the congresses, especially since the fair offered so many diverse attractions. Widespread publicity—in newspapers, magazines, and general works of nonfiction—underscores the seriousness with which the congresses were regarded. Impossible as it would be to chronicle all their proceedings, a glance suggests some of the issues that most interested people a century ago, some of which continue to speak to our own age.

The International Congress on Education met for two weeks in July to discuss both the content and methodology of instruction, from kindergartens to the highest levels of American education. Presided over by college and university presidents and featuring distinguished professors in a variety of fields, this congress focused on a pivotal question that divided educators then and now: What constitutes an acceptable college education?

For as long as anyone could remember, a traditional liberal arts curriculum had provided the foundation for American colleges. Then, a generation before the Columbian Exposition, Charles W. Eliot, who was and would continue to serve as president of Harvard University for forty years (1869–1909), revolutionized collegiate education by introducing the elective system. Responding to cries of protest, Eliot insisted he was not trying to destroy the liberal arts but instead was allowing students greater participation

in their own education. Although more and more colleges were adopting the elective system, discussion at the Congress of Education indicated that the issue had not been resolved. Some educators, including the botanist David Starr Jordan, who two years earlier had become the first president of Stanford University, called for the elimination of Greek and Latin as undergraduate requirements. The removal of these touchstones of a liberal arts education would free undergraduates to pursue courses more to their taste and perhaps more "relevant" to contemporary matters. Other educators expressed fears that this change, far from strengthening higher education, would create major problems. Woodrow Wilson, then a professor of jurisprudence and political economy at Princeton University and later its president, argued that a solid liberal arts training was preferable to specialization, which more properly belonged to graduate study.

Some other participants at the congress took the opposing point of view and questioned the whole notion of a liberal arts education. According to Robert H. Thurston, former president of Stevens Institute (New Jersey), the liberal arts might conceivably benefit those with sufficient finances and leisure time, but the middle and lower classes were in no position to take advantage of such a luxury. Thurston advocated vocational and manual training for lower-income students, with cultural matters sparingly introduced. Anticipating criticism, he insisted that his point of view was not antidemocratic, nor would it deprive the lower classes of their opportunity for social mobility. On the contrary, he argued, a manual or vocational education would provide them with more practical and immediate benefits. Thurston's arguments paralleled those of Booker T. Washington, former slave, founder of Tuskegee Institute, and the most influential spokesperson for the educational concerns of

black Americans. But other black educators, notably W. E. B. DuBois, soon challenged this approach, advocating a liberal arts education as the proper course for racial advancement. As for the International Congress on Education, it reached no consensus on the rewards of a liberal arts education versus those that prized specialization and the nonliberal arts. One hundred years later the debate continues.

Similar to the experience of the Congress on Education, the World's Labor Congress reached no agreement on the problems of working people and what could be done to solve or alleviate them. Most participants did agree, however, that something must be done, and quickly. The congress sat for a week beginning in late August, at a time when the economic downturn of 1893 was spreading across the land. Unemployment was growing but had not yet reached alarming proportions. Still, a group of the unemployed had clashed with Chicago police only two days before the Labor Congress opened, leaving some to wonder whether this represented an ominous portent. What would happen if the panic did not abate by the time the exposition closed, especially with so many who had come to work at the fair having no jobs waiting for them elsewhere? What of local Chicago workers? Alarmists began to speak of anarchy and revolution. When Governor John Peter Altgeld, believing that justice had miscarried, pardoned the surviving three anarchists who had been jailed after the Haymarket Riot, fear—and anger—increased. Such feelings had been growing since the violent strike the previous summer at Andrew Carnegie's Homestead steel plant outside Pittsburgh, which claimed thirteen lives and many more injuries.

Advocates for the working class gathered in the Art Institute to air views on the labor question. Denouncing insensitive owners and the increasing concentration of

wealth, they elaborated on the chief problems of the day: low wages and long hours, lack of union recognition, child and female labor, poor working conditions, the lack of social insurance, the growth of slums, the impact of an accelerating immigration from abroad. Some participants proposed modest goals—though modesty is in the eye of the beholder, and many employers of the time saw nothing "modest" in their proposals. London-born Samuel Gompers, who had been elected president of the American Federation of Labor in 1882, and who was to be continuously reelected except for one year until his death in 1924, pressed for the bread-and-butter issues of improved wages, hours, and working conditions. (It was already clear that Gompers's main concern was for skilled workers; he recognized how difficult it was to organize unskilled workers under the circumstances of the time.) The reformer Henry George, still advancing the ideas he had expressed in his famous work *Progress and Poverty* (1879), spoke more obliquely to the concerns of workers by once more advocating a single tax on unused land for the benefit of all—workers, employers, consumers alike—save for those who parasitically withheld land with the speculative aim of driving its price higher through scarcity. By the time of the exposition the single-tax proposal had become a significant reform movement, with believers in the United States and abroad. George himself, running as an independent candidate, had nearly won the race for mayor of New York in 1886, but had been cheated of victory by Tammany Hall.

George's ideas represented a brand of reform capitalism, and so, in a sense, did those of Samuel Gompers, who was asking for a larger portion of, but not the entire, pie. Others at the World's Labor Congress dissented. Socialists of various stripes—Marxian, Fabian, Christian—urged the replacement of capitalism with some form of communal property.

Only through this more radical surgery, they insisted, could workers obtain justice.

The most famous advocate of socialism in the United States at the time of the exposition was Edward Bellamy, a journalist and author from Massachusetts. Bellamy's utopian novel *Looking Backward, 2000–1887* (1888), had become an almost instantaneous bestseller, influencing a generation of reformers in the United States and in foreign countries. Blending Victorian romance, futuristic technology, and visionary economic and social organization, the novel promised relief from capital-labor antagonism in the form of a regimented society that prized cooperation over competition. Egalitarian though it was, Bellamy avoided the term "socialism" and described his visionary community as "nationalist." Nomenclature made a great difference. Middle-class people who would have been horrified to be called socialists, but who also were alarmed by the animosity and strife that plagued capital-labor relations, formed Nationalist clubs in an effort to give substance to Bellamy's dream. Henry Demarest Lloyd, as secretary of the program committee of the World's Labor Congress, invited Bellamy to attend. The severely ailing reformer declined, but a number of his Nationalist followers were present to champion his cause.

Not everyone perceived the condition of the working class as desperate. Paul de Rousiers, a French visitor to the United States just before the exposition, reported that American workers possessed great self-respect and very real hope for social advancement. "The mistakes of one generation," he noted, "have not much influence on the succeeding one. All the young people begin life with the same, or very nearly the same advantages. This," he concluded, "is especially noticeable in the West." The visitor's assessment of the American worker, while not idiosyncratic, reflected a tacit comparison between American laborers and their European counter-

parts. Most Americans would have agreed with it; some, including the young historian Frederick Jackson Turner, also would have agreed with the Frenchman's observations about opportunities in the American West.

Born in rural Wisconsin the year the Civil War broke out, Frederick Jackson Turner later earned both a bachelor's and master's degree from the University of Wisconsin. In 1892 he received his doctorate in history from the Johns Hopkins University, which at the time provided the most advanced historical training in the United States. (A fellow classmate of Turner's was Woodrow Wilson.) The next year Turner accepted a teaching position at his undergraduate alma mater, where he remained until 1910 and helped to create one of the nation's outstanding history departments. Turner then relocated to Harvard, where he continued to teach until his retirement in 1924. At the Columbian Exposition, as a relatively unknown scholar, he spoke before the American Historical Association, one of the smaller groups that met in Chicago as part of the World's Congress. That address, "The Significance of the Frontier in American History," was to become one of the most influential theses in American historiography.

From earliest colonial times to the quadrennial celebration of Columbus's historic voyage, the "West" connoted frontier—a frontier that might have been as east as western New England or the Appalachians. Through almost three centuries of American life this "West" had provided, both as symbol and reality, a place of refuge from the cultural, institutional, and geographical boundaries of the East. As early as 1787 Thomas Jefferson had warned, "When we get piled up upon one another in large cities, as in Europe, we shall become corrupt as in Europe, and go to eating one another as they do there."

Others, both before and after Jefferson, understood the

importance of the frontier. In Turner's lifetime William Graham Sumner, professor of political and social science at Yale University, and Theodore Roosevelt, in his *Winning of the West*, prefigured some of Turner's insights. But it was the Wisconsin-born historian who elaborated the meaning of the frontier more fully than any of his predecessors.

The thesis that Turner propounded at Chicago was remarkably simple, bold, and sweeping in scope. "The existence of an area of free land," he asserted, "its continuous recession, and the advance of American settlement westward, explain American development." Pioneers had continuously encountered the wilderness in their westward trek, and in the struggle to tame that wilderness they themselves emerged changed. Out of the crucible of this almost primeval clash with nature burst forth an American figure markedly different from Europeans as well as from his counterpart in the settled East. Chiding contemporary historians for having overemphasized the Anglo-Saxon genesis of American institutions, Turner argued that "American social development has been continually beginning over again on the frontier." The result was "a new product that is American." The frontier experience had created a renewed sense of nationalism at the expense of localism, much as it had contributed to the emancipation of the nation from cultural subservience to the Old World and to the focusing of politics on such questions as tariffs and internal improvements.

Most important, according to Turner, the frontier experience had promoted democracy through self-reliance and scorn for authority. That experience, he admitted, had also produced drawbacks: "...the democracy born of free land, strong in selfishness and individualism, intolerant of administrative experience and education, and pressing individual liberty beyond its proper bounds, has its dangers as well as its benefits." But as long as "free land" on the frontier

continued to exist, democracy, its fruits more sweet than
bitter, would prosper. But how long would this "free" land
last? Citing the Report of the Superintendent of the Census
for 1890, Turner began his address by noting, "Up to and
including 1880 the country had a frontier settlement, but at
present the unsettled area has been so broken into by
isolated bodies of settlement that there can hardly be said to
be a frontier line." He concluded: "And now, four centuries
from the discovery of America...the frontier has gone, and
with its going has closed the first period of American
history."

As both teacher and author, Turner went on to develop
these ideas first presented at the Columbian Exposition.
Generations of his students, as well as other historians,
intrigued by the force of his thesis, continued his labors.
Some found evidence to support his assertions. Others were
less certain, clinging to a belief in the Anglo-Saxon origins
of American democracy or pointing to the questionable
"democracy" of a frontier that could produce vigilantism
and anti-intellectualism. While Turner had stressed the fron-
tier as a safety valve for the discontented of settled towns
and cities, some doubted whether these people had sufficient
funds or the will to uproot and transplant themselves. Still
others criticized Turner for stressing the uniqueness of the
American frontier experience; they called for and sometimes
offered comparative studies of frontier developments else-
where. Some complained that Turner had largely neglected
the effects of the frontier on French and Spanish settlers in
the New World. Others chafed at what they considered
Turner's emphasis on the frontier to the virtual exclusion of
other formidable forces that had helped to shape the con-
tours of the nation's history. One of the chief challenges to
the Turner thesis has come from those who argue that the
institutions and practices of settled areas were *not* undemo-

cratic; indeed, settlers on the frontier sought to replicate much of what they had already encountered.

Turner's critics have also pointed out that while the frontier was "closed" as of the Census of 1890, a great deal of land remained available for settlement. Furthermore, much of what passed for "urban," according to that census— habitations of 2,500 or more—scarcely differed from rural habitations. Of the 1,348 locales classified as "urban terri- tory" in 1890, almost 50 percent had populations from 2,500 to 5,000; and fewer than 10 percent of these places had populations that exceeded 25,000. Urbanization was gaining rapid momentum by the 1890s, but much of the United States—physically, culturally, psychologically—remained ru- ral, caught somewhere between the polar extremes of wil- derness and metropolis.

How gratifying was frontier life in contrast to urban life? Americans already were learning about the perils and disad- vantages of urban existence by the 1890s. But the warm, nostalgic glow of the pastoral life was in fact largely mythi- cal. Far from settling into an idyllic habitat, adults on the frontier in the nineteenth century were likely to move four or five times on the average. By neglecting the negative aspects of nonurban life, the frontier myth shortchanged urban life by stressing its weaknesses at the expense of its strengths. The Norwegian-born novelist Ole Rölvaag, for example, captured the starkness of frontier life during the late nineteenth century in *Giants in the Earth* (1927). The novel told of hard work, isolation, madness, death. Published nearly a half-century later, Michael Lesy's *Wisconsin Death Trip* (1973) depicted in words and grim photographs the real-life tragedies of several rural Midwestern counties at the turn of the century. More recently the historian William Cronon has posed yet another challenge to the Turner thesis: While Turner interpreted the growth of Western towns as

heralding the end of the frontier, Cronon, in his *Nature's Metropolis* (1991), reformulates the frontier as a stepping-stone to a higher goal to which settlers aspired, the creation of new towns and cities from the wilderness. And Chicago, through much of the nineteenth century, stood as the finest expression of that goal.

The Columbian Exposition reflected the mixed emotions of Americans about the wilderness and urban life as well as their desire to make the best of both worlds. Wherever visitors went they could see evidence of attempts to preserve and harmonize the natural and the artificial. According to the historian Justus Doenecke, "One could seldom walk from one exhibit to another without contact with either woods or water. Around each palace of industry was a carpetlike turf of grass." Rural themes blended with manu-factured goods in building after building, suggesting that the nation had not yet made up its mind whether it was urban or rural, industrial or agricultural. The Manufactures Build-ing might house commercial machines and artifacts, but outside its entrance stood statues of a farmer and a draft horse, suggesting, in Doenecke's fitting phrase, the "pastoral-ization of technology."

The conscious concerns of Frederick Jackson Turner for the disappearance of the frontier, and the less conscious attempts of fair officials to integrate agriculture with indus-try, mirrored a more widespread anxiety and nostalgia for a vanishing America. As early as the 1850s Frederick Law Olmsted had grasped the powerful need of urbanites for nature and had made a career of designing landscapes to ameliorate the harshness of urban life while preserving its advantages. Those who found this compromise unsatisfac-tory could supposedly depart for greener pastures. But by the end of the nineteenth century what had once seemed an endless cornucopia of virgin land had become finite, presag-

ing an end to a dream that had nourished settlers for almost three centuries.

In perhaps a subconscious attempt to capture the passing of the frontier, Americans embraced popular and artistic expressions of its vanishing realities. Buffalo Bill's Wild West Show offered excitement, nostalgia, and various thrills. Frederic Remington would soon win acclaim for his paintings and statues of Western themes, as would Owen Wister, a patrician Philadelphian whose *The Virginian* (1902) served as a prototype for cowboy stories.

Conservationists meanwhile endeavored to preserve what remained of the country's natural heritage. Scottish-born John Muir, the first president of the Sierra Club and the most notable conservationist in the nation's history, had begun his legendary struggle to create national parks and to arouse the public against further encroachments on land and wildlife. Young urbanites who were soon to distinguish themselves in public life—Theodore Roosevelt, Henry Cabot Lodge, Elihu Root—had organized a Boone and Crockett Club in 1888 in order to experience the wilderness before it passed into history. Even Congress, which had contributed to the spoliation of natural life in the West after the Civil War, had become alarmed and began to set aside reserves of land for the public domain. Now, in Chicago, Fredrick Jackson Turner added his voice to the increasing chorus that lamented the passing of the frontier. Acknowledging receipt of Turner's Columbian Exposition address a few months after its delivery, Theodore Roosevelt, the greatest of the future conservation-minded American presidents, praised the historian for having "put into definite shape a good deal of thought which has been floating around rather loosely." Conservation had not yet taken the form of the quasi religion it would assume a century later, nor should it be

mistaken for the ecology movement of today. But it clearly had inspired a number of apostles.

The Columbian Exposition itself had no need of ersatz religions. Its World Parliament of Religions proved the most popular of all divisions of the Congress. A committee of local Chicago church figures had organized the appropriate convocation. Led by John Henry Barrows, a Presbyterian minister, the committee drew up an ambitious program in which more than forty denominations held individual conclaves from late August to mid-October. Virtually all major and many minor denominations, with the exception of the Mormons, received and accepted invitations, though the Baptists later withdrew as a result of the dispute over whether the exposition should remain open on Sundays.

The World's Parliament of Religions, which met for more than two weeks in September, highlighted the program. Ecumenical in the extreme, the parliament featured not only Protestants, Catholics, and Jews but also non-Western faiths that included Moslems, Hindus, Buddhists, Confucianists, and Shintoists. Accentuating the spirit of toleration, James Cardinal Gibbons, the leading Catholic prelate in a predominantly Protestant United States, led the opening-day assemblage in a recital of the Lord's Prayer and joined others— Christians and non-Christians alike—in speeches of welcome. To be sure, not everyone accepted ecumenicism. The Archbishop of Canterbury declined to attend the parliament, flatly denying that all religions were equal; others agreed with him, expressing their own sectarian fears. One conservative Catholic bishop decried participation with "every pretense of religious denomination from Mohammedanism and Buddhism down to the lowest form of evangelicalism and infidelity." Still others, a Buddhist monk from Japan among them, seemed overwhelmed by the presence of so many diverse religions and sects gathered together. The

puzzled Japanese visitor asked if they could not be reduced to a single religion since truth was singular?

Misgivings notwithstanding, the parliament proceeded with extraordinary harmony. Organizers had stipulated that its purpose was neither to proselytize nor to engage in theological disputation, but rather to extol religion in general and to discuss the problems it encountered in the secular world. Here too the parliament practiced as well as preached tolerance. Evolution, a particular nemesis, was discussed with the parliament's consent if not exactly its blessings. Invited but unable to attend were the British Darwinists Thomas Huxley and Herbert Spencer. Huxley, who was especially anathema to antievolutionists, had his paper read to the parliament.

Probably more discussed than Darwinism at the time of the exposition was the role of religion in socioeconomic matters. This question especially but not exclusively concerned Social Gospelers, those American Protestants who sought to apply the principles of Christianity to such social issues as urban problems and the continuing antagonism between capital and labor. A number of lay persons and religious figures, including Richard Ely, professor of economics at the University of Wisconsin, and the well-known crusading ministers Lyman Abbott and Washington Gladden, addressed the parliament and its various subdivisions on these issues. Some of the speakers, reflecting the more conservative wing of the Social Gospel movement, urged little more than the application of the golden rule to human conduct. Others, less impressed with the possibilities of moral suasion, pressed for more radical measures to reform society or to reconstruct it altogether. Some of these speakers were avowed socialists, though of the Christian rather than the Marxian variety. As one of them assured his audience, "Christ ... was the great socialist...." Many Social Gospelers

shied away from socialist solutions in favor of what they considered more practical reforms to achieve day-to-day goals. This was similar to the path pursued by the settlement houses, where, for all their secularism, religious overtones abounded.*

Most Protestants, however, were not active Social Gospelers. Fueled by more traditional concerns for individual sin and redemption, such believers sought the comforts of "the Old-Fashioned Gospel" as preached by, among others, Chicago's Dwight L. Moody and his popular vocalist, the hymn writer Ira M. Sankey. Already the most famous revivalist in the nation, Moody solemnly asked those he met, "Are you a Christian?" and devoted himself to spreading the Gospel through countless meetings and the Bible Institute which he established in the same year that Jane Addams and Ellen Gates Starr organized Hull House. The salvation of the individual soul, rather than that of society, remained Moody's paramount concern, even as he preached to throngs of people who had come to Chicago for the exposition.

What most impressed observers at the exposition were the fervor and regular attendance at parliament and subdivision meetings. For the French writer Paul Bourget, this enthusiasm attested to a belief in the power of religion in human affairs. An Anglican priest was more ebullient. Formally thanking his American hosts for the hospitality accorded foreign visitors, he extolled the World's Parliament of Reli-

*Quaker-bred Jane Addams had been baptized a Presbyterian the year before she cofounded Hull House with Ellen Gates Starr, whose religious odyssey took her from Unitarianism to Episcopalianism and finally to Roman Catholicism. To understand the vitality of the religious impulse that propelled the settlement house movement, it is necessary only to note that in the quarter-century before World War I more than two-thirds of all settlement workers sprang from families in which there was one or more ministers, and that one-third of these workers themselves had contemplated entering the ministry.

gions as "the greatest event so far in the history of the world...." Daniel Burnham was no less effusive: he predicted that history would speak of the parliament a millennium hence.

It is doubtful whether many would have agreed with Burnham's optimistic prediction, still fewer with the assertion of another observer that the gathering represented the most memorable occurrence in history. Yet few would have denied the event's importance. At a time when the secular values of what one historian has called a "generation of materialism" seemed to be eroding spiritual worth, those concerned about religion had rallied and found solace in one another's company. "Not Men, But Ideas. Not Matter, But Mind" had proved an apt motto. And if the idealism expressed seemed hopelessly divorced from reality for some, probably most of the seven thousand who gathered in the rooms of the Art Institute for closing ceremonies did not concur. At the closing of the World's Congress Auxiliary nearly a month later, Charles C. Bonney praised the efforts of all the groups. As for the World's Parliament of Religions, he concluded, it had liberated the world "from bigotry, and henceforth civil and religious liberty will have a larger and easier sway." Not all groups could agree.

6

For Some, a Harder Struggle

EIGHTEEN NINETY-THREE was an historic year for women: New Zealand became the first country to grant them suffrage. With the adoption of the Nineteenth Amendment twenty-seven years later, the United States became the sixteenth country to do so. Despite its patent tardiness in extending the suffrage, the United States had enjoyed—at least among most of its males—a reputation for treating women liberally. The visiting Paul de Rousiers was astounded by what he observed. Due to the "decency of American manners," both sexes lived "on terms of intimacy without any bad results." Unchaperoned arrangements for young single women in France, in contrast, would have been "disastrous." Unlike the widespread custom in France and elsewhere, American mores sanctioned marriages for love rather than arranging them. Once wed, the American wife became a "queen" who enjoyed "a very dignified position in a household," with each spouse respecting the other's ways. Should the marriage prove unhappy, noted the bemused Frenchman, divorce was relatively easy to obtain, unlike the situation in England and on the Continent. He added, however, that "a divorced woman is not received in certain circles, even in Chicago." A more famous visitor, Lord James Bryce of England, agreed with the invidious distinc-

tion between the condition of women in the United States and those in Europe. For American women, according to this author of *The American Commonwealth*, "it is easier... to obtain work of an intellectual or commercial kind...."

The observations of these two foreign visitors were essentially correct, as far as they went. American women, by and large, did fare better than their European sisters, not to speak of women in non-Western countries. But in terms of socioeconomic and civil rights they had not achieved equality with men of their own society, and their limited progress in these areas came only after exhaustive struggle and widespread resentment. According to the Census of 1890, women accounted for less than 2 percent of the clergy, dentists, bankers, and brokers in the United States, less than 5 percent of the physicians, surgeons, and journalists, and less than .03 percent of the lawyers and engineers. Women differed among themselves as to what rights they did or did not want. Class, race, and ethnicity all played a role in this, as did individual inclination. Differences among women unavoidably obstructed consensus and the achievement of goals. Progress is rarely linear in any case, and the women's movement proved no exception, its advances coming in fits and starts.

The period between 1890 and 1920 was to constitute one of the most successful chapters in women's uneven history: suffrage would be gained; some social, economic, and legal inequalities would be redressed; consciousness, to use a more contemporary phrase, would be raised. Injustices and frustrations, fundamental differences over goals, pervasive male opposition, insensitivity, or indifference would remain. The World's Columbian Exposition provided women with both a focal point and forum for gauging how far they had advanced and how much further they might go. It also afforded an exemplary view of the achievements of American women.

Reform-minded women had attended the previous two American world's fairs. Although not invited to participate in official proceedings, the early heroines of the women's movement—Susan B. Anthony, Lucretia Mott, Lucy Stone, and others—had braved ridicule at the 1853 world's fair in New York to plead their diverse causes, which included abolition and temperance as well as equal rights for their gender. Women fared better but not all that well at the Philadelphia Centennial.

As it debated plans for celebrating Columbus's discovery of the New World, Congress initially found little need to include women. Seethed Isabella Beecher Hooker:

> I have never been so moved in my life. The Philadelphia Centennial, the neglect and insult of it, sank deep into my soul, but this one stirs me to the very depths. A male oligarchy has called itself a republic for a hundred years, and during forty of them good men and women have patiently protested against the misnomer and asked for justice.

Other feminists were likewise determined to resist exclusion. Anthony gathered a petition bearing the names of more than a hundred prominent women who voiced their desire to become part of the planning commission. When it voted to establish a national commission to prepare for the Chicago celebration, Congress did allow it to name a board of lady managers. Few anticipated that this board (which ultimately consisted of 115 women from the various states and territories, including Isabella Beecher Hooker), with no specific powers to wield or duties to perform, would do more than soothe enflamed feminist tempers. Congress was wrong.

The successful participation of women at the Columbian Exposition derived from the efforts of many, both the well known and the obscure. In addition to Elizabeth Cady

Stanton's behind-the-scenes efforts, there were the impressive labors of May Wright Sewall, a noted educator, president of the National Women's Suffrage Association (1882–1890), and chair of the World's Congress of Representative Women. Yet one individual stood out most prominently: Bertha Honoré Palmer, whom the members of the board of lady managers chose as their president.

As the final decade of the century unfolded, "Cissie" Palmer seemingly had reached the pinnacle of success. The reigning queen of Chicago society, the wife of a multimillionaire, the owner of an impressive mansion and serious art collection, a relation (through her sister's marriage) to Ulysses S. Grant and his family, the mother of two loving sons (Honoré and Potter), the possessor of rich velvet gowns and furs and costly jewels (purchased largely by her husband at the Paris branch of Tiffany's), she had already counted more blessings in her two score years than most would in a lifetime. But Bertha Palmer was no frivolous grande dame. On the contrary, she prided herself on her civic-mindedness and sense of noblesse oblige. As early as 1874 she had delivered a paper, "The Obligations of Wealth," to the Fortnightly, the first literary club for women in Chicago.

While it is currently fashionable to denigrate the achievements of those with great wealth during the late nineteenth century and to focus on the problem-filled lives of the less fortunate, it is nonetheless true that Bertha Palmer and not a few of her high-society female friends were genuinely concerned for others. In 1876, the year of the Centennial, the Chicago Women's Club was organized. Thanks in no small measure to its involvement with social problems, the club, which met at the original Art Institute, increased its enrollment from an initial 21 to 566 by the eve of the exposition. Joining its upper-class members over the years were middle-class lawyers, journalists, and reformers such as Jane

Addams and Frances E. Willard. By 1893 the Women's Club also counted among its members some two hundred physicians and surgeons, thus lending credence to Lord Bryce's observation about women and the professions. To say, however, that the club was "feminist"—a term that came into common usage in the United States in the early twentieth century—would misstate the case. All members had a concern for the "woman's question," but they defined that question differently, urged varying tactics, and brought uneven enthusiasm to matters at hand.

The feminism of Bertha Palmer illustrates the ambiguity of the women's movement in the United States during the late nineteenth century. On the one hand she championed education and an improved economic status for women. She was an early fighter for "equal pay for equal work," an issue that remains unresolved to this day. She interested herself especially in the condition of working women, holding receptions for them in her home and lectures for upper- and middle-class friends which presented and analyzed the plight of female workers. She aided Addams and Starr in their work at Hull House; she backed the Women's Alliance in its war against sweatshops. (Later she broke with Addams who, while no friend to anarchism, had dealings with anarchists.) She also enthusiastically endorsed temperance, like so many other female reformers of the time, despite the profitable trafficking in wine and liquor at the Palmer House hotel. On the other hand, Bertha Palmer was lukewarm toward woman's suffrage and was adamantly opposed to women cutting their hair short or wearing apparel such as bloomers, a garment associated with radical feminism.

Whether or not they subscribed to her points of view, the 115 women who comprised the board of lady managers had no great difficulty in selecting Bertha Palmer as their president when they convened in late 1890 at Kinsley's Restau-

rant on Adams Street. (They rejected the term "chairman" because of its masculine connotation.) At this same meeting they agreed to take a more active part in the exposition than Congress had anticipated. They further resolved that exhibits by women should compete at all levels.

In the months before the exposition opened its doors, Bertha Palmer worked to insure the successful participation of women. She induced her husband to donate $200,000 for a separate Woman's Building that would house women's exhibits and provide offices and meeting halls. She also helped to obtain more funds from Congress and more space from exposition officials for the building. And she successfully insisted that the architect of the Woman's Building be female. After a nationwide competition, Sophia G. Hayden, the first female graduate of the four-year architecture course at the Massachusetts Institute of Technology, itself the first school of architecture in the country, became the first woman to design a major building in the United States.

Pathbreaking as was the selection of a female architect, Sophia Hayden's design was traditional: a two-story edifice in the Italian Renaissance style. Situated at the point where the Court of Honor met the Midway Plaisance, the building blended well with the neoclassicism that pervaded the fair and drew accolades from no less an authority than Richard Morris Hunt. Various adornments drew attention to the historic contributions of women. The Hall of Honor inscribed the names of three illustrious queens—Isabella, Elizabeth, and Victoria—and contained busts of the current feminist champions Susan B. Anthony and Elizabeth Cady Stanton. Sculptures and paintings graced the interior. Famed actress Sarah Bernhardt created a bas-relief of Ophelia. Bertha Palmer traveled to Paris to commission her friend Mary Cassatt and Mary Fairfield MacMonnies, wife of the American sculptor, to provide large murals that, when

completed, were respectively called "Modern Woman" and "The Primitive Woman." American female artists ultimately painted twenty-five panels. Palmer also persuaded Queen Margherita of Italy to contribute precious laces to the exposition. Even the official motto of the Woman's Building echoed the determination to dramatize what women were capable of achieving: *Juncti valemus* ("United we prevail").

In addition to exhibiting women's arts and crafts, the board of lady managers was determined not to neglect women in their domestic roles as wives and mothers. Installed in the Woman's Building was a model kitchen. Equipped with the novelties of ceramic tile flooring and a gas cooking range, it provided the setting for dietitians to demonstrate nutritious meals. A Children's Building adjoined the Woman's Building. With its nurseries and gymnasium, this precursor of day-care centers allowed adults to leave their children behind while they toured the fairgrounds. More than a depository, it also provided a variety of instruction in child rearing, in physical and manual training, and in teaching the deaf.

Bertha Palmer dedicated the Woman's Building on opening day, May 1, 1893. Speaking before a large audience and a dais filled with dignitaries who included the Duchess of Veragua, Mrs. John Peter Altgeld, and Mrs. Walter Q. Gresham, the wife of President Cleveland's secretary of state, the tall, attractive, prematurely grey president of the board of lady managers diplomatically combined a call for change with a plea for the preservation of accepted norms and beliefs. "Social and industrial questions are paramount," she insisted. Inventions had reduced the cost of goods "but have not afforded the relief to the masses that was expected. The struggle for bread is as fierce as of old." For some, life "scarcely seems worth living. It is a grave reproach to modern enlightenment," she hectored, "that we seem no

nearer the solution of many of these problems than during feudal days." Just as it seemed this bastion of proper society might go on to advocate some form of socialism, she veered away, protesting that "it is not our province...to discuss these weighty questions except in so far as they affect the compensation paid to wage earners, and more especially that paid to women and children." Speaking for the board of lady managers, Palmer assured her listeners that "in our opinion, every woman who is presiding over a happy home is fulfilling her highest and truest function...." This was the ideal; but reality, she confessed, obliged many women to work, and in this regard they met with strong resistance from "idealists" who wished to protect them by keeping them at home, and from those with a more selfish motive, namely, a reluctance to have them compete with men for employment.

Bertha Palmer's solution was a masterpiece of verbal jugglery. Only education and training, she insisted, could equip the American woman "to meet whatever fate life may bring, not only to prepare her for the factory and workshop, for the professions and arts, but, more important than all else, to prepare her for presiding over the house." Concluding her speech, she dedicated the Woman's Building to "an elevated womanhood, knowing that by so doing we shall best serve the cause of humanity." The lady managers rose and saluted their leader, though for women's rights advocates—some then and many more now—her proposals were far too mild, her words too conciliatory. Yet this moderation honestly expressed her views. By refusing to countenance the status quo, she also set the tone for the week-long World's Congress of Representative Women that opened May 15.

More than 500 delegates representing 27 nations and 126 separate organizations attended the congress, presided over by May Wright Sewall. In addition, a crowd estimated at

150,000 was present during Women's Week, exploring the building and its exhibits and listening to more than 300 presentations. No more than 10 percent of the speakers were suffragists, estimates one historian of the fair, but the most noted suffragists—Anthony, Stanton, Anna Howard Shaw, and Lucy Stone—spoke to large, appreciative audiences on all sorts of pertinent topics: suffrage, temperance, prostitution, education, dress, religion, the arts. A number of foreign women also addressed the congress, but since most spoke in their native tongues, Americans in the audience satisfied themselves by ridiculing those speakers' European-styled dresses. More attention and respect were paid to black women such as Fannie Barrier Williams and Ida B. Wells, who spoke movingly of the conditions of black American women.

Bertha Palmer had the final official words at the World's Congress of Representative Women. She stressed how the congress had avoided "theory" and "Utopian ideals" in favor of presenting the hard facts of the woman's question. She acknowledged that neither radicals nor traditionalists had approved this approach, but, at the very least, women from throughout the world had discussed their mutual and individual problems. The ties of sisterhood had been bound more tightly, at least for the time being.

No one can measure with precision the effects of the World's Congress of Representative Women on the woman's movement in the United States. For some it seemed largely an oratorical exercise in futility, with a patriarchal society turning a deaf ear to legitimate protest for years to come. But for others the congress, the papers presented by women elsewhere throughout the fair, the Woman's Building with its art and artifacts, the exchange of ideas with those of different ethnicity and cultural backgrounds—all contributed, however imprecisely, to furthering the women's cause.

"The triumph of women," observed Alice Freeman Palmer, former president of Wellesley College and dean of the women's department of the University of Chicago at the time of the exposition, "has been unexpectedly great." This member of the board of lady managers prophesied that future world's fairs would not insult women by calling for their special treatment but would regard them simply as "human beings." The Chicago World's Fair, she insisted, had demonstrated the independent power of women, broadened their appreciation for beauty, heightened their sense of nationalism, and helped them to become better professional workers—and homemakers. Given the moderation of her views, it seems safe to infer that Alice Freeman Palmer would have agreed with Bertha Honoré Palmer (no relation), who confessed, "Our utmost hope is, that woman may become a more congenial companion and fit partner for her illustrious mate, whose destiny she has shared during the centuries." (Freeman had resigned the presidency of Wellesley College in 1887 in order to marry George Herbert Palmer, a professor of philosophy at Harvard University.)

Jeanne Marie Weimann has noted in *The Fair Women* that it was these "new women" of the 1890s—the two Palmers, the board of lady managers, the Chicago Women's Club—"who became leaders of society because of their money, their family connections, their intelligence, their energy and their appeal to the press [and who] could not be shrugged off as 'suffrage women'... organized, hosted, and dominated women's proceedings at the Columbian Exposition. More maternalistically sympathetic than democratically inclined with respect to the lower classes, they infused a new vigor and sense of responsibility into reform, woman's and otherwise." They had achieved at the very least, according to Lois W. Banner, "a brilliant publicity stroke."

* * *

If women generally took heart as a result of their participation in the fair, black American women did not. They played only a marginal role despite their efforts to do more. This mirrored the situation of blacks in American society at large. Freed from the fetters of bondage, few had gained equality. Most had continued to live in the South, where they were soon to confront disfranchisement and segregation, and where already they were being lynched at a frightening rate.

Outside the South blacks faced less violence but considerable antagonism, widespread indifference, and only a limited welcome. Their experience in Chicago was not atypical. The first blacks to settle in Chicago in appreciable numbers were fugitive slaves during the 1840s. Totaling almost a thousand by the time of the Civil War, they met with segregation in schools, transportation, and public accommodations. Conditions improved in the quarter-century that followed the war. Blacks received the franchise in 1870; legal segregation in schools ended in 1874. But most blacks continued to live on the city's largely segregated South Side during these years and to work as domestics or in lower-paid services. After the precipitous decline of the Knights of Labor, which had enrolled them in significant numbers, unions offered blacks a cool reception. Philanthropists and reformers like Jane Addams and her associates at Hull House tried to help blacks improve their status and conditions, but they faced formidable obstacles.

As the plight of blacks worsened in the South, they drifted northward in growing numbers. Chicago's black population of little more than six thousand in 1890 increased fivefold during the ensuing decade. The increase caused the city's white population more anxiety, though blacks continued to form only a very small portion of the entire community. This anxiety further hindered the advancement of

blacks and helped to transform their neighborhoods into ghettos.

Some black visitors referred to the Columbian Exposition as "the white American's World's Fair." The description overstated the case. As paying customers, blacks were welcome to eat in the fair's restaurants and to enjoy its admission-free exhibits. At least one state, Michigan, proudly included black participants in celebrating its special "state days." Frederick Douglass, who had lived in Detroit during the 1850s, spoke during Michigan Days (September 13–14) as did an eighty-five-year-old black woman who had served as an underground railroad agent during the antebellum years. Yet the basis for black disappointment and anger was real enough. President Harrison at first refused requests to appoint blacks to the national commission for the exposition, a body that included more than two hundred members; so did the director-general of the commission. Bertha Palmer likewise turned down appeals to name black women to the board of lady managers on grounds that only representatives from a national organization were eligible to serve. (This was a contributing factor to the establishment of a national organization of black women's clubs in Boston in 1895.) Palmer did appoint a Secretary of Colored Interests, but the woman, with a desk inside Mrs. Palmer's office, had little authority. Having failed to secure noteworthy appointments to various official bodies, blacks were relegated to seeking menial employment.

The subject matter of exhibits also proved galling. Blacks could view those from Haiti and Liberia but were chagrined at the paucity of entries by black Americans. Hampton Institute and a few other colleges that were entirely or predominantly black mounted exhibits. The New York and Pennsylvania state exhibits housed black needlework and drawings, and the Woman's Building displayed cotton gar-

ments handcrafted by Southern black women. For the most part, however, black achievements were minimized. As one black visitor noted, those achievements had been "buried so deep that Gabriel's trump [sic] could not waken them." Disturbed by what they saw as insufficient representation, blacks debated the wisdom of a separate display. But the exposition's board of directors ordered blacks to integrate their exhibits within those of the various states, each of which had an ultimate authority of selection. Given the deteriorating situation in the Southern states, where most of them lived, this decision did little to inspire confidence among blacks and further divided the integrationists and separatists. The integrationists had their way. Explained the black commissioner belatedly named by President Harrison as an alternate to the national commission: "We wish...to be measured by the universal yardstick, and if we fall short the world knows why."

Underrepresented though they may have been in the exhibits, blacks did not lack for spokespersons who could articulate their anger and concerns. Fannie Barrier Williams was one. Born in 1855 to the only but much respected black family in Brockport, New York (outside Rochester), she moved during the 1880s to Chicago where she organized the first training school for black nurses. Prominent as a lecturer, writer, and organizer, she spoke to both the World's Congress of Representative Women and the World's Parliament of Religions. Before the women's audience she blamed slavery for "every moral imperfection that mars the character of the colored American." "It is a great wonder," she concluded, "that two centuries of such demoralization did not work a complete extinction of all moral instincts." Weeks later she flatly informed her audience at the Parliament of Religions that "no class of American citizens has had so little religion and so much vitiating nonsense preached to them."

The maltreatment of her race, she insisted, demanded more Christian love and less theological exegesis.

Ida B. Wells was no less determined than Fannie Barrier Williams to denounce injustice. Born to slave parents in Mississippi in the midst of the Civil War, she endured a painful childhood during which both parents and three siblings died, leaving her as a teenager to rear four younger brothers and sisters. After teaching several years she moved to Memphis where she briefly taught and wrote journalism. When she was fired as a teacher for criticizing the inferior education offered blacks, she became a traveling reporter investigating racial conditions throughout the South. Then came the mob lynching of three black grocery store owners in Memphis in 1892. Wells's newspaper, the *Free Speech*, denounced the act, claiming that the men were murdered because they had been competing successfully with white merchants, not because they had allegedly raped a white woman. After an enraged mob of whites stormed the newspaper office, friends warned Wells, who was away, not to return to the city. She heeded their advice but also launched a spirited crusade against the rising tide of black lynchings in the South. She began compiling a record of these crimes and published it a few years later with an introduction by Frederick Douglass. At the Columbian Exposition she and Douglass used funds solicited through black newspapers to pay for a pamphlet, *The Reason Why the Colored American Is Not in the World's Columbian Exposition*, which they distributed to visitors, especially foreigners. Little came of their efforts; too many blacks thought the pamphlet inflammatory or misguided.

Frederick Douglass, an ardent champion and the greatest spokesperson for black Americans in the nineteenth century, had become an alienated figure. Having celebrated the end of slavery and the first bright hopes of Reconstruction, he

endured the bitter disappointments and declining fortunes of his people. Warmly applauded at the Philadelphia Centennial years earlier, in Chicago he now found himself an outsider, even though he had been United States minister to Haiti and was currently that country's representative to the exposition. On dedication day he noted that not one black sat on the dais for dignitaries. He was further incensed after seeing the Dahomey Village, an African attraction on the Midway which was especially popular because of its war dances and the reputed cannibalistic practices of its members. Fair officials, Douglass claimed, had assembled "African savages brought here to act the monkey." The implied comparison was a stinging rebuke.

Upset as he was, Douglass applauded the decision of fair officials to stage a Colored People's Day. Special "days" that honored various nations, states, ethnic groups, occupations, organizations, persons, and national holidays filled the exposition's calendar. Liberia and Haiti days gave recognition and expression to black culture and achievements, and Douglass believed that a special day could do likewise for black Americans. Neither he nor anyone else, of course, could fail to note that officials had scheduled these days with an eye to inflating attendance. Ida B. Wells, in contrast to Douglass, denounced plans for the observation as condescending. The promoters' promise to supply two thousand watermelons for the occasion only intensified her opposition.

Despite denunciations by Wells and others, Colored People's Day took place on August 25. From several accounts, including that of Wells, it demonstrated the variety and vigor of black achievements. The internationally famous Jubilee Singers of Fisk University offered gospels; Will Marion Cook staged portions of his popular opera *Uncle Tom's Cabin*; Paul Laurence Dunbar, the talented young writer born to slave parents, who would later die in his

mid-thirties, read his poem "The Colored American." To the surprise of no one, Frederick Douglass delivered the main speech, and to no surprise, that speech, "The Race Problem in America," excoriated those who had betrayed blacks. The North, he charged, had yielded to the wishes of its former foes, who were "cheating, whipping, and killing Negroes." For blacks the Columbian Exposition bore witness to "a moral regression—the reconciliation of the North and the South at the expense of Negroes."

If blacks felt short-changed at the exposition, Native Americans had even less to be pleased about. Yet unlike blacks, most Native Americans probably had abandoned hopes for obtaining fair treatment. The difficulties they experienced before the Civil War accelerated afterward. By throwing open the West to settlement, the federal government had initiated the final chapter in the uneven contest for domination of the land. General William Tecumseh Sherman, despite bearing a middle name that had belonged to the great Native American chief of the earlier nineteenth century, summed up the attitude of many whites when he issued orders about the Plains tribes: "Get them out as soon as possible...and it makes little difference whether they be coaxed out by Indian commissioners or killed." General Philip Sheridan was even more blunt. Although he later denied it, a report circulated that this Union cavalry hero, when asked by a Native American why he was being abused even though he was a "good Indian," tartly replied, "The only good Indians I ever saw were dead."

Not all white Americans were as cruelly insensitive. Nor were all of them bent upon defrauding Native Americans of their land and cultural heritage. *The Nation*, the preeminent journal of the educated middle classes during the Gilded Age, acknowledged George Armstrong Custer's courage but

then asked, "Who shall blame the Sioux for defending themselves?" Helen Hunt Jackson's *A Century of Dishonor* (1881) made many readers aware of mistreatment and perfidies committed against the native tribes. The United States government itself, historically the leading practitioner of deceit against Native Americans, groped for a solution which would take into account the demands of both settlers and those whom they were uprooting. The Dawes Severalty Act of 1887 gave Native Americans the option of receiving citizenship and an individual plot of land, and assimilating (or at least trying to do so) into white American society, or withdrawing onto reservations where tribal culture presumably would remain intact. Meant as a beneficent reform, the measure brought further hardship and grief. Those who chose acculturation were usually treated as second-class citizens; those who elected to remain on reservations suffered disease and poverty. Both were inordinately susceptible to alcoholism and suicide.

The Columbian Exposition did not exclude Native Americans. Artifacts and crafts from diverse tribes contributed to the wealth of exhibits that pervaded the fairgrounds. But few fair officials or visitors regarded Native American culture as the equal of white, Eurocentric culture. Visitors tended to view Native Americans, like the visiting Dahomans, as fierce savages or at least as representatives of a distinctly inferior civilization. One of Chicago's leading attractions that summer strongly reinforced that stereotype: William F. "Buffalo Bill" Cody's Wild West Show and Congress of the Rough Riders of the World.

William F. Cody (1846–1917) already had become a legendary figure by the time of the exposition. As a young army scout serving on the Great Plains immediately after the Civil War (in which he had enlisted while drunk), he claimed to have single-handedly killed more than four

thousand buffalo. Easterners lionized him for his exploits; the government awarded him the Congressional Medal of Honor. An inspiration for the Western dime novels of Ned Buntline, "Buffalo Bill" first took to the stage and then organized his own Wild West Show in 1884. Within a few years he was touring Europe as well as the United States and making a small fortune, which he proceeded to squander in acts of generosity and poor investments. But Cody soon recovered. Adding to his traveling extravaganza the subtitle "Congress of the Rough Riders of the World," he brought to appreciative audiences exotic horses and their riders from Europe, the Middle East, and Mexico, combining them with American-bred horses and cowboys and his own sharpshooting exhibitions. He also showcased another sharpshooter, the enormously popular Mrs. Frank Butler, better known then and now as Annie Oakley. And his show included Native Americans in profusion.

Buffalo Bill was by no means unsympathetic to the predicament of Native Americans, which he attributed largely to whites. Certainly one can argue that the hundreds, even thousands of Native Americans who toured with him over the years earned a better living than they would have otherwise. Sitting Bull, leader of the Sioux at the Little Big Horn, briefly gave up the tedium of settled life on a reservation during the mid-1880s for a munificent (in those days) salary of fifty dollars a week from Buffalo Bill. It helped him to support his two wives and eleven offspring. As the annihilator of General Custer and his forces, Sitting Bull earned more than a typical Native American cast member. Yet even those who strongly disapproved of Cody's employing Native Americans admitted that these people received much needed financial support and experience in self-reliance.

The crux of the opposition to Native Americans in

Buffalo Bill's Wild West Show had to do with nonmonetary considerations. Government and private reformers interested in the welfare of Native Americans placed their hopes on education and a settled, sober life. Commissioner of Indian Affairs John H. Oberly complained in 1889 that to travel "all over the country among, and associated with, the class of people usually accompanying Shows, Circuses and Exhibitions, attended by all the immoral and unchristianizing surroundings incident to such a life," jeopardized "the present and future welfare of the Indian." His successor, T. H. Morgan, was no less opposed to Native American participation in these touring spectaculars: "The schools inculcate morality, the shows lead almost inevitably to vice. The schools encourage the Indians to abandon their paint, blankets, feathers, and savage customs, while retention and exhibition of these is the chief attraction of the shows."

Buffalo Bill's business agent, unable to procure a site within the Columbian Exposition grounds, cleverly rented one nearby. In all, an estimated six million persons attended Cody's spectacle. Part of his program featured Native Americans as skilled horsemen or portrayed their "life customs." More prominent and enticing, however, were those portions that showed them attacking whites crossing the prairie en route to settlement, in a settlement itself, or on the Deadwood mail coach. Cody and his associates dramatically repulsed these attacks and rescued the besieged whites, leaving no doubt as to the savage and ferocious nature of their foe. As the historian Francis Paul Prucha has observed, "Glorification of the savage past was hardly a way to lead the Indians down the paths of decorous white civilization." Nor was it the way to convince whites that Native Americans were capable of traveling such paths. Those participating in the Wild West Show had been paid to reenact their defeat and humiliation. Cody, not surprisingly, needed help

in keeping these performers sober enough so that they would not fall off their horses during the mock attack on the Deadwood coach. The story sounds apocryphal, but Chief Red Bull, one of the cast, reportedly announced, "This big show all about pale face who found red men over here. Ugh! Bad medicine."

Meanwhile, within the confines of the exposition itself, Native American cultural artifacts were displayed in what one official of the Board of Indian Commissioners ruefully described as "a little mean-looking building in the midst of... grand and imposing structures." The exposition celebrated no Native American Day. Fair officials did invite Chief Simon Pokagon of the Potawatomi to speak as the guest of honor on Chicago Day, October 9. And well they might have, for it was Pokagon's father who in 1833 had deeded to whites the land that now served as the site of the celebration. Less than pleased with arrangements, Pokagon the son publicly deplored the exposition's lack of respect for Native Americans.

Looking back a century later, one can discern a certain hierarchy of race and culture that permeated the Chicago World's Fair of 1893. One "authority," speaking before the International Folk-Lore Congress, assured his audience that the "utterances of savage people were omitted, these being hardly developed to the point at which they might be called music." A contemporary music critic echoed these sentiments as he deprecated Edward MacDowell's *Indian Suite* and the *New World Symphony* of Antonín Dvořák, two works that have retained both popularity and critical respect. These compositions, with their use of Native American and black American themes, represented for the critic "a mere apotheosis of ugliness, distorted forms, and barbarous expressions" that had derived from "essentially barbaric material."

It was impossible to characterize Orientals as barbaric since Westerners prized their art and artifacts. Yet even here a pecking order existed. Japan received considerably more respect than China primarily because of its willingness to adopt Western technology, institutions, and practices, although that acquiescence derived from a need to protect itself from the Western powers. No doubt some of this preference for Japan over China resulted from the simple beauty of the Japanese temple and surrounding flora on the lagoon at the exposition. Then, too, many more Chinese than Japanese had settled in the United States. Prejudice against the Chinese, particularly on the West Coast, was rampant; they had the dubious distinction of being the first group barred from American shores as a result of the Exclusion Act of 1882. The Japanese would soon have their turn to experience the sting of racial prejudice, as exclusion loomed on the near horizon. But at the time of the exposition the Japanese seemed less threatening.

By the 1890s prejudice was also mounting against new immigrants from southern and eastern Europe. The American Protective Association had been established in 1887 to defend against the "Catholic menace." Seven years later, when this organization was reaching the peak of its influence, the Immigration Restriction League was founded by a group of Boston Brahmins who asked whether the United States was "to be peopled by British, German and Scandinavian stock, historically free, energetic, progressive, or by Slav, Latin and Asiatic races, historically down-trodden, atavistic, and stagnant." In 1896 one of their number, Senator Henry Cabot Lodge, who would serve as president of the league, introduced a bill in Congress to require that all immigrants be literate and thereby to exclude many "undesirables" from the "wrong" parts of Europe. President Grover Cleveland vetoed this measure during his last days in office,

but more instructive is the fact that both the Senate and the House passed the bill in the first place.

Despite some aversion and fears—Daniel Burnham had not wanted foreigners hired as police for the exposition—the World's Fair welcomed the so-called new immigrants, who could enjoy the exhibits of both their native and adopted countries. This was, after all, a *world's* fair, and the nation as well as the fair wished to project its best image. Italians were much despised, but October 12 (Columbus Day today) was Italian Day at the fair. Five days earlier it had been Polish Day. More surprising, the fair celebrated Roman Catholic Day on September 2 and, as noted, had scheduled Cardinal Gibbons to offer various benedictions and to speak at the World's Parliament of Religions. Of course, fair officials hoped to increase attendance with these events. The diverse ethnic days—German, Swedish, Welsh, British, Bohemian, Austrian, Irish, along with Italian and Polish—attracted paying crowds of sometimes more than 200,000. (Polish Day attendance, by way of example, was 222,176.) But the fair was never solely about money-making, nor, given the enormous expenses involved and the exigencies of the Panic of 1893, could these special days alone have kept it solvent. As it turned out, only the Midway could do that.

7

Satisfying Popular Tastes

JACQUES BARZUN'S OBSERVATION that to understand America one must understand baseball overstates the case. But broadening the premise from "baseball" to "recreation" would make the idea more valid. For entertainment and play reveal as much about a society as its more "serious" aspects, and American society in the 1890s was no exception. The World's Fair of 1893, in addition to its visual beauty and its formal exhibitions and assorted congresses, provided an extravaganza of entertainment. Aptly calling itself by the French word for "pleasure," the Midway Plaisance proved the most compelling attraction of the fair.

Harlow N. Higinbotham, president of the board of directors of the Columbian Exposition, rationalized the Midway in his official report published five years afterward. He argued that "the eye and mind need[ed] relief" from the stately Court of Honor. The Midway granted the "opportunity for isolating ... special features, thus preventing jarring contrasts between the beautiful buildings and the illimitable exhibits on the one hand, and the amusing, distracting, ludicrous, and noisy attractions" on the other. Low or popular culture, in short, must not violate the sanctity of high culture. Higinbotham, wittingly or not, was presenting only part of the larger explanation. Much more than a

conduit for diverting vulgarity, the Midway was a financial godsend.

Encompassing an area roughly one mile long and two hundred yards wide, connecting Jackson Park with Washington Park, the Midway Plaisance—or simply the Midway, as it was commonly known—had its source in a desire to instruct rather than amuse. A Harvard University professor headed the exposition's Department of Ethnology with the intention of amassing significant materials from all quarters of the globe. These were to be exhibited in the Midway area. But increasing costs of constructing the fair and concerns for its profitability led the board of directors in 1892 to locate some amusements on the Midway. Enter youthful entrepreneur and future longtime New York congressman (1923–1951) Sol Bloom.

Bloom epitomized the success story of many nineteenth-century immigrants and their offspring. He was born in 1870 in downstate Pekin, Illinois, to Jewish parents who had emigrated from eastern Europe. Ruined by the decade's severe depression, the family relocated to San Francisco. There, by the time he was scarcely twenty years of age, young Bloom had gained a reputation for financial acumen. He had already negotiated for the rights to run the Algiers Village exhibit at the fair when a fellow San Franciscan, the newspaper publisher Michael de Young, who was one of the commissioners for the fair and later the principal organizer of the noted San Francisco museum that bears his name, invited him to manage the entire Midway. Surprising everyone, the young man asked for a weekly salary of one thousand dollars. More astonishing, he received it.

With the scoffing delight (sometimes deserved) in which the self-educated sometimes hold the formally educated, Bloom in his *Autobiography* recorded that the earlier selection of the Harvard ethnology professor to run the Midway

was tantamount to placing Albert Einstein in charge of a circus. Bloom had no qualms, and in fact took great pleasure, in redirecting the focus of the Midway from education to entertainment, and in the process transforming it into a profitable venture. Some railed against the carnival atmosphere that permeated the Midway, whose name would become eponymous with honky-tonk entertainment. And for some Sol Bloom must have seemed, pure and simple, the quintessential huckster. But the matter of defining the Midway was no more simple than it was pure.

Still not completed, the exposition drew disappointing crowds of little more than thirty thousand daily during its first month. Directors were well aware of the monetary losses sustained by the Philadelphia Centennial. Mindful of creditors and shareholders, they fretted over whether their efforts were doomed to financial failure. Warmer weather and the completion of work helped to increase attendance, but probably not as much as printed and word-of-mouth advertising and aggressive promotion. Nor was it only the Sol Blooms who helped to swell attendance. Frank Millet, the director of decoration and certainly a devotee of art rather than Mammon, understood the need to promote the fair through popular diversions, which he began to schedule during the summer months. These included athletics, popular music, processions, and even a mock military battle that, as the historian Helen Lefkowitz Horowitz has noted, left Chicago patrons of the "high" arts stupefied.

Important as it was, the financial motive for popularizing the fair did not preclude enjoyment for its own sake. Frederick Law Olmsted had worried that visitors to the fair looked too somber, and, like Millet, he encouraged informal and colorful amusements. In the end the Olmsteds and the Millets, as well as the more financially motivated, had their way. Daily attendance averaged more than 150,000 during

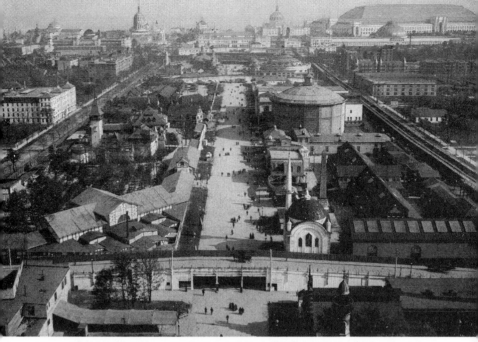

Taken from atop the Ferris Wheel, this photograph shows the informal Midway and the more formal White City beyond. Note the size of the Manufactures and Liberal Arts Building at the far right. *(Columbian Gallery)*

Visitors were fascinated by the exotic culture and peoples of the Middle East, especially Little Egypt, who performed in this dancing theater. A ticket of admission cost 25 cents, but a sign advised buying more than one. *(Columbian Gallery)*

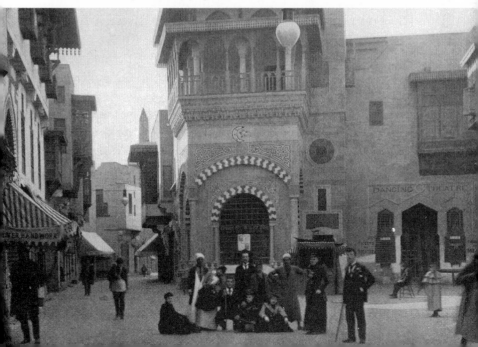

the final two months of the fair as, according to one observer, America for "the first time...turned out for an unrestrained good time...."

Part of this pleasure consisted in simply mingling with the crowds, observing fresh faces and being observed in return, rushing from one site to another on the vast grounds of the exposition. The fair was no place for claustrophobics, and there was always the possibility of having one's pocket picked, one's purse snatched, or succumbing to the lure of a con game despite efforts of the exposition's two thousand security officers. Scurrying from one place to another at the fair, often in broiling heat, afraid to miss an important attraction during the visit, could be exhausting. Many accounts note this feverish quest to see all and miss nothing.

Americans of the 1890s were by and large used to an active life and ready for the rigors of the fair. Much like our present age, the era emphasized physical culture and fitness. The rage for cycling is a case in point. In 1882 Americans owned only twenty thousand bicycles; a decade later they had more than a million one-, two-, three-, and even four-wheeled vehicles; by 1900 the figure reached ten million. When they were not riding themselves, they were watching others ride. In the fall of 1891 New York's Madison Square Garden hosted the first international bicycle race in the United States; most of the entrants were eventually hospitalized for exhaustion.

Much like today, bicycles were not only vehicles but fashionable objects as well. A typical A. G. Spalding model sold for ninety dollars, a considerable price, while even a used bicycle could fetch fifty dollars. The popular singer and actress Lillian Russell rode a gold-plated bicycle that her lover, "Diamond Jim" Brady, had thoughtfully given her; Brady himself sported jewelry configured to a miniature bicycle made of gold and diamonds. One of the most

popular tunes at the time of the exposition was Harry
Dacre's "Daisy Bell" (1892), much better known as "A
Bicycle Built for Two." Then as now, thieves thrived on the
pastime by stealing bicycles or their parts and reselling them.

Competitive sports in America were accelerating in popu-
larity. Dudley Sargent, the first professor of physical training
at Harvard, played a critical role in placing physical fitness
in college curriculums. An organizer in 1885 of the Ameri-
can Association for the Advancement of Physical Education,
he stressed competition rather than pure gymnastics and
inculcated the worth of the "strenuous life" in such Harvard
undergraduates as Theodore Roosevelt. One of his followers
modeled the Young Men's Christian Association into an
organization that emphasized athletics and physical fitness.
That follower, Canadian-born James Naismith, in 1891 in
Springfield, Massachusetts, also devised a brisk game that
came to be known as basketball. Paul de Rousiers concluded,
however, that baseball was "the chief National American
game." Harvard, Yale, and other colleges, he claimed, found
it necessary to field "first-rate" teams in order to encourage
enrollment. Among a growing number of professional fran-
chises, the Chicago White Stockings (renamed the "White
Sox" in 1900) had been playing baseball since the 1870s.
Attesting to the pervasive popularity of the game, Bertha
Palmer and Susan B. Anthony, notwithstanding their busy
schedules, attended a White Stockings game during the
summer of the exposition. (The best seats cost fifty cents,
equal to the price of admission to the exposition.)

Other sports—horse racing, track events, wrestling—simi-
larly thrived during the 1890s, but none more so than
football, especially at Ivy League colleges. Boasted Yale
undergraduates: "We toil not, neither do we agitate, but we
play football." Second only to football in growing popularity
during the decade was prize fighting, now made more

respectable by the substitution of boxing gloves for bare fists and the triumph of "Gentleman Jim" Corbett over the coarser John L. Sullivan in their heavyweight title fight.

The rage for boxing at this time not only underscores the allure of the physical but also offers an insight into the issue of race. Throughout his legendary career Sullivan refused to fight blacks, including Peter Jackson, the champion of Australia and New Zealand. Corbett, in contrast, was less prejudiced and fought Jackson to a sixty-one-round draw before the referee halted the bout. (De Rousiers, attending the fight with some 2,500 others, arrived late and was forced to stand even though he had paid two dollars for a reserved seat. Although fascinated by the ability of the boxers, he considered the exhibition "too brutal a sight for a Frenchman of the nineteenth century. . . .")

Both Corbett and Jackson also appeared on the Midway. The former starred in a program entitled "Gentleman Jim"; the latter gave punching-bag demonstrations, offered to spar with any takers in the crowd, and played in the always popular *Uncle Tom's Cabin*. The most unusual display of boxing on the Midway, however, stemmed from the fertile mind of Sol Bloom, who staged an exhibition between a man and a kangaroo that ended abruptly when the animal kicked his opponent out of the ring. The Midway hosted other crowd-pleasing spectacles involving the body. The young impresario Florenz Ziegfeld, Jr., contracted European strong man Eugene Sandow to demonstrate his muscular prowess to admiring audiences; Bernarr MacFadden, soon to be recognized as the high priest of the health cult, presented his techniques for bodily exercise.

Enthusiasm for physical fitness and exercise also fired American women. Bicycling seems to have been the favored athletic pastime of women, though nervous moralists cautioned that the bicycle enabled young single women to travel

unescorted to questionable rendezvous. Whatever the social perils of bicycling, some pointed to the risks that women faced for want of exercise. Dudley Sargent accepted the innate inferiority of women but argued, in good Darwinian fashion, that they could improve through a regimen of exercise. Something of a fetishist, he attempted to prove his point at the fair by displaying the measurements of twenty thousand college coeds. If his arguments for good personal health and the elevation of the species did not convince, he hoped that his link between exercise and beauty would prove decisive.

Robust looks did become the national standard of beauty for women during the 1890s. In the ever-changing ideal of feminine comeliness the voluptuous woman of the Gilded Age, her natural body curves accentuated by fashion designs, retained some vogue well into the last decade of the century. Lillian Russell illustrated the appeal. But the so-called Gibson girl, named for the sketches of illustrator Charles Dana Gibson which first appeared in *Collier's* magazine, was rapidly becoming the yardstick for beauty. Shortly after the fair closed she became the rage.

As Lois W. Banner has noted in *American Beauty*, her splendid study of changing ideals of feminine looks, the Gibson girl was "indisputably tall, with long arms and legs, her body was clearly that of the natural and not the voluptuous woman." Broad-shouldered, her hair piled atop a head adorned by a straw bonnet, and wearing a sweeping skirt and a shirtwaist, often with a celluloid collar and tie, this "new woman" seemed physically capable of competing with men or at least of joining them in athletics and exercise. Far from repelling the opposite sex with her new looks and attire, she attracted them with her wholesomeness. Strolling through the Chicago fairgrounds in 1893, men in fashionable summer flannels and blazer doffed their hats to

the "fairy" (beautiful woman), who was a "pippin" (a remarkable thing).

The hat that men routinely tipped at the time of the World's Fair was evidence of traditional formality as well as a relaxation of custom. For decades the well-dressed man had sported a high silk hat which signaled a stolid propriety. By the 1890s most men had discarded their stovepipe for the more relaxed derby or, in summer, a straw hat known as a skimmer or boater which retailed for about $1.25. As if to underscore their growing flexibility, men also turned to the easily washable and replaceable celluloid collar. Still, men's fashions were a long way from being informal, at least by today's standards. The well-groomed man did not go bare-headed; his celluloid collars, which could and did catch fire and cause serious injury or even death, were uncomfortable. What strikes the modern-day viewer of the many photographs of people at the exposition is how well-dressed they appear. Rich, poor, or middling, they seem to be wearing their Sunday best to attend hot, crowded festivities that today would be regarded as informal occasions calling for casual attire.

Fair officials and concessionaires saw to it that the physical needs of visitors were met. Given the size of the crowds and the absence of a truly comparable experience to draw upon, they served these needs extraordinarily well. Restaurants offered both American and Continental meals at generally reasonable prices. A good lunch could be had for twenty-five cents, good dinners for between thirty-five and sixty cents. Sometimes, of course, the public was short-changed. The highly popular Ostrich Farm, surrounded on the Midway by Sitting Bull's Camp, the Brazilian Music Hall, and the Captive Balloon, claimed to be serving ostrich eggs that were in fact chicken eggs. Customers could find lighter (and more honest) fare at the Vienna Cafe, Polish

Cafe, or Japanese Tea House; lemonade and light beer that sold for five cents a glass were abundant, while two buildings devoted themselves to the vending of that esteemed snack, popcorn, whose popularity was being challenged by a new product that originated in 1893, Cracker Jack. In fact, the fair initiated Americans to such new items as Juicy Fruit chewing gum, Aunt Jemima's pancake mix (demonstrated at the fair by a former slave woman), and Pabst Blue Ribbon beer, which won the award as the finest beer served at the exposition. It also introduced cereal enthusiasts to Shredded Wheat, which began to compete with other recent cereals— the corn flakes of the Kellogg brothers, the granola of Dr. James Caleb Jackson, and the assorted nutriments of Charles W. Post, inventor of Postum.

Other amenities matched the variety of food and drink. A moving sidewalk, elevated railway, and rolling chairs brought efficient transportation to the fair and helped to minimize congestion. The use of electric illumination at night not only enhanced the beauty of the exposition but also provided a sense of safety. Billboards were forbidden, the distribution of pamphlets was tightly controlled, and commercial deliveries were regulated so as not to interfere with the crowd's enjoyment. A "sanitary wonder," the exposition provided paved thoroughfares, regular sweepings and cleanings, wholesome drinking water and sewage disposal, and more than three thousand toilets. According to the historian William H. Wilson in *The City Beautiful Movement*, the exposition represented "the apotheosis of nineteenth-century urban sanitary engineering" at a time when filth and disease were the scourge of American cities. It also presaged the fastidious care lavished on Disneyland and other amusement centers in the twentieth century.

While visitors doubtless appreciated these comforts, they were more likely to remember the fair for its exotic attrac-

tions. The animal show of Karl Hagenbeck, for example, featured carefully trained lions and tigers, and a thousand parrots. But the greatest satisfactions for exotic tastes were provided by the assemblage of foreign villages clustered along the Midway. Recent critics have asserted that the arrangement of these villages exhibited racial and ethnic biases and were consciously designed to proclaim the superiority of white, Eurocentric culture. Officials, they charge, arranged for non-Western exhibits to be closer to the "black" city (Chicago) and farthest from the White City. Supposedly this represented a ranking of cultural achievements, a microcosm of the world of imperialism that exalted Westerners over non-Westerners.

Yet a glance at any guide map to the fair fails to confirm this argument. While the Midway was itself isolated from the White City, the exhibits within the Midway reveal no distinct hierarchy of culture whatsoever. The Bedouin Encampment, at the entrance to the Midway, did stand farthest from the White City, and the Dahomey Village loomed nearby. But the Brazilian Music Hall and the Hungarian National Orpheum were just as remote. The Persian Concession, the exhibits of Algeria and Tunis, and the Turkish Village all were closer to the central White City than Old Vienna. The same was true of the German Village and the Javanese Settlement, the latter facing the Samoan Islanders, and both nearer the White City than the German display.

Nonetheless, there was ample cause for chagrin. Frederick Douglass's protest that the warriors of the Dahomey Village perpetuated the stereotype of blacks as savages has earlier been noted. The Samoan Islanders fared worse. Billed as people "so recently rescued from cannibalism," the Samoans sang and danced but impressed visitors more with their size and reputed appetite for human flesh. No doubt audiences appreciated their playing "Yankee Doodle" on drums and

gongs at the end of their staged presentation. (If Ole Bull and Jenny Lind could perform "Yankee Doodle," why not the Samoans, one might ask?) Yet exhibits of other non-Westerners were by no means demeaning. Japan and Ceylon erected impressive temples; Morocco featured a model mosque; China presented a theater and tea house; Hawaii showed a panorama of a volcano.

Educational or aesthetic exhibits and those intended simply to amuse could not be neatly categorized. A German Village, complete with town hall, was educative; so too were a Lapland Village with reindeer, a fifteen-foot-high model of Saint Peter's Basilica, and a small representation of the Eiffel Tower. But they were also entertaining. Assuredly the Midway Plaisance suggested both commercialism and racism, but to interpret the Midway, as a number of critics have done, almost exclusively in those terms misses the point that it provided genuine entertainment and no little educational instruction. At the time of the exposition few people living in the United States who were not either well-to-do or immigrants had ventured beyond the nation's borders. To glimpse the exoticism of foreign lands and peoples, stereotypical as they may have been, was an opportunity not to be cavalierly dismissed. George Pullman and his wife Hattie, staunch pillars of proper Chicago society and patrons of the arts, repeatedly visited the Midway with guests that summer. The Midway, it would seem, profited both the sellers and the purchasers of tickets.

No one ever claimed that Fahreda Mahzar fostered educational values. But as "Little Egypt," this Syrian-born dancer became the most memorable person on the Midway and thereafter a legend. From earliest times women of different cultures had gyrated their pelvises to music as part of fertility rituals. In the nineteenth century such dances remained a living tradition in Moslem cultures in the Near

East. Westerners became fascinated with orientalism and the East during this time, and by the second half of the century the *danse du ventre*, the French name for the belly dance, had invaded Paris. The "hootchy-kootchy," as the American version of the suggestive dance came to be popularly known, first appeared, according to at least one source, in 1876 in a variety hall that had formerly been the site of a church. Imported for the Turkish Theatre at the Philadelphia Centennial's smaller version of a midway, the entertainment proved a fiasco. The theatre did not enjoy a favorable location. More important, the scanty (for that era) attire of the two female dancers—abbreviated skirts, silk bands encompassing their breasts, and bare feet—were too audacious. Some of those who found the hootchy-kootchy unacceptable preferred the cancan, the Parisian dance that was actually more provocative but featured more clothing.

For reasons not fully clear, American audiences were more receptive to the hootchy-kootchy and other sensuous dances as performed on the Midway. It may have been, as one historian of American culture has observed, that by this time, "our morals having become more puritanical, the act was a sizzling success." Sol Bloom claimed that he had nothing to do with having introduced Little Egypt to the Midway, though others have thought differently. Whoever was responsible, Ms. Mahzar had been engaged to perform what was billed as "the genuine native muscle dance" along the banks of the Nile, now transported to the shores of Lake Michigan. Her dance, predicted one person, "will deprive of a peaceful night's rest for years to come." With supporting dancers, she moved rhythmically to music performed by a Zulu band. Clad in a full but partially transparent skirt and bra, and sporting what appeared to be diamonds on her garters, she scandalized many. A horrified seventy-four-year-old Julia Ward Howe, author of "The Battle Hymn of the

Republic," spoke for herself and others as she fumed: "...simply horrid, not a touch of grace in it, only a most deforming movement of the whole abdominal and lumbar region. We thought it indecent." Hattie Pullman and Mrs. Frederick Law Olmsted found the performance "disgusting." So did Anthony Comstock, the nation's leading crusader for the suppression of vice, and a variety of women's groups who viewed the fleshly display of Little Egypt and her companions with the same attitude displayed by antipornography groups today.

In addition to Little Egypt and other dancers, the Midway also presented a Congress of Beauty. The master showman P. T. Barnum may have originated the beauty contest, but promoters in Chicago hoped to surpass his efforts. Their marquee advertised forty women from forty countries. After purchasing tickets, customers eagerly moved into a large building where they found women respectably clad in their native garb. Customer reactions seem to have gone unrecorded.

After the close of the exposition, Little Egypt and her imitators became a staple of popular culture. By 1894 no fewer than twenty-two Little Egypts were displaying their dancing talents at New York's Coney Island Amusement Park. The original Little Egypt, Fahreda Mahzar, danced in vaudeville as well as at Coney Island. She gained further notoriety for supposedly dancing naked and for emerging unclad from an immense pie served at a stag dinner at the normally staid Waldorf-Astoria Hotel in New York. Whether performed by the original Little Egypt or her numerous imitators, the hootchy-kootchy became a fixture in burlesque, which was gaining great acceptance during the 1890s. A half-century later the dance could be seen in such Broadway musicals as *Show Boat* and *Carousel*, and its familiar, if by now trite, musical strains can be heard to this

day. In the Columbian Exposition, Little Egypt contributed mightily to the "unrestrained good time" of Americans other than Anthony Comstock, Julia Ward Howe, and their assorted bluestocking allies. Like Little Egypt, America was wearing its hair more loosely abandoned.

The fair also took into account and tried to provide for expanded tastes in music, from classical to popular. Theodore Thomas's efforts to schedule a crowded program of serious music had been widely hailed but narrowly appreciated. Daily free programs of serious music unsurprisingly outdrew the evening concerts with their admission charges. After Thomas resigned in the midst of the Paderewski contretemps, fair officials cut back on programs devoted exclusively to classical compositions. Even before, both Thomas and fair officials recognized the need for programs more entertaining than sublime. For this purpose they engaged a number of concert bands, including several from Europe.

Patrick S. Gilmore (1829–1892), an Irishman who emigrated first to Canada and then to the United States, organized in Boston what may have been the nation's first but indisputably the finest concert band of its time. During the Civil War Gilmore served as bandmaster of the Union Army and composed the ever-popular "When Johnny Comes Marching Home." In 1869 he organized a gargantuan peace festival in Boston in which an orchestra of one thousand and a chorus of ten thousand entertained in a coliseum specially built to accommodate an audience of fifty thousand. Hailed as "the greatest musical festival ever known in the history of the world"—the Gilded Age has never been known for its modest statements—it featured, among other works, Gilmore's own "American Hymn"; patriotic compositions that featured a cannon; and one hundred red-shirted firemen pounding anvils for the Anvil Chorus of Giuseppe

Verdi's *Il Trovatore*. President Grant and other dignitaries in attendance may have enjoyed the five-day gala; John S. Dwight, a prominent Boston musicologist who did much to advance the cause of serious music for decades during the century, purposely left town.

But concert bands were not opposed to serious music. Most of them consistently included large doses of the classics in their repertoires, thus making it possible in an age before phonographic recordings for millions to hear classical works performed by large-scale ensembles. Even as Theodore Thomas and others were developing fine symphony orchestras, bands continued to perform serious music. Had he survived, Patrick Gilmore, who brought a high degree of professionalism to the concert band, much as Theodore Thomas had done to the symphony orchestra, would surely have participated in the Columbian Exposition. His place, then and after, was taken by one of his former band members, John Philip Sousa.

The third of ten children born to a German mother and Portuguese father, John Philip Sousa (1854–1932) gave strong indications as a child that he had inherited the musical talents of his father, a trombonist in the United States Marine Band. Young Sousa, possessing perfect pitch and able to sight-read music before he was ten years old, attended a conservatory, established his own seven-piece dance orchestra at age twelve, and joined the Marine Band as an apprentice a year later. At the Philadelphia Centennial he played violin in the Centennial Orchestra conducted by the French composer of light operas Jacques Offenbach, for whom he specially composed a fantasia. In 1880, while still in his mid-twenties, Sousa became director of the Marine Band. Serving under five successive presidents, he augmented the band's fund of works, heightened its morale, and increased its prestige. With a wife and three children to

support, Sousa yielded to the lure of private enterprise, and in 1892 he resigned his government position and agreed to form a civilian band. His salary quadrupled. Two days before his band offered its initial concert, news came of the death of Patrick S. Gilmore. Sousa took on seventeen of the deceased bandmaster's players and his engagement to perform at the exposition. He then proceeded to march into history.

As the composer of 136 marches, Sousa merited his nickname, the "March King." A number of them—"The Stars and Stripes Forever," "Semper Fidelis," "The Washington Post," "El Capitan," "Liberty Bell"—remain nearly as popular today as they were during the famous bandmaster's long and productive life. But Sousa was more than a prolific creator of marches. Working right up to his sudden death, he composed operas, fantasies, overtures, suites, waltzes, and songs, as well as three novels and an autobiography, *Marching Along*. As bandmaster he toured the United States and Canada annually, Europe on several occasions, and the world once. An ardent patriot, he joined the naval reserve to assume command of the Navy Band when the United States entered World War I. He was then more than sixty years old. It goes almost without saying that the Sousa band performed during his lifetime at all significant American expositions from 1893 on.

Educated and trained to appreciate serious music, Sousa reshaped the concert band of his time along lines that Gilmore had begun to establish in his last years. By tempering the blare of brass and the booming of drums, and simultaneously allowing more prominence to woodwinds, he muted band sound so that the sonority of classical music, which his band performed regularly, found truer expression. In his devotion to serious music he was at one with Theodore Thomas, with whom he played on dedication day at

the Columbian Exposition. Years later he recalled his lunch with the German-born conductor at the Auditorium Hotel Restaurant, after their performance, as "one of the happiest afternoons of my life. Thomas was one of the greatest conductors that ever lived." A number of music critics praised Sousa for carefully nourishing and presenting the classics. Others were less laudatory, quick to point to his custom of interspersing popular with serious music, something, of course, that Theodore Thomas had also done. Denying that "popular" meant "vulgar," Sousa summed up his career as an attempt to "cater to the many rather than the few." Thomas, he claimed, sought to educate the public, while he, Sousa, strove to entertain.

Entertain he did. Massive crowds thronged to his concerts at the exposition, much as they would during the rest of his life. His audiences in Chicago received a strong sampling of the classics, but they also heard such favorites as "Way Down upon the Sewanee River," "Old Folks at Home," and that year's rage, "Tarara-Boom-De-Ay," which even formed a part of every program performed by the Marine Band that summer on the White House grounds.

"Tarara-Boom-De-Ay," though made famous by the singer Lottie Collins in 1892, derived from a minstrel show that had opened the previous year. Despite the abysmal treatment generally received by blacks, their music enjoyed great favor. The gospels and spirituals of the Jubilee Singers enchanted audiences, both black and white, at home and abroad, but it was the minstrel shows that proved the most popular. Before the late nineteenth century, whites commonly appeared as blacks (but not vice versa) in minstrel entertainments that were usually, but not invariably, segregated. Soon, however, white entertainers were abandoning the old-time minstrel revues and focusing on ethnic humor, especially that of the Irish, Germans, and Jews. Al Jolson and Eddie Cantor,

themselves immigrants, thrived on blackface song-and-dance routines well into the twentieth century, but they were exceptions. Greater popularity in the 1890s came to those, like the celebrated team of Joe Weber and Lew Fields, who mimicked immigrants and regaled audiences with jokes that frequently cast immigrants in an amusing, even ridiculous, light. Although interest was shifting to the culture of urbanization and immigration, the minstrel show remained nationally popular at the time of the Chicago World's Fair. Black minstrels continued in demand, especially in the South and West, but their white imitators continued to receive priority in the finer theaters that booked vaudeville and musicals.

Ironically, the 1890s, which witnessed the decline of political, civil, and social rights for blacks, brought renewed attention to black entertainers. The number of all-black companies increased; black women, for the first time, became regulars in theatricals. Following the production of *Black America*, a musical spectacular held in Brooklyn's Ambrose Park, black musical comedies attracted greater attention. At the same time the "chalk-line walk," a dance that had been a favorite among black Americans for years, became known as the "cakewalk" and caught on among white Americans. A few "serious" composers incorporated the melodies and rhythms of blacks into their works. New Orleans-born Louis Moreau Gottschalk (1829–1869), the first American composer to achieve significant recognition abroad, composed his delightful "Cakewalk" before the Civil War, and Claude Debussy wrote "Golliwog's Cakewalk" in the early twentieth century. But the cakewalk flourished principally as an American dance. A national cakewalk contest took place at Madison Square Garden, and the elite "400" of New York society reportedly undertook this intricate dance that had originated on antebellum plan-

tations, where a cake had been awarded to the best performers.

The celebration of the cakewalk was linked to the rise of a kind of music most Americans had never heard before the 1890s. The precise origin of ragtime remains in doubt to this day, though it is agreed that this music, with its unorthodox syncopation, derived from black American culture. Kerry Mills's ragtime march, "Rastus on Parade" (1893), helped to widen the audience for the cakewalk, but it may have been the immensely popular and unfortunately titled "All Coons Look Alike to Me" (1896) that inaugurated the craze for ragtime.

A good many musicians came to Chicago, drawn to the fair. Some already had been playing ragtime. One was an itinerant musician who was born in Texas to a former slave and currently was working in honky-tonks in St. Louis. With posthumous fame and personal tragedy still in the future (he would lose a child, have his most serious works met with indifference, and suffer a mental breakdown and fairly early death), Scott Joplin (1868–1917) performed without fanfare that summer. Not many could have foreseen that this young pianist would soon become the "king of ragtime," composing more than fifty rags.

Many whites at first refused to play ragtime. Their resolve softened, according to the black entertainer Tom Fletcher, when John Philip Sousa and his band won a prize at the Paris Exposition of 1900 for their spirited rendition of "My Ragtime Baby."

Popular tastes ranged well beyond the rhythmic beats of ragtime and the stirring tempos of band concert music. Much as a taste for the lyrical, sentimental ballad continues in our current age of ear-shattering, nerve-jangling rock and rap music, so in the 1890s many preferred more soothing, syrupy, frequently nostalgic or moralizing works. Included

among the most popular songs during the first half of that decade were "Little Annie Roonie" (1890); "Oh, Promise Me" (1890); "The Pardon Came Too Late" (1891); "The Picture That's Turned to the Wall" (1891); "The Sweetest Story Ever Told" (1892); "Happy Birthday to You" (1893); "When the Roll Is Called Up Yonder" (1893); "His Last Thoughts of You" (1894); "The Little Lost Child" (1894); and "She Is More to Be Pitied Than Censured" (1894). Few could compete with Charles K. Harris's "After the Ball" (1892). Not all favorites catered to sentiment or nostalgia. "Tarara-Boom-De-Ay," "Daisy Bell" ("Bicycle Built for Two"), and "The Bowery" (1892) were rollicking works that Americans sang, hummed, whistled, and played on instruments, then and even occasionally now. We can only wonder, however, why "Throw Him Down McCloskey" (1890) became a national favorite.

No formal public opinion poll surveyed reactions to the World's Fair of 1893. Had there been one, and had respondents been asked to cite its single most memorable attraction, the reply of most could scarcely have been in doubt: the Ferris Wheel. The brainchild of a young Pittsburgh engineer with the patriotic name of George Washington Gale Ferris, the structure immediately became the icon of the exposition and a fixture at future fairs and amusement parks.

The origin of the Ferris Wheel purportedly dates back to a banquet given by Daniel Burnham for architects and engineers in 1892. During the course of his welcoming address the fair's chief architect twitted his audience about the sensational effect produced by the gigantic Eiffel Tower at the Paris Exposition of 1889. Unlike the extraordinary feat achieved by French engineers, their American counterparts had planned nothing comparable. Collectively the audience

Soaring more than 250 feet skyward and affording a spectacular view of the fair and the city beyond, the Ferris Wheel was the most popular attraction in Chicago that exposition summer. *(Columbian Gallery)*

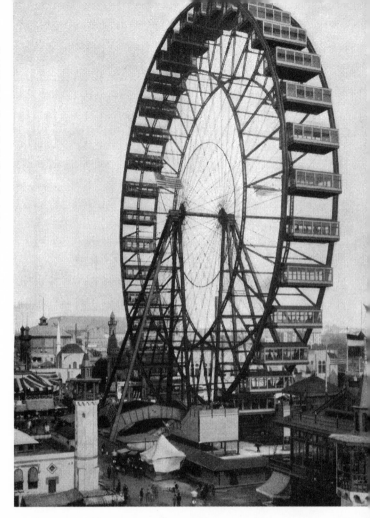

Visitors to the fair could hire guides to push them through the grounds in rolling chairs built for one or two persons. *(Chicago Historical Society)*

refused the challenge; George W. Ferris did not. Having conceived of a giant wheel years earlier, and now with an opportunity to construct a machine that would serve "as a medium of observation for passengers" and "as one of the architectural monuments at the Fair," he invested $25,000 for a concession. He next incorporated with others to expend more than $250,000 to erect the wheel near the center of the Midway Plaisance and next to the twenty-foot-high replica of the Eiffel Tower.

Ferris and his colleagues, after receiving permission in late 1892 to install the wheel, began their labors the following February. Work proceeded slowly, and the wheel did not begin operation until June 1. Underground foundations were sunk a required 40 feet to support a structure that weighed more than a thousand tons. The wheel's diameter was 264 feet; its 36 cars, each of which was suspended at the circumference of the wheel, measured 27 feet long, 13 feet wide, and 10 feet high. Each car, paneled with wood, had 38 comfortable, plush-covered, revolving seats plus standing room for 22 riders. At maximum capacity each car could carry 60 passengers and the entire wheel 2,160 passengers. To lift this enormous mass required remarkable engineering and technological skills which included construction of the world's largest steel axle. Doubting Thomases—and there were many of them—anticipated a dreadful accident. When hundred-mile-per-hour hurricane winds gusted through the fairgrounds that summer, the intrepid Ferris, with his equally brave wife and a reporter, personally rode the wheel. No accidents occurred that day or any other day.

More than 1.5 million passengers boarded Ferris's creation during its five months of operation. At a cost of fifty cents for a ride that completed two full revolutions in twenty minutes (the wheel had to stop frequently to disembark riders), the structure afforded an unparalleled view of the

fairgrounds and beyond. The panorama at night, with electricity illuminating the White City and surrounding water, must have been breathtaking, but even seen from an opposing perspective by those approaching the fair, the wheel greatly impressed. Passengers purchased tickets by the dozens, according to Sol Bloom, and rode the wheel continuously. Hunger pains presented no problem for riders: each of the thirty-six cars featured a small dining counter to be used for food brought on board. Food was not the sole appetite the wheel could accommodate. For some the romance of soaring aloft led to formal proposals of marriage.

Both George Washington Gale Ferris and his invention met with ill-starred fates. Ferris shared in handsome profits that exceeded $300,000 but died impoverished in 1896. His wheel fared no better. Dismantled and then removed to a new site on the city's North Side, its popularity languished. It enjoyed a final burst of success at the St. Louis Exposition of 1904, but two years later it was dismantled for the last time. Still, the fame of the wheel has proved enduring. In 1900 smaller imitations appeared at the Paris World's Fair and the Prater in Vienna. Amusement parks have been running their own wheels throughout the century.

Although primarily a source for enjoyment, the Ferris Wheel, like the World's Columbian Exposition for which it served as a symbol and memento, was also a source of enormous pride. The Eiffel Tower, as John Kouwenhoven, an authority on the culture of technology, has pointed out, depended on an American invention (the elevator) to function and presented only its great height as a novelty. Costing more than sixty times what the wheel would cost, the tower was barely four times as high. The wheel, in contrast, was an innovative marvel of engineering know-how, a metaphor for the uniqueness of the fair and of America. "It gave symbolic expression, as the Tower could not do," concluded

Kouwenhoven, "to significant characteristics of nineteenth-century technology and democracy: those characteristics of mobility and change with which modern art has been largely preoccupied." In no small way had the Ferris Wheel contributed to making the Columbian Exposition, in the words of one guidebook, the "grandest Exposition this planet has ever witnessed."

8

Legacies of a City of Dreams

FEW EVENTS OF the late nineteenth century captured
the popular imagination as did the World's Columbian
Exposition of 1893. Visitors often described their experiences
with inflated rhetoric. The usually imperturbable John Hay,
who had served as personal secretary to President Lincoln
and who would become secretary of state under President
McKinley, confessed, "We were all knocked silly. It beats the
brag so far out of sight that even Chicago is dumb." Hay's
close friend Henry Adams, a curmudgeon who rarely was
lost for negative opinions, conceded that "Chicago was the
first expression of American thought as unity; one must start
there." Hamlin Garland, noted for his realistic depiction of
prairie life, swore that "the wonder and beauty of it all
moved these dwellers of the level lands to tears of joy which
was almost as poignant as pain. The scene had for them the
transitory quality of an autumn sunset, a splendor which
they would never see again."

More striking than these flights of prose are the frequent
descriptions of the exposition, especially the White City, as
something unreal. The French visitor Paul Bourget admitted
he was "struck dumb...with wonderment" and likened the
exposition to a "dream city." So did Professor W. P. Trent of
Sewanee College. After a night of insomnia that followed a

day of too much excitement at the fair, he composed a sonnet
in which he also spoke of a "dream city." Richard Watson
Gilder, a poet of the genteel tradition and editor of the
respected *Century* magazine, apostrophized the exposition as
the "City of Dreams" in his elegiac "The Vanishing City."
Meanwhile the English writer Sir Walter Besant offered his
own hyperbole: "Call it no more the White City on the Lake;
it is Dreamland." Never "in any age, in any country," he
asserted, "had there existed any comparable arrangement of
buildings," which were "the greatest and most poetical dream
that we have ever seen." Academics added their overheated
descriptions. Professor Hjalman H. Boyesen regarded the
spectacle as "a vision of delight unrivalled on this side of
Fairyland"; for Professor Thomas R. Lounsbury of Yale
University "it was simply a journey into Fairyland."

Architects and architectural critics may have been most
concerned with the practical substance of building, but some
readily invoked the rhetoric of fantasy. The critic Fiske
Kimball likened the White City to a "classic phantasm,"
while Montgomery Schuyler, who denigrated the architec-
ture as a "success of illusion," called it a "fairy city." Henry
Van Brunt, the designer of the Electricity Building, ap-
plauded Daniel Burnham for having rubbed "his wonderful
lamp of Aladdin." (Paul Bourget also suggested the "Alad-
din-like magic" of the White City.) Mary Hartwell Cather-
wood, a popular writer of the day, saw the entire exposition
as a "Wonderland" where she was "emancipated from the
troubles of earth." But, she asked, "what shall we do when
this Wonderland is closed?—when it disappears—when the
enchantment comes to an end."

The exposition truly had been a "dream city," a "Fairy-
land," a "Wonderland" of escape. At the same time it had
provided the site for grim events. The cold storage building
at the fair caught fire in July. Seventeen firemen perished in

that blaze before the horrified gazes of many of the 130,000 visitors in attendance. Crime, as noted, was an omnipresent fear and frequent enough reality at the fair, despite the efforts of the Columbian Guard and plainclothesmen. Outside the fairgrounds lurked an even greater menace in Chicago proper, now flooded with criminals who were preying upon the unwary and the helpless. Of these malefactors, none could compare with H. H. Holmes, alias Herman W. Mudgett, who tortured and killed perhaps scores of victims in his three-story, ninety-room "castle" located not far from the exposition at the southwest corner of Wallace and Sixty-third Streets. (Only a few years later was this most notorious serial killer of the nineteenth century apprehended in Philadelphia, tried, and hanged.)

Dr. Mudgett/Holmes was not the only murderer to operate within the shadows of the Columbian Exposition. Carter Harrison, like Bertha Palmer and countless others, had worked zealously to make the World's Fair a success. He had entertained a great many visiting dignitaries at his handsome residence on fashionable Ashland Boulevard. His vigor and enthusiasm belied his sixty-eight years. Twice widowed, he was about to marry a considerably younger woman. Whether it was the galvanizing effects of this May-December romance or an unslaked thirst for public life, Harrison delivered forty official speeches during the course of the fair. On Saturday, October 28, three days before the scheduled closing, he welcomed a delegation of visiting mayors. Proud of his city, he boasted that he would live to see Chicago become the largest city in the United States and the third largest in the world. (It was then the world's seventh largest city.) Chicago, he assured his audience, "knows nothing it cannot accomplish...." Exhausted but pleased, he returned home, dined, and was resting when he heard a knock at his front door. There he found a local

citizen, Patrick Eugene Prendergast, who thought he had deserved the position as the city's corporation counsel, even though he had studied law solely through a self-help booklet. Prendergast, who blamed Harrison for his disappointment, fired three bullets into the mayor. Minutes later Harrison died. Stunned fair officials muted closing-day ceremonies, canceling music and fireworks, curtailing speechmaking, and ordering flags lowered to half-mast. The city mourned Harrison with what one writer called the greatest show of grief since the assassination of Lincoln. Even "Hinky Dink" Mike Kenna was touched. Upon hearing the news of the murder, he mused, "He was a good man, Carter." But ever the realist, he added, "But now we gotta think of the future."

Attempts by fair officials to conclude the celebration on a staid, respectful note proved less than successful. The subdued festivities failed to prevent heavy drinking and raucous behavior on the Midway or the defacement of various buildings with graffiti. Generally well behaved throughout the course of the fair, portions of the crowd now turned unruly. An understandable if misplaced excitement that normally accompanies the end of a long-standing celebration accounts for some of this behavior. But there was another factor: the economic panic had worsened, and with it had come diminished self-control. Thousands of workers attached to the fair or drawn to Chicago in hope of employment had joined with the local jobless to create an alarming level of unemployment. As the end of the exposition approached, a significant number may have sensed the scarcity of jobs in and around Chicago—and throughout the country.

Making matters worse were drifters. Without adequate programs to deal with massive unemployment, Chicagoans improvised. Saloons and soup houses provided an estimated

sixty thousand free lunches daily during the harrowing winter of 1893–1894. The rapidly increasing numbers of homeless took to sleeping in police stations and even in city hall. They congregated in parks and in the fair's deserted buildings, which the city had not decided whether to preserve or to raze. Normal wear and tear, petty acts of vandalism, and fires lit by the homeless to warm themselves had caused some damage, but the main buildings remained largely intact until the evening of July 5, 1894, when Chicago was paralyzed by the Pullman Strike. As federal troops, ordered to Chicago by President Cleveland, battled with strikers, arsonists laid waste the fair's buildings. Within a few hours the once magnificent White City was rubble. Only the Palace of Fine Arts, alone among all its buildings, remained. (It became first the Field Museum of Natural History and later the Museum of Science and Industry.) Although not as stupendous as the Great Fire of 1871, the fire of 1894 lived on in memory as a sad finale to a joyous occasion, a painful refrain to Mary Hartwell Catherwood's query, "What shall we do when this Wonderland is closed? —when it disappears—when the enchantment comes to an end."

But the exposition was neither the idyll that Catherwood envisioned nor a transient spectacle doomed to oblivion. As an historical event of widespread interest and importance, it exerted an influence that extended well beyond its brief existence.

The writer Charles Dudley Warner, who with Mark Twain had written *The Gilded Age* (1873) twenty years earlier, insisted that the Columbian Exposition had "introduced into practical lives the element of beauty...." He added: "It is no criticism upon the people of the United States, absorbed in material development, to say that they received such an uplift. If it cannot be called a spiritual

influence, it is an aesthetic impulse that leads away from materialism." Having exchanged views with others, Warner concluded that his judgment was not an isolated one. He was right. The late nineteenth century *was* witnessing a renewed and remarkable enthusiasm for beauty, which expressed itself with varying emphases and through different names: aesthetic movement, decadence, arts and crafts movement, Gothic Revival, and American Renaissance. The impulse was a reaction against what many saw as the corrosive squalor, increasing strife, and unsettling conditions of modern life. While the exposition alone did not give rise to this impulse, it accelerated and broadened the force. In the process the fair raised important questions, brought forth a spirited debate, and led to new directions.

The White City, for example, had a substantial impact on American architecture. Montgomery Schuyler might deplore its emphasis, but others did not. Margaret G. Van Rensselaer, another eminent critic of the era, praised the White City as the most splendid sight "since the Rome of the Emperors stood intact...." "Any one of us can point to good and beautiful buildings in American towns," she noted, "but can any one think of a single satisfactory large group or long perspective?" The United States required a coherent style of architecture, Van Rensselaer thought, and the example of the exposition would encourage popular taste and lead to a new national style. She was sure the United States "is capable of supremely successful effort in intellectual as well as political paths."

Joseph McKim concurred. With its emphasis on harmony and grandeur, he reasoned, the neoclassical style was eminently suited to the needs of the nation as the new century dawned. McKim and his partners were already utilizing the style with impressive results and would continue to do so for

years.* McKim went on to establish the American School of Architecture in Rome, now renowned as the American Academy in Rome, for those who wished to study classicism in its various expressions. The architectural historians John Burchard and Albert Bush-Brown concluded more than a century later, "There can be no doubt that the new classical manner was exactly what the society wanted." According to another twentieth-century critic, those who selected the classical style for the White City "only symbolized popular taste," but in designing this "tremendously impressive group of buildings ... they did more; they astonished, delighted and fixed popular taste." The widespread acceptance of the neoclassical had resulted from a dialectical process: influential artists and architects urged the style on audiences who, through their enthusiastic reception, reinforced the will and determination of the designers.

The impact of this enthusiasm for neoclassicism on a burgeoning modern style is not easy to determine. It seems odd to blame the half-century delay in America's acceptance of the modern (International) style on neoclassicism. The architecture of the White City was no doubt something of an impediment, but not a strong one. Besides, some of the finest examples of progressive architecture, especially in Chicago, were undertaken or completed *after* 1893. The decline of the Chicago school of architects, the leader in building innovation, was by no means clear for more than a decade following the exposition.

Regardless of whether the neoclassicism of the White City delayed the flowering of modern architecture, it is important to ask why so many artists and critics were and continue to

*This predilection stemmed from aesthetic taste, not ideological commitment. Neoclassicism may have seemed quintessentially an architecture of imperialism to some, both then and now, but for McKim and associates it was imperial rather than imperialistic.

be fiercely hostile to the neoclassical revival of the late nineteenth and early twentieth centuries. To argue, as some have, that the revival represented the triumph of a foreign culture over an indigenous one is to border on provincialism, if not chauvinism. Like it or not, the United States has always owed much of its cultural heritage to Western traditions, including classicism and neoclassicism, that stemmed from Europe. Those who deplore those traditions may concur in the playwright Samuel Beckett's curt dismissal of tradition as "the ballast that chains a dog to its vomit." Others, less iconoclastic, may agree with Paul de Rousiers's contention that Americans are not hostile to tradition. The quest for the new, according to him, complemented rather than eclipsed their reverence for the past. "They have never had any idea of breaking with the past, as we in France have," he claimed, "because their rulers have never interfered with their natural development, no heavy hand has stayed their flight, no absolute power has attempted to enslave them." For some, admittedly, the Old World was the proverbial den of iniquity, a cesspool of corruption to be shunned. For others the Old World had much to offer. It is important to keep in mind that while thousands of Europeans crossed the Atlantic to see the exposition, some ninety thousand Americans journeyed eastward to pay homage to Europe that same year. For those who cherished historical links to the Western past, "the obsession of newness and New World originality," to use Thomas S. Hines's apt phrase, was unacceptable.

In any case, it would be wrongheaded to view the exposition as a slavish, tedious imitation. The buildings of the White City exhibited undeniable variety beyond their uniform height and overall neoclassical design. White was their primary color, but the black dome of the Administration Building, the gilded statue of the *Republic*, the myriad

electrical lights, the lagoon, the island, the voluminous plant life and floral displays, the flags and banners—all contributed to a vast panorama of stunning visual diversity. It is doubtful that many of the millions of visitors to the fair questioned the decision to accept a traditional style of building rather than one that was future-oriented. They admired the White City because, quite simply, it stirred their sense of the beautiful.

If exposition visitors made few connections between the past and the neoclassicism of the White City, that was not the case with regard to the exposition's Colonial American architecture, arts and artifacts, and assorted presentations. With considerably less rationale than the Philadelphia Centennial, the Columbian Exposition devoted a good deal of effort and space to commemorating the nation's colonial and early national history. In almost two dozen exposition buildings—chiefly those of the states—that expressed this heritage, in thousands of assorted relics donated for display, and in parades, speeches, and historical reenactments, millions of Americans were exposed to a past culture with which most were probably only remotely acquainted. To inspect artifacts once possessed by George Washington, Thomas Jefferson, or other founding fathers was to savor the richness of history. Moreover, as Susan Prendergast Schoelwer has pointed out, Chicago, unlike the Atlantic seaboard, had no colonial experience. Hence the cultural expression of the colonial past was much more a novelty at the exposition than at the Centennial, where proportionally more visitors came from areas of the country that maintained vestiges of colonial culture. The fair undoubtedly spurred an interest that in the twentieth century ballooned into the colonial revival that reached its zenith with the historic restoration of Williamsburg, Virginia. To the present day an appetite for colonial

houses and for colonial art and artifacts to fill their interiors remains unappeased.

Many Americans living at the time of the exposition may have looked back on their colonial past with increased respect, but considerably fewer exalted their urban present. The exposition, as William H. Wilson has observed in *The City Beautiful Movement*, provided "a showcase of American possibilities" and "affirmed the possibility of making cities beautiful." Wilson has challenged the prevailing belief that directly links the exposition to the City Beautiful movement that emerged shortly thereafter. The Chicago celebration, in his view, served as an example, not an initiation, of forces that generated this movement. Sporadic efforts by various park and sanitary reformers to enhance the nation's cities from the mid-nineteenth century onward, as well as the example of Baron Haussmann's radical restructuring of the heart of Paris, antedated the Columbian Exposition and influenced the City Beautiful campaign. Yet the exposition certainly helped to propel the movement. In the two decades following the exposition a great many individuals and groups, from city planners, city commissions, and architects to artists and art leagues, fought to make aesthetic considerations an integral part of urban life.

No figure associated with the City Beautiful movement loomed larger than Daniel Burnham, who turned to the "social possibilities of municipal architecture." Thanks in no small measure to the recognition he received for the World's Fair, Burnham's office became the nation's largest architectural firm, one that devoted itself overwhelmingly to public and commercial building. Burnham played an active role in revitalizing urban centers in Washington, D.C., San Francisco, Cleveland, and Manila during the first decade of the twentieth century. His ambitious Plan for Chicago, drawn

up with the assistance of others, ultimately led to the preservation of more than one hundred blocks of lakefront.

These cities erected grand civic centers, elegant malls, and splendid parks in the years before the nation's entry into World War I. Other American cities, both large and small, followed suit, executing sweeping plans that expanded commerce and invariably employed a modified version of classical architecture. Some critics, then and now, protested that the City Beautiful movement was too concerned with Mammon or sheer aesthetics, and not sufficiently attentive to neighborhood life and housing for the poor. Time has given some weight to their arguments. The reformers of the late nineteenth and early twentieth centuries had savored the prospect of more wholesome, attractive urban living; few if any suspected the urban nightmare of the late twentieth century.

But in addition to visually pleasing cities, some end-of-century reformers, inspired by the Columbian Exposition, hoped for more fundamental civic improvements, although given the breadth and depth of urban problems, demands for such reforms would have been made had there never been an exposition. Henry Demarest Lloyd, scourge of the Standard Oil monopoly, hoped that the White City, through its example, might inspire an urban America that would incorporate industry and agriculture and a human scale of living. In "The Parable of No Mean City" he predicted that a municipal regeneration would lead to an equitable socialist economy. This vision of a cooperative- rather than a competitive-minded society also found expression in utopian fiction. The protagonist of William Dean Howells's *A Traveller from Altruria* (1894), for example, exhorted all whom he met to build future cities along lines suggested by the exposition's White City. For Howells as for others, beauty and the good society were inseparable.

The Columbian Exposition similarly stirred the reform sentiments of William T. Stead, a noted English journalist who visited the exposition shortly before it closed. Impressed with what he saw within the fairgrounds, this minister's son was aghast at what he beheld without, in the larger city. Stead, who was to perish aboard the *Titanic*, chronicled the city's ills, emphasizing its poverty, grime, gambling, prostitution, and corrupt politicians and police. His sensational exposé, *If Christ Came to Chicago* (1894), summoned citizens to establish a "civic church" to serve as a "union of all who love in the service of all who suffer." Hundreds responded. In early 1894 they organized the Chicago Civic Federation and elected Lyman J. Gage president and Bertha Palmer vice president. Prophesying greatness for the city, Stead predicted that Chicago would one day become the nation's capital and the world's most important city. This metropolis of the future would enjoy religious harmony, the coveted eight-hour day for workers, Hull House–like organizations for the needy, municipally owned public utilities, honest government, and an array of cultural institutions, events, and amenities that would be the glory of its day. The philanthropy of local businessmen and a benevolent paternalism would bring about this metamorphosis, which would capture worldwide attention. Stead's work ends on a note of reverie, with an official visit by Germany's Kaiser Wilhelm II to Chicago's newly elected mayor, Bertha Palmer.

Kaiser Wilhelm never ventured to Chicago, but numerous American writers did. During the 1880s the city was beginning a rapid rise to the status of a major literary center. After his visit to Chicago and the exposition, Hamlin Garland confidently predicted that the city would become the very hub of American letters. Garland was mistaken, but Chicago did enjoy an extraordinary burst of literary creativity in the years before World War I. By the early twentieth

century it stood second in importance in publishing only to New York.

The Columbian Exposition contributed to this flowering by bringing writers like Garland and Theodore Dreiser to the city. It also furnished the setting for more than a dozen novels. Common themes of several of them included the stark contrast between the White City and the Black City, as well as the difficulties of acculturation experienced by those who had been nourished on rural values and who were trying to cope with their new, frequently overpowering milieu. Henry Blake Fuller's now largely and unfairly neglected *The Cliff-Dwellers* (1893), offers a compelling and useful account of the malaise of metropolitan life at the time. Fuller appealed mainly to a middle-class audience; other writers sought a broader appeal. A significant number of "dime novels," inexpensive, page-turning staples of late-nineteenth-century popular reading, seized upon the exposition as a focus for their usually sentimental, often lurid, pulp fiction. An anonymous author published *Caught in Chicago; or, Bob Brooks Among the World's Fair Crooks* (1893). Similar would-be thrillers included Cap Collier's *Infanta Eulalia's Jewels* (1893) and *The Chamber of Horrors* (1895), which was based on the gruesome crimes of H. H. Holmes.

It was appropriate that the fair's influence ranged widely— from serious architecture to municipal reform to diverting pulp fiction—for the exposition itself embraced both the edifying and the amusing. Some have seen a sharp demarcation between the high culture represented by the White City and the popular culture of the Midway—between the forces of order and disorder, of planning and spontaneity. The bipolarities seem too perfect. The line between the high and the popular, the instructive and the entertaining, was more like a porous membrane. The main purpose of the Midway, after all, was not to separate the classes and their supposedly

conflicting tastes but to keep the exposition afloat financially. Nor did visitors impose any such segregation upon themselves. They were enchanted with the formal expressions of the White City as well as with the excitement and hurly-burly of the Midway. There seems no good reason to believe that the experiences of the humblest farmer or laborer milling about the White City and its endless exhibits were less gratifying than those of George and Harriet Pullman, who, with family and wealthy friends, thoroughly enjoyed their more than two dozen separate visits that included the Midway. This was no more odd than the serious and sedate Bertha Palmer and Susan B. Anthony attending and enjoying a baseball game. It may be, as Lawrence W. Levine has forcefully argued, that lines of class and culture were becoming more divisive by the late nineteenth century. If so, the Columbian Exposition is not a persuasive example. Clearly, some from the upper and middle classes hoped that the White City and the exposition's educational and artistic exhibits would elevate the tastes of the masses and promote social unity. But coercion was not a terribly active agent in this equation.

Similarly, to focus on the exposition as an exercise in racial, ethnic, or gender discrimination is to exaggerate its deficiencies and to distort its meaning through the wrenching twists of our present-day values and beliefs. The exposition openly manifested such biases, yet they were not uniformly displayed or experienced. Native Americans received short shrift; black Americans had cause for complaint. The exposition was Eurocentric, but Columbus, symbol of the celebration, was European. Moreover, the broad range of displays of non-Western cultures, stereotypical though most of them were, showed an urge to transcend geographical limits and create a *world's* fair. So too did the enormously popular and widely acclaimed World's Parlia-

ment of Religions, which downplayed sectarianism and exalted the commonality of theism. Women could also derive genuine satisfaction from the fair. Whether at their own exhibits or in other fair activities, they mingled freely, discussed problems, voiced protests, affirmed resolutions, and vowed to continue their battle to overcome the inequalities imposed upon them. The opposite sex could scarcely avoid being impressed by their presentations, lectures, and achievements.

To overemphasize the tolerance and goodwill expressed at the exposition would be a historical distortion of the world of 1893. Women were indeed struggling, without much success, to secure their rights. Black Americans, at least in the South, teetered on the verge of losing most of the rights they had; and Native Americans were exchanging a "century of dishonor" for one that would bring continued grief. The "new immigrants" from Europe were about to encounter increased resentment and demands for their exclusion. The West, far from enacting the noble sentiments voiced at the World's Parliament of Religions, continued and expanded its policy of imperialism at the expense of non-Westerners. The gap that separated the world of the Columbian Exposition from the larger world loomed as wide as it was real. In this sense the exposition was indeed an "illusion," a "wonderland," a "dreamland." But it was no mere chimera, a trick of mirrors. If it was a dream, it was also an expression of what Americans had accomplished, were accomplishing, and promised to accomplish. "In the highest sense," according to one historian, it was a "patriotic exercise." Even so, it transcended nationalism and became something more: The Great World's Fair.

A Note on Sources

IN THIS NOTE on Sources, rather than list all works consulted I cite only those that have been most useful to me.

I have benefited richly from general works, both primary and secondary, that provide details of the World's Columbian Exposition. Among the former are Rossiter Johnson, ed., *A History of the World's Columbian Exposition,* 4 vols. (New York, 1897); Benjamin C. Truman, *History of the World's Fair* (Philadelphia, 1893; reprint New York, 1976); and Daniel H. Burnham, *The Final Report of the Director of Works of the World's Columbian Exposition* (New York, 1989). Two full-length modern studies of the exposition currently exist: David F. Burg, *Chicago's White City of 1893* (Lexington, Ky., 1976), and Reid Badger, *The Great American Fair: The World's Columbian Exposition and American Culture* (Chicago, 1979). Much useful information may also be found in Robert W. Rydell, *All the World's a Fair: Visions of Empire at American International Expositions, 1876–1916* (Chicago, 1984); *The Chicago World's Fair of 1893: A Photographic Record with Text by Stanley Applebaum* (New York, 1980); James Gilbert, *Perfect Cities: Chicago's Utopias of 1893* (Chicago, 1991); Alan Trachtenberg, *The Incorporation of America: Culture and Society in the Gilded Age* (New York, 1982); and John Cawelti, "America on Display: The World's Fairs of 1876, 1893, 1933," in Frederic Cople Jaher, ed., *The Age of Industrialism in America* (New York, 1968), pp. 317–363. The following are other particularly helpful sources.

PREFACE

A succinct but highly informative account of Columbus's reputation during the four centuries following his encounter

with the New World is Claudia L. Bushman, *America Discovers Columbus: How an Italian Explorer Became an American Hero* (Hanover, N.H., 1992). John Noble Wilford, "Discovering Columbus," *New York Times Magazine*, August 11, 1991, pp. 24–28ff, lends perspective to the acrimonious debate over Columbus and his historical legacy. Kirkpatrick Sale, *Conquest of Paradise: Christopher Columbus and the Columbian Legacy* (New York, 1990), is probably the most sustained attack to date on the effects of the Genoese seaman's voyage to the New World. For a defense, though by no means an uncritical one, see Stephan Thernstrom, "The Columbus Controversy," *American Educator* 16 (Spring 1992), 24, 28–32.

1. Setting for a Celebration

For certain information regarding the Crystal Palace Exhibition I am indebted to a remarkably stimulating work, O. B. Hardison, Jr., *Disappearing Through the Skylight: Culture and Technology in the Twentieth Century* (New York, 1989). Merle Curti, "America at the World's Fairs, 1851–1893," *American Historical Review* 55 (July 1950), 833–856, provides an overview of American involvement with world expositions during the second half of the nineteenth century. Dee Brown, *The Year of the Century* (New York, 1966), and Dorothy Gondos Beers, "The Centennial City, 1865–1876," in Russell F. Weigley, ed., *Philadelphia: A 300-Year History* (New York, 1982), look at the nation's first successful world's fair.

2. The City on the Prairie

The quotation that begins the chapter comes from William H. Jordy and Ralph Coe, eds., *American Architecture and Other Writings by Montgomery Schuyler* (Cambridge, Mass., 1961). General histories of Chicago abound. Among the best is Bessie Louise Pierce, *A History of Chicago*, vol. III: *The Rise of a Modern City* (New York, 1957). Other useful, more anecdotal works are Emmett Dedmon, *Fabulous Chicago* (New York,

1953); Stephen Longstreet, *Chicago: An Intimate Portrait of People, Pleasures, and Power, 1860–1919* (New York, 1973); and Lloyd Lewis and Henry Justin Smith, *Chicago: The History of Its Reputation* (New York, 1929). Less a traditional history but a seminal modern work is William Cronon, *Nature's Metropolis: Chicago and the Great West* (New York, 1991). The impressions of visitors to Chicago may be found in Pierce's *As Others See Chicago: Impressions of Visitors, 1673–1933* (Chicago, 1933); W.[illiam] T. Stead, *If Christ Came to Chicago?*; Paul Bourget, *Outre-Mer: Impressions of America* (New York, 1895); and Paul de Rousiers, *American Life*, trans. A. J. Herbertson (New York, 1892). *Baedeker's The United States: A Handbook for Travellers, 1893* (New York, 1893; reprint, 1971), pp. 279–286, is a treasure trove of hard-to-find details. Among numerous works that treat the Great Fire of 1871, Ross Miller, *American Apocalypse: The Great Fire and the Myth of Chicago* (Chicago, 1990), is essential. Rebuilding the razed city has received deserved attention. Carl W. Condit's *The Rise of the Skyscraper* (Chicago, 1952) and *The Chicago School of Architecture: A History of Commercial and Public Building in the Chicago Area, 1875–1925* (Chicago, 1964) are instructive, as is Wayne Andrews, *Architecture, Ambition and Americans: A Social History of American Architecture* (New York, 1964). A good glimpse into the lives of Chicago's rich is the highly sympathetic Ishbel Ross, *Silhouette in Diamonds: The Life of Mrs. Potter Palmer* (New York, 1960). More analytical and critical is Helen Lefkowitz Horowitz, *Culture and the City: Cultural Philanthropy in Chicago from the 1880s to 1917* (Lexington, Ky., 1976). For Jane Addams, her work, and her difficulties with Chicago politicians, see Jane Addams, *Twenty Years at Hull House* (New York, 1910); Allen F. Davis, *American Heroine: The Life and Legend of Jane Addams* (New York, 1973); and Anne Firor Scott, "Saint Jane and the Ward Boss," in Stephen B. Oates, ed., *Portrait of America*, vol. II, 3rd ed. (Boston, 1983), 115–126. Lloyd Wendt and Herman Kogan, *Bosses in Lusty Chicago: The Story of Bathhouse John and Hinky Dink* (Bloomington, Ind., 1967), traces the careers of two unforgettable

politicos; Claudius O. Johnson, *Carter Henry Harrison I: Political Leader*, 2 vols. (Chicago, 1928), is the best biography of Chicago's five-time mayor. Significant studies of police forces include James F. Richardson, *Urban Police in the United States* (Port Washington, N.Y., 1974), and Robert M. Fogelson, *Big City Police* (Cambridge, Mass., 1977).

3. A GATHERING OF ARCHITECTS

Thomas S. Hines, *Burnham of Chicago: Architect and Planner* (New York, 1974), was of inestimable help for my work. Those interested in the fair's Director of Works might also turn to an earlier work, Charles Moore, *Daniel H. Burnham: Architect, Planner of Cities*, 2 vols. (Boston, 1921). Donald Hoffman, *The Architecture of John Wellborn Root* (Baltimore, 1973), offers a useful estimate of Burnham's friend and partner, as does the more personal and less technical Harriet Monroe, *John Wellborn Root* (Boston, 1896). Laura Wood Roper, *FLO: A Biography of Frederick Law Olmsted* (Baltimore, 1973), provides information and insights on America's greatest landscape architect. So too does Thomas Bender, *Toward an Urban Vision: Ideas and Institutions in Nineteenth-Century America* (Lexington, Ky., 1975). The literature on Louis H. Sullivan keeps growing. Hugh Morrison, *Louis Sullivan: Prophet of Modern Architecture* (New York, 1935); Sherman Paul, *Louis Sullivan: An Architect in American Thought* (Englewood Cliffs, N.J., 1962); and Robert Twombly, *Louis Sullivan: His Life and Work* (Chicago, 1987), are important studies, but for the full flavor of Sullivan's ideas and hyperventilating rhetoric one must read *The Autobiography of an Idea* (New York, 1924; reprint, 1956). Paul R. Baker, *Richard Morris Hunt* (Cambridge, Mass., 1980), provides additional perspective on the builders of the exposition. The debate over the choice of style for the Court of Honor seems endless. No work on the exposition can escape, or as far as I know has escaped, dealing with this matter. Joan E. Draper has provided a most astute historiographical account of this debate in her

198 A NOTE ON SOURCES

introduction to Burnham's *The Final Report of the Director of Works.* . . . Most helpful to me concerning the Colonial American architecture and artifacts at the exposition was Susan Prendergast Schoelwer, "Curious Relics and Quaint Scenes: The Colonial Revival at Chicago's Great Fair," in Alan Axelrod, ed., *The Colonial Revival in America* (New York, 1985), pp. 184–216. For the larger question of America's deference to European culture I have drawn from Cushing Strout, *The American Image of the Old World* (New York, 1963).

4. "You Must See This Fair"

The previously cited *Baedeker's* has provided me with details of costs regarding a visit to Chicago and the fair. Paul Boyer, *Urban Masses and Moral Order in America, 1820–1920* (Cambridge, Mass., 1978), a highly thoughtful work, affords some understanding of the behavior of the crowds at the Columbian celebration. My information pertaining to science and technology derived from various sources, no one of which was preeminent. But Thomas J. Schlereth, *Victorian America: Transformations in Everyday Life, 1876–1915* (New York, 1991), is highly informative about technology and material life during the late nineteenth century, including the exposition. I have given rather short shrift to the exhibits organized by individual states, but the interested reader may explore this path with profit. One exemplary work is Larry Massie, "The Great American Fair: Michigan and the Columbian Exposition," *Michigan History* 68 (May/June 1984), 12–22. Douglas L. Wilson, ed., *The Genteel Tradition: Nine Essays by George Santayana* (Cambridge, Mass, 1967), explores a major aspect of American intellectual and cultural life during the late nineteenth century. John Tomsich, *A Genteel Endeavor: American Culture and Politics in the Gilded Age* (Stanford, 1971), further delineates the genteel tradition, while the Howard Mumford Jones quotation concerning that tradition comes from his *The Age of Energy: Varieties of American Experience, 1865–1915* (New

York, 1971). From a different perspective, Lawrence W. Levine, *Highbrow/Lowbrow: The Emergence of Cultural Hierarchy in America* (Cambridge, Mass., 1988), deftly explores rifts in the nation's cultural matrix. My knowledge and understanding of the arts has been aided by a variety of works. Among the general ones are Oliver W. Larkin, *Art and Life in America*, rev. ed. (New York, 1960); E. P. Richardson, *Painting in America: From 1502 to the Present* (New York, 1965); John Burchard and Albert Bush-Brown, *The Architecture of America: A Social and Cultural History*, abridged (Boston, 1966); and Russell Lynes, *The Lively Audience: A Social History of the Visual and Performing Arts in America, 1890–1950* (New York, 1985). *The American Renaissance: 1876–1917*, with a foreword by Michael Botwinich (Brooklyn, 1979), which served as the catalog for an exhibit at the Brooklyn Museum, has a splendid series of essays that accompany rich illustrations. Among the more specific works on the American Renaissance that I have used are Homer Saint-Gaudens, ed., *The Reminiscences of Augustus Saint-Gaudens*, vol. II (New York, 1913); Paul R. Baker, *Stanny: The Gilded Life of Stanford White* (New York, 1989); and H. Wayne Morgan, *Keepers of Culture: The Art-Thought of Kenyon Cox, Royal Cortissoz, and Frank Jewett Mather, Jr.* (Kent, Ohio, 1989). John Tasker Howard, *Our American Music: A Comprehensive History from 1620 to the Present*, 4th ed. (New York, 1965), offers encyclopedic details concerning the music and musicians of late-nineteenth-century America. I am especially indebted to Levine's *Highbrow/Lowbrow* for material on Theodore Thomas.

5. A COMMUNITY OF IDEAS

Most of the factual material for this chapter comes from previously cited sources. Frederick Jackson Turner's remarkable essay on the frontier is readily available in a variety of editions. Roderick Nash, *Wilderness and the American Mind*, 2d ed., rev. (New Haven, 1973), provided indispensable back-

ground information. I have drawn freely on Justus D. Doen-
ecke, "Myths, Machines and Markets: The Columbian Exposi-
tion of 1893," *Journal of Popular Culture* 6 (Winter 1972),
535–549, both here and elsewhere.

6. FOR SOME, A HARDER STRUGGLE

Both Lois W. Banner, *Women in Modern America: A Brief
History*, 2d ed. (San Diego, 1984), and Eleanor Flexner, *Century
of Struggle: The Woman's Rights Movement in the United States*,
rev. ed. (Cambridge, Mass., 1975), have been of marked assis-
tance for the section on women in this chapter, as has been the
Ross biography of Bertha Honoré Palmer. Jacqueline Van
Voris, *Carrie Chapman Catt: A Public Life* (New York, 1987),
and Alice Freeman Palmer, "Some Lasting Results of the
World's Fair," *Forum* 16 (December 1893), 517–523, have
offered further illumination. For the most complete account by
far of the role and treatment of women at the fair, see the
substantial Jeanne Marie Weimann, *The Fair Women* (Chicago,
1981). The worsening plight of black Americans and Native
Americans has been well documented. Rayford Logan, *The
Betrayal of the Negro from Rutherford B. Hayes to Woodrow
Wilson*, rev. ed. (New York, 1965), for one, is informative. For
information about black Chicagoans I have relied chiefly on
Allan H. Spear, *Black Chicago: The Making of a Negro Ghetto,
1890–1920* (Chicago, 1967), and Thomas Lee Philpott, *The
Slum and the Ghetto: Neighborhood Deterioration and Middle-
Class Reform, Chicago, 1880–1930* (New York, 1978). A brief but
incisive account of black Americans at the Chicago World's
Fair is Elliot M. Rudwick and August Meier, "Black Man in
the 'White City': Negroes and the Columbian Exposition,
1893," *Phylon* 26 (Winter 1965), 354–361. Philip Weeks, *Fare-
well, My Nation: The American Indian and the United States,
1820–1890* (Arlington Heights, Ill., 1990), has provided service-
able background information. I have relied on Francis Paul
Prucha, *The Great Father: The United States Government and the*

American Indians, vol. II (Lincoln, Nebr., 1984), for more specialized details. Joseph G. Rosa and Robin May, *Buffalo Bill and His Wild West* (Lawrence, Kans., 1989), in addition to its fine illustrative material, was also helpful.

7. SATISFYING POPULAR TASTES

I have culled information pertaining to the social history and popular culture of the period from diverse sources. J. C. Furnas, *The Americans: A Social History of the United States*, vol. II (New York, 1969), provides a wealth of details in a sprightly manner, as does Cleveland Amory, *The Proper Bostonians* (New York, 1947). Lois Banner, *American Beauty* (Chicago, 1983), expertly analyzes changing tastes with regard to female beauty. *The Autobiography of Sol Bloom* (New York, 1948), provides an interesting glimpse into the origins and workings of the Midway. For the section on Little Egypt I have heavily relied upon Bernard Sobel, "Hootchy-Kootchy," *Dance* 20 (October 1946), 13–15, 46. Information concerning the March King, in addition to previously cited sources, has come chiefly from John Philip Sousa, *Marching Along: Recollections of Men, Women, and Music* (Boston, 1928). But see also Paul E. Bierley, *John Philip Sousa, American Phenomenon* (Englewood Cliffs, N.J., 1973). Although originally published more than half a century ago (1940), Douglas Gilbert, *American Vaudeville: Its Life and Times* (reprint ed., New York, 1968), retains its luster and usefulness. The same holds true for a work that is part history, part reminiscence, that was originally published nearly forty years ago (1954), Tom Fletcher, *100 Years of the Negro in Show Business* (reprint ed., New York, 1984). A brief but helpful essay on the minstrel show is Robert C. Toll, "Show Biz in Blackface: The Evolution of the Minstrel Show as a Theatrical Form," in Myron Matlaw, ed., *American Popular Entertainment* (Westport, Conn., 1979), pp. 21–32. John A. Kouwenhoven, "The Eiffel Tower and the Ferris Wheel," *Arts Magazine* 54 (February 1980), 170–173, offers astute insights into the famous invention of George Washington Gale Ferris.

8. Legacies of a City of Dreams

The various introductory quotations that depict the exposition (or at least the White City) as transcending reality can be found in William A. Coles and Henry Hope Reed, eds., *Architecture in America: A Battle of Styles* (New York, 1961), pp. 137–211 *passim*, and "Literary Tribute to the World's Fair," *Dial* 15 (October 1, 1893), 176–178. The Henry Adams quote comes from his *Education*. The quotation by Charles Dudley Warner comes from the *Dial*, p. 177. Margaret G. Van Rensselaer's encomium for the fair's architecture is reprinted in Coles and Reed, pp. 187–189. Montgomery Schuyler's doubts, expressed in "Last Words About the World's Fair," are reprinted in the earlier cited William H. Jordy and Ralph Coe, eds., *American Architecture...*, pp. 556–578. William H. Wilson, *The City Beautiful Movement* (Baltimore, 1989), has been a source for my understanding of both that movement and aspects of the exposition. For the influence of the exposition on the thoughts of Henry Demarest Lloyd (and others), see John L. Thomas, *Alternative America: Henry George, Edward Bellamy, Henry Demarest Lloyd and the Adversary Tradition* (Cambridge, Mass., 1983), and Stanley Buder, *Visionaries and Planners: The Garden City Movement and the Modern Community* (New York, 1990). For the growing importance of Chicago as a focus for literary activity and for the literary influences of the exposition, see Hugh Dalziel Duncan, *The Rise of Chicago as a Literary Center from 1885 to 1920: A Sociological Essay in American Culture* (Totowa, N. J., 1964); Clarence A. Andrews, *Chicago in Story: A Literary History* (Iowa City, 1982); and Carl S. Smith, *Chicago and the American Literary Imagination: 1880–1920* (Chicago, 1984).

Index

206

Holabird and Roche, 32, 55
Holmes, H. H. (Herman W.
Mudgett), 181, 191
Home Insurance Building, 32
Homer, Winslow, 10, 107
Homestead Strike, 85, 119
Hooker, Isabella Beecher, 134
Horowitz, Helen Lefkowitz, 156
Horticulture Building, 67
Hovenden, Thomas, 107
Howard, John Tasker, 108
Howe, Julia Ward, 166, 168
Howells, William Dean, 189
Hull House, 36–38, 130, 142
Hunt, Richard Morris, 54–56,
58–59, 66, 68, 79, 137
Hunt, William Morris, 106
Huxley, Thomas, 129

If Christ Came to Chicago, 190
Immigration Restriction League,
152
Infanta Eulalia, 78
Infanta Eulalia's Jewels, 191
Inness, George, 107
Insull, Samuel, 90
International Congress on
Education, 117–119
International Folk-Lore Congress,
151
Irving, Henry, 33
Isabella, Queen, 77, 94, 137

Jackson, Helen Hunt, 148
Jackson, James Caleb, 163
Jackson, Peter, 160
Jefferson, Thomas, 122
Jenney, William Le Baron, 32, 51,
54–56, 60
Jenney and Mundie, 67
Joliet and Marquette, 17
Jolson, Al, 171
Jones, Howard Mumford, 95
Joplin, Scott, 173
Jordan, David Starr, 118
Jubilee Singers, 146, 171
Jungle, The, 20

Kelley, Florence, 38
Kenna, "Hinky Dink" Mike, 40–41,

44, 182
Kimball, Fiske, 62, 180
Kipley, Joseph, 43
Kipling, Rudyard, 14–15, 25
Knights of Columbus, ix
Knights of Labor, 142
Kouwenhoven, John, 177–178

La Farge, John, 10, 106
Langtry, Lillie, 33
La Rabida, ix
Larkin, Oliver W., 102
Lathrop, Julia, 37
Lawrence, Mary, 100
Leiter, Levi, 23, 28
Leo XIII, Pope, ix
Leopold, King, 84
Lesy, Michael, 125
Levee, 41–42, 46
Levine, Lawrence W., 110, 112, 192
Lewis, Sinclair, 63
Lincoln, Abraham, 179, 182
Lincoln, Robert Todd, 29
Lind, Jenny, 107, 165
"Little Egypt" (Fahreda Mahzar),
165–168
Liverpool Times, 6
Lloyd, Henry Demarest, 52, 121,
189
Lodge, Henry Cabot, 127, 152
London *Times*, 5–6
Looking Backward, 121
Louisville Courier-Journal, 76
Lounsbury, Thomas R., 180

Machinery Building (Machinery
Hall), 67–68, 84, 88
McAllister, Ward, 14–15
McCormick, Cyrus Hall, 28–29
McCormick Harvesting Machine
Company, 15, 19, 46
MacDowell, Edward, 110, 151
MacFadden, Bernarr, 160
McKim, Joseph, 58, 184–185
McKim, Mead and White, 55, 64,
67, 106
McKinley, William, 179
MacMonnies, Frederick William,
99–100
MacMonnies, Mary Fairchild, 137

A NOTE ON THE AUTHOR

Robert Muccigrosso is professor of history at Brooklyn College and at the Graduate School and University Center of the City University of New York. Born in Elmira, New York, he studied at Syracuse University and at Columbia University where he received M.A. and Ph.D. degrees. He has been a Woodrow Wilson fellow and is also the author of *American Gothic: The Mind and Art of Ralph Adams Cram* and, with David R. Contosta, *America in the Twentieth Century*, and editor of the *Research Guide to American Historical Biography*.